Roger Fry and
the Beginnings of
Formalist Art Criticism

Studies in the Fine Arts: Criticism, No. 8

Donald B. Kuspit

Chairman, Department of Art
State University of New York at Stony Brook

Kenneth S. Friedman, Ph.D.
Consulting Editor

Other Titles in This Series

Roger Fry and the Beginnings of Formalist Art Criticism

by Jacqueline V. Falkenheim

umi
RESEARCH PRESS

Produced and distributed by
UMI Research Press
an imprint of
University Microfilms International
Ann Arbor, Michigan 48106

Library of Congress Cataloging in Publication Data

Falkenheim, Jacqueline Victoria, 1945-
 Roger Fry and the beginnings of formalist art
criticism.

 (Studies in fine arts : Criticism ; no. 8)
 Originally presented as the author's thesis, Yale, 1972.
 Bibliography: p.
 Includes index.
 1. Fry, Roger Eliot, 1866-1934. 2. Art criticism—
England. 3. Art, French—England. 4. Impressionism
(Art)—England. 5. Post-impressionism (Art)—England.
I. Title. II. Series.

N7483.F79F34 1980 709'.2'4 80-23577
ISBN 0-8357-1086-6

To the Memory of
my Mother and Father

Contents

Abbreviations

The following abbreviations are used throughout this text:

Ath	*Athenaeum*
Burl	*Burlington Magazine*
Cézanne	*Cézanne: A Study of His Development*
SR	*Saturday Review* (London)
Times	*London Times*
Transformations	*Transformations: Critical and Speculative Essays on Art*
V&D	*Vision and Design*

Foreword

The role of the art critic is paradoxical. He makes the first, and presumably freshest, response to the work of art, grasps it when it is still new and strange, and gives us a preliminary hold on its meaning. Yet his response is not comprehensive, for it is inexperienced: the work has not yet had a history, a context of response to give its "text" density. When the critic encounters it as a contemporary product, it lacks historical "bearing." Indeed, part of the critic's task is to win it a hearing at the court of history. This is why, as Baudelaire says, the critic is often a "passionate, partisan observer" of the work, rather than a detached judge of its value. As its contemporary, he plays the role of advocate, knowing the case only from the viewpoint of the work itself. For the sensitive critic the work will always remain a surprise, and he will always be its enthusiast. He will leave it to the future historian to engage in that dissection of art which presupposes a settled opinion of its significance.

Yet — and this is the paradox — the temporary opinion of the critic often becomes the characteristic one. The critic's response is, if not the model, then the condition for all future interpretation. His attention is the work's ticket into history.

A sign of the critic's power, in modern times, is his *naming* of new art. Louis Vauxcelles' labels "Fauvism" and "Cubism," for instance, have had an enormous influence on the understanding of these styles. Through such names art assumes an identity for future generations. And an understanding which begins as no more than a "semiotic enclave," to use Umberto Eco's term, becomes a whole language of discourse, creating an entire climate of opinion. Clearly, the responsibility is awesome. Clement Greenberg once wrote that the best moment to approach a work of art critically was after the novelty had worn off but before it became history. Yet it is at just that moment that the work is most unsettled and vulnerable, when the critic's swift "decision," in the form of an impromptu name, can seal its destiny forever. In so

seemingly trivial an instance as naming we see criticism's enormous power of determination.

Criticism, then, as Oscar Wilde wrote in "The Critic as Artist," is vital to art. Criticism grasps and preserves, cultivates and exalts. The history of art criticism is the history of different generations' responses to the art. No doubt the interests of the generation determine what is interesting about the art. As Reinhild Janzen tells us in her study of Altdorfer criticism, the assumption of *Rezeptionsgeschichte*—the history of critical response to an art—is that "a work of art is a piece of dead matter until it is drawn into a dialectic, dynamic relationship with an observer," and the interests of the observer obviously influence the nature of the relationship. The history of art criticism is both the record of such relationships and the demonstration of their significance to the work of art. This insight underlies the Janzen study as well as the other volumes in this series.

At stake in the encounter between art and its observer is ideology or, in H. R. Jauss' words, the "recipient's . . . horizon of expectation." That ideology both conditions the recipient's response to the work of art and is itself affected by the encounter.

At the same time, as Janzen says, the recipient's horizon of expectation leads to the differentiation between "primary and secondary types of reception. The first is the original experience or encounter with a work of art." The second is influenced by "knowledge of preceding, traditional interpretations." In Janzen's study, Friedrich Schlegel's essay on Altdorfer's *Battle of Alexander* is an example of primary reception and Oskar Kokoschka's later interpretation of the same painting illustrates secondary reception. Clearly, from the viewpoint of *Rezeptionsgeschichte*, there are no absolute criticisms of art, for even the primary reception is determined by the interests of the critic, and thus is dialectical. Indeed, as Janzen implies in her endorsement of Herder's concept of criticism, the recognition of the dialectical character of criticism that *Rezeptionsgeschichte* forces upon us is an antidote to "aesthetic historicism's static view of history," i.e., its concept of the aesthetic finality of the work of art.

This series of titles selected from dissertation literature exemplifies *Rezeptionsgeschichte* in a variety of ways. First, it shows us the history of the reception of artists whom we have come to regard as "major," in particular Altdorfer (in the Janzen volume) and Van Gogh (in Zemel's study). The authors discuss both how these artists moved from minor to major status and the meaning of the move for the culture in which it was made.

Second, the series offers us the history of individual critics'

reception of a variety of art. We trace the development of a characteristic view of art in Baudelaire, Ruskin, Proust, and Pater (in the Johnson work), in Champfleury (Flanary), and in Claudel (Gelber). Sometimes, as in the case of Champfleury and Claudel, we are dealing with figures whose primary identity does not seem connected with the visual arts. At other times, as in the cases of Baudelaire, Ruskin, Proust, and Pater, even when the figure is associated with the visual arts, the ideology is grounded in larger cultural issues as well as other, usually literary, arts. The perspective of such a mind often leads to unexpected insights and lends fresh significance to the work of art.

Third, the series addresses the critical response to whole movements of art, in particular Cubism (in the Gamwell treatise) and Abstract Expressionism (Foster). We learn how an art that seemed aberrant came to seem central and how critical response created a unified outlook on a highly differentiated group of artists.

Fourth, we have portraits of figures — Félix Fénéon by Halperin and Roger Fry by Falkenheim — who are more or less exclusively art critics. As professionals their horizons of expectation developed in close encounters with art. And their outlooks are also shown to involve larger cultural orientations — the ideology that makes their responses to art dramatic, part of a larger dialectic, dynamic relationship with their culture.

Finally, Olson's treatise examines the development of journalistic criticism in New York. We see *Rezeptionsgeschichte* as it enters a new, democratic, populist phase. Journalistic critics spearhead the advance of culture for the masses in which the encounter with art is there for the asking by anyone.

These five genres of *Rezeptionsgeschichte* demonstrate the richness and complexity of art criticism as an intellectual and cultural enterprise. They also make clear that there is no such thing as neutral, ideology-free criticism. Indeed, the very meaning of criticism is to put information to a larger use, to subject it to an *Aufhebung* or mediation which makes it truly telling — truly revelatory of the art. Art criticism, as it is examined in these volumes, is neither description nor evaluation of art. It is a means of entry, through art, into a study of the complex intentions that structure the life-world, and a demonstration of art's structural role in the life-world that produces it.

In concluding, let us note some particulars of the volumes in this series, especially the ways in which they tie in with broader cultural issues. Janzen makes clear that Altdorfer's reputation hangs on the familiar North/South — Northern Romantic/Southern Classical — conflict. Altdorfer's slow acceptance corresponds to the reluctant acceptance of

Northern irrationality or abnormality and Southern (Italianate) rationality and normativeness. In her study of Van Gogh, Zemel shows that at issue in the reception of Van Gogh's art was the artist's temperament or emotionality, as the foundation of his creativity. Van Gogh came to be accepted when it was recognized that emotions were a major component of creativity. Van Gogh's art became the proof of this assumption.

Johnson shows us that the art criticism of Baudelaire, Ruskin, Proust and Pater demonstrates the growth of bourgeois individualism. The "poetic" individuality the critic can achieve through the art becomes emblematic of bourgeois self-possession and integrity in the eyes of the world. Their art criticism is also caught up in the shift from the concept of art as a (romantic) depiction of nature to the idea of art for art's sake. Art for art's sake is another means whereby individuality is achieved and refined.

In her work on Claudel, Gelber offers us a new perspective: modern art seen in a religious context. Claudel is haunted by the possibility of a modern religious, specifically Christian, art. Gelber shows how one well-formed ideology, even if based more on non-art than art encounters, can lead to a powerful analysis of art. Flanary makes a similar point in his study of Champfleury, although here the ideology is secular rather than sacred. Champfleury's sense of the importance of realism and Claudel's sense of the importance of Christianity as comprehensive *Weltanschauungs* shape their perspectives on art.

In Gamwell's volume on Cubist criticism and Foster's on Abstract Expressionist criticism we see the way in which complexity of meaning can interfere with an understanding of art. In these studies we have a sense of how much an art can deliver, and how uncertain we finally are about what is delivered. Yet, we sense that the art is aesthetically important because it has become a stylistic idiom for many.

Halperin's work on Fénéon offers us a study of a critic's language. In Falkenheim's book we learn the historical background of Roger Fry's formalism, which became a major ideology as well as an empirical mode of analysis of 20th-century art. Olson acquaints us with critics who claim to represent the masses in their encounter with art—popularizers of criticism as well as of art. All three studies show us criticism in a practical as well as theoretical light. Criticism can be a short, sharp look as well as a considered opinion, a way of dealing with a newly given object as well as with a standing problem.

These volumes demonstrate the versatility and subtlety of art criticism.

Whether we accept Robert Goldwater's notion that criticism is a "provisional perspective" on art and so implicitly journalistic, or Pater's

notion that it is a means to profound spiritual experience and self-discovery, or Claudel's view that criticism is the study of art in the light of a dominant *Weltanschauung*, art criticism displays a unique range of methods for the investigation of art.

Donald B. Kuspit
Series Editor

Preface

The subject of this study is the development of Roger Fry's concerns as a critic in relation to the artistic events in England that provided the context for this development. I am invoking the idea of formalism to help explain Fry's priorities as he might have seen them and to give them a place in the progress of twentieth-century art criticism. Formalism here describes a primary interest in the structural order of a work of art, the significance of which can then be interpreted in various ways.

This study is divided into two parts. The first part is a discussion of the introduction of modern French art into England between 1895 and 1912. Increasing interest in the work of Impressionist and, above all, Post-Impressionist artists, such as Cézanne, Gauguin and Matisse, prepared the way for an acknowledgment of formal problems as valid concerns for the artist. This interest also helped create the need for critics to explain the more seemingly abstract experiments of these artists. Fry became one of the most important of these critics.

The second part of this essay is an analysis of Fry's practical and theoretical discussions about the requirements for artistic creation. I shall be concentrating on that part of his art criticism in which Fry seems to have been most preoccupied with ideas about structural order and with general issues in aesthetic theory. I shall also only discuss other events in Fry's life, besides those connected with his concerns as a critic, when these events are directly related to the development of his critical thought.

I would like to thank Robert L. Herbert, my dissertation advisor, who has helped and encouraged me at all stages of this study. I am also very grateful to Pamela Diamand, the daughter of Roger Fry, who took the time to talk to me about her father's work and who generously permitted me to examine all of Fry's unpublished papers that are in her possession. In addition, I would like to thank Denys Sutton, who kindly allowed me to read the typescript of his forthcoming edition of Fry's letters.

Many people helped me and answered my inquiries while I was in England. Among these are: Professor Quentin Bell, Sir Anthony Blunt, Alan Bowness, Sir Kenneth Clark, Douglas Cooper, A.N.L. Munby, Benedict Nicholson. I would like to thank all these people.

Jacqueline V. Falkenheim

New Haven, Connecticut
1972

Preface — After Eight Years

I am presenting here, in a slightly altered version, the dissertation that I wrote at Yale University, between 1971 and 1972. As the title suggests — and it is exactly the same title that enclosed the original text — I have assumed two tasks. The first, which is the more circumscribed and direct and, as it turns out, the one that I could more easily assume if I were now to start all over again, is to provide information and a simple structure for the writings of Roger Fry. Fry remains firmly with us as a very, if not the most influential early supporter of Modern art, and as a critic who did proud justice to the language in which he was writing. On a number of occasions over the last eight years I have grown impatient with Fry, impatient with his principles, impatient with the seemingly easy and elegant way in which he glided and sometimes tramped across the history of art. But at the same time, I have become more and more convinced of the *importance* of his activity, for the accumulation of his perceptions and reflections that allow both the making and thinking about art to seem like subtle and complex, and thus very worthwhile, human enterprises.

Between 1969 and 1972 I set about trying to find and read everything Fry had written about the visual arts. I also attempted to invade his thoughts by learning as much as I could about what this very curious and energetic critic was looking at, reading, and generally responding to in the England of particularly 1890 to 1914. I spent contented hours — the especially contented hours of the student newly liberated and wanting to experiment with just learned patterns of research — sifting through journals, newspapers, catalogues, archives, conversations with helpful friends and supporters of Fry, and trying to find the works of art he might have seen, and in this particular case, those he made himself. I have added little to the accumulation of this information since 1972, and hence I present it here, with the exception of some changes in prose, unaltered from the original text.

My second task was to bring some intellectual order to the

information I had gathered and to offer coherent meaning to Fry's writings. This is the task that I realized then to be the more open-ended one and the one that I would handle somewhat differently, if I were to attempt here to obliterate the time that now separates me from my original dissertation. I mean, not only that I hope I know more than I did eight years ago, but also that I now see this dissertation, in its original form, as quite specifically inspired by the concerns of the decade at the end of which it was written. As I am now more clearly aware, I was writing about the priorities of the artistic period that had not come to an end while I was studying it. Simply stated, formalism loomed large in the attention of students of Modern art of the sixties. It was at once intimidating and comforting to be confronted by a pattern of critical investigation that suggested standards and seemingly coherent and rigorous means for apprehending works of art. Roger Fry was then, as he still is now, looked to as a pioneering, if unwitting, practitioner of this pattern of inquiry. Thus it seemed especially important to study Fry *because* he stood at the beginning of these Modern concerns for the visual arts.

I have shaped my discussion of Fry's writings, particularly in Part II of this essay, around the attempt to isolate and explain whatever tenets might be essential to formalist criticism. *Isolate* is an important word here; in 1972 I was especially concerned with certain points of differentiation and discrimination. First of all, I saw much reason to distinguish Fry's brand of criticism from other Modern, but generally earlier, preoccupations, such as those of Romanticism. Fry's own history, his mode of inquiry, as well as his manner of writing, suggest a turn of mind at odds with emphatic displays of emotion and introspection. And even if we take for granted, as we should with any critic, the intuitive basis for his judgments and associations, Fry still seems, nevertheless, to have always wanted to demonstrate the process of his thinking; that is, his critical judgments appear to be quite rationally and logically ordered ones.

This apparent attention to reason and order is related in turn to the second main distinction I have attempted to make here. I came to locate Fry's concerns for his contemporary art, what in the end he is to be most remembered for, in a compatible, even necessary, relationship of these to his earlier and continued study of the old masters. That is, for Fry, who was quite a firm believer in tradition for the discipline and vocabulary it offers the artist, conventions became at times synonymous with the forthright experimenting with formal elements, such as color, line and space, that has otherwise been taken to be the special preoccupation of artists like Cézanne and Matisse. Of course, anyone familiar with Fry's

writings knows that I did not invent this smooth transition from his discussion of the Moderns to that of the old masters. In his most reflective and slightly autobiographical essay Fry himself maintains his logical and essentially linear movement from past to present within the history of art. But I did seize upon these reflections as a means of isolating and bringing order to Fry's development as a critic. I am concerned in this text with what is unique about Fry's critical involvement with the visual arts—what separates his interest in his contemporary art from that of other Moderns and what as well is specifically appropriate in his writings to the *visual* arts. If Fry, as I hope, does not emerge from the second part of this essay in a vacuum, it is because I have attempted, first of all, to suggest for his thinking a basically art-historical development and tried less to probe his more general participation in his contemporary world.

It occurs to me eight years later that this linear and exclusive order I have attempted to bring to Fry's writings is also a formalist one, to be distinguished, for example, from an order informed by a search for the disparate threads that make up what is more inclusively Modern. In recent years I, myself, have become more sympathetic to the latter approach. And if I were to redo this study now I would probably look to dissolve some of the differences between Fry and his contemporaries, such as Julius Meier-Graefe, to resolve seeming contradictions, between for example Impressionism and Post-Impressionism, and, generally, to look about among Fry's contemporary writers, philosophers, psychologists, maybe even politicians, for compatible concerns. But then, when I am alone again with Fry, or with his writings through which I have come to know him, I am not so sure that he would understand my change of heart, or approve my attempts to obliterate distinctions and dismiss hierarchies. Worst of all, I am afraid that he might accuse me of being too capricious, of now being taken by the priorities of another decade, that is, of sounding simply like a student of the seventies. And so I have decided to leave these first attempts at scholarship virtually unchanged. I have only made some alterations in language and phrasing, and added and subtracted several footnotes, where I thought that these changes would clarify my suggestions, or at least make them more palatable.

Because I have not significantly altered the original structure and content of this essay and thus not taken advantage of work published on the subject after 1972, I have not attempted to update the bibliography. But there are two recent studies, especially close to my concerns here, that I would like to mention to anyone now wanting as thorough an understanding as possible of the texture of Fry's life and thought: Donald A. Laing, *Roger Fry—An Annotated Bibliography of the Published*

Writings, New York: Garland, 1979; and Frances Spalding, *Roger Fry Art and Life*, London: Granada, 1979.

I again want to express my appreciation to Robert L. Herbert, for his continued support and interest in my work. I am also grateful for the concern of a number of people who over the last eight years have helped me to sustain my enthusiasm for my subject and to see the issues with greater clarity and subtlety. I want, in particular, to thank: Theodore M. Brown, David Cast, Clement Greenberg, Anne Mochon, and Richard Shiff for their advice and encouragement.

<div align="right">Jacqueline V. Falkenheim</div>

Ithaca, New York
1980

Part One

English Criticism
and French Art, 1895–1910

The decisive years in the development of Roger Fry's critical thought were also important ones for the English art world. It was during the period from about 1895 to 1910 that England was slowly awakening to contemporary French art. The increased practical, financial, and aesthetic involvement with avant-garde movements on the continent reinforced Fry's own discoveries about modern art and set the scene for the impact his theories were to have on his English audience.

During the several decades before 1895, the British interest in art was primarily insular. The Pre-Raphaelites determined the prevailing taste for much of the period. The influence of William Morris also remained strong. Generally, the English expressed an interest in the refinements of the decorative and graphic arts. Aubrey Beardsley, one of the most celebrated artists towards the end of the century, determined this taste for the finely drawn line. These preferences are further revealed in the pages of two of the leading periodicals, *The Studio* and the *Art Journal*, where the most prevalent articles were those on the applied and decorative arts. Although English artists and writers were, during this period, growing more enthusiastic about contemporary developments in France, the public remained relatively uninterested and uninformed. Their awareness of French art came second-hand, through the writings of James McNeill Whistler and Oscar Wilde.

Before 1895 there was little opportunity for the English to experience directly contemporary art from the continent. The public collections were restricted to the work of the old masters, and there were not many private galleries where contemporary work, English as well as French, could be seen. Picture-collecting was also a discreet activity. As far as French art was concerned, the Barbizon painters were favored. The English maintained a marked fondness for this particular school of landscape painting. In fact, part of their reluctance to accept later developments in French art can be attributed to this persistent interest in

the paintings of artists like Corot, Millet and Daubigny. Well into the first decade of the twentieth century, Barbizon paintings remained the most popular foreign art, and works by these artists made up the bulk of three important English collections, those of Alexander Young, James Staats-Forbes, and Sir John Day. A look at *The Year's Art*[1] for 1905 reveals that, included among the paintings by foreign artists sold in England for over 90 guineas in 1904, the only French works were by Daubigny, Dupré, Fantin-Latour and Monticelli. The same journal for 1910 reports that, in 1909, of the 78 pictures that sold for 1400 guineas or more, 7 were by Corot, 4 by Daubigny, 2 by Harpignies, 1 each by Diaz, Jacque, Millet and other Barbizon painters. Not one was by an Impressionist.

Inevitably, as ties between England and France became more numerous and art became a more important commodity, as well as a source of pleasure, a larger number of more recent French works began to find their way across the Channel. The introduction of Impressionism marked the beginning of a real acceptance of modern French art in England. The initial reactions to the new French art were predictably hostile and suspicious. Durand-Ruel brought some Impressionist paintings over to London in 1882,[2] but these works were almost completely ignored. Frederick Wedmore, who was one of the few critics to comment on the exhibition, offered in the *Fortnightly Review* only minor praise to these artists for their faithfulness to modern life. Wedmore mainly condemned the absence of moral concerns and the "indifference to the finer forms of humanity" in these paintings. He objected to the absence of 'soul' in Monet's landscapes and to the unattractive types whom Degas chose to paint.[3]

A decade later, in 1893, the public had another opportunity to see an example of Impressionist painting. Degas' painting, called *l'Absinthe* (Paris, Louvre) was exhibited at the Grafton Galleries early that year.[4] This time, the unfamiliar French art attracted more attention, centered around precisely the same issue of ugliness and moral responsibility in Degas' paintings that had preoccupied Wedmore 11 years before. A heated controversy developed in the British press over the moral implications of the supposed homage herein portrayed "to the wicked liquor that drives men mad."[5] The nature of the subject matter was at that time the main criterion being used to judge works of art, and the British people, accustomed to the portrayal of idealized human beings and mythological or historical subjects, were shocked by this apparent glimpse into the sordid aspects of real life. Even George Moore, the supposed defender of Degas and of French art, added his own moral

condemnation of the idleness and low vice written on the face of the woman. "The tale is not a pleasant one but it is a lesson."[6]

The initial objections to Impressionist painting gradually lessened as exposure to the French art in London increased. During the last few years of the nineteenth century several new galleries opened that made this direct exposure possible. For example, in 1898, the International Society of Sculptors, Painters and Engravers was founded, with Whistler as the first president. Subsequently, its annual exhibitions at the New Gallery became an important outlet for Impressionist paintings. And in 1901 paintings by Monet, Pissarro, Sisley, and Renoir were to be seen at the Hanover Gallery.[7]

Around the turn of the century several books appeared in England devoted entirely to Impressionist painting, which helped to publicize the French artists. From our vantage point these studies seem naive and uninformed, but they did initially supply information where none had been available before. The first of these works was George Moore's *Modern Painting*, published in 1893. Moore offered a gentle acceptance of the French artists, but he does not seem really to have understood how Impressionist paintings were made. In the name of beauty and aestheticism reminiscent of Pater and Whistler, he took up the cause of art for art's sake, which the French painters seemed to represent. Later studies of the Impressionists, such as Wynford Dewhurst's *Impressionist Painting*, 1904, and Paul George Konody's translation of Camille Mauclair's *French Impressionists*, 1902, are characterized by an emphasis put on the ties between the French artists and Turner's generation in England. Mauclair, for example, maintained the importance of Bonnington and Turner for the French painters. He further 'discovered' a common interest in the Primitives, which the French artists shared with the Pre-Raphaelites.[8]

The commentary on French Impressionism by English critics was not always naive or hostile. In fact, two English writers, who happened to be on the scene when the French art was introduced, have left us with some of the most enlightened analyses of the way these painters worked. The first of these men was R.A.M. Stevenson, who was a contributor to *The Studio* and the regular critic for the *Pall Mall Gazette* between 1893 and 1899.[9] Stevenson also published several important critical works in the late 1890s — *Velasquez* in 1895, *Rubens* in 1898 and *Raeburn*, published posthumously in 1900. His most important work was the *Velasquez*, significant for its popularity with English artists at the end of the century and for the aesthetic defense of Impressionist painting it offered. Stevenson claimed the prime importance of the artist's technique over subject matter. He called Velasquez an Impressionist

because of his method of unifying the picture plane by gradations of tone rather than by fixed contours. All the art he appreciated was characterized for him by this method of gradation. He stressed "direct painting" whereby the artist avoids such preliminary steps as sketching his image onto the canvas to be colored in later and instead attacks the canvas directly with the brush in order to create a unified surface texture. Stevenson's artistic position stood at the opposite extreme from that of the Royal Academy. He offered technical concerns and formal problems as the criteria for judging a work of art, whereas the Academy attached a far greater importance to subject matter and to narrative content. It was partly the latter tradition that was responsible for the hostile reactions to Degas' paintings in 1882 and 1893.

D.S. MacColl, one of Stevenson's most influential and intelligent disciples, carried on the battle to make Impressionism acceptable to the British public. Writing for the *Spectator* and later for the *Saturday Review*, MacColl set aside the moral issues and defended Degas and the Impressionists, in general, for their ability to use paint and for their right to choose their own subject matter. Thus he raised in the pages of the daily press the fundamental issue of the importance of form versus content, which was to be crucial to the acceptance of the new French art in England.[10]

MacColl's most important contribution towards making Impressionism comprehensible was his study, *Nineteenth Century Art*, published in 1902. The main text of the book is an attempt at a readable appraisal of nineteenth-century art, based on the paintings exhibited in the International Exposition at Glasgow in 1901.[11] Frank Rutter, a contemporary of MacColl, and another influential spokesman for modern art, summed up the significance of this book as follows:[12]

> (1) It exploded the pretensions of the type of work seen in the Royal Academy Annual exhibitions. (2) It set forth the achievements of the great French painters of the period. (3) It directed attention to the contemporary work of (a) the Glasgow school, (b) the New English Art Club, Steer in particular.

Impressionism had come a long way in England between 1882 and 1902. Thanks to critics like MacColl, sufficient information about the new art was available to counter older standards that had initially made the French art unacceptable. We have only to look at some sample commentary on an exhibition in 1905, which brought together a large number of Impressionist works, to see to what extent the critical reaction had changed. In that year Durand-Ruel again brought some French pictures over to London. In January and February over 315 paintings by Boudin, Cézanne, Degas, Manet, Monet, Pissarro, Renoir, Sisley, and

others could be seen at the Grafton Galleries.[13] This time the exhibition did not go unnoticed. The critic for the *Daily Mail* hailed it as the "most important picture exhibition held in London for many years."[14] He went on to explain:

> . . . the aims of the Impressionists, as demonstrated by the pictures at the Grafton Galleries were of a twofold nature—a revolution in technique and a revolution in subject matter. The one may be identified with the name of Claude Monet, the other with that of Edouard Manet . . .

The critic for the *Daily Telegraph* referred to "one of the most remarkable exhibitions that have of late years been seen in London."[15] He acknowledged the formal priorities of the group.

> And Impressionist art, even more than the art of any other school, depends on decision and felicity in the main design, the structure of a landscape. What may, at first sight, seem thrown on a canvas with a light heart, a light hand, and no particular intention as regards design, is really, as a rule, the result of prolonged experiment and elaborate preparation.

Predictably, it was once more left to MacColl to sum up the situation in the English art world in 1905:[16]

> In London also the general attitude has changed with almost bewildering rapidity. The keen interest shown in the Impressionist exhibition at the Grafton, the transformation of Rodin into a popular idol, and the crowds that pass through the Whistler exhibition,[17] if they do not, in the case of many of the worshippers, prove more than that the watchwords have changed, testify at least to a collapse of official superstition . . .

After seeing that Impressionism was successful in England during the final years of its introduction, we should now consider what kind of sustained reaction it met up with in subsequent years. Here we are in for a surprise. In spite of the enthusiastic reception offered the Durand-Ruel exhibition in 1905, more often than not critics and artists were seeking to challenge the basic tenets of the French painters. Unlike the objections that confronted Degas in 1882 and 1893, the newer criticism, that is, that which appeared between about 1905 and 1910, was not naively based on old-fashioned aesthetic criteria. It was founded on a more complicated ethical and philosophical resistance to the unidealistic and unanthropocentric character of the new art. The educated judgments of Stevenson and MacColl, who accepted the formal bias of Impressionism with no ideological claims made upon it, remained the minority view. The majority of intelligent, if less visual, critics continued

to suspect the French artists because of their purely painterly and supposedly scientific concerns.

This more characteristic view of Impressionism is perhaps that expressed by Laurence Binyon,[18] writing in the *Saturday Review* in 1908.[19] Binyon considered Impressionism to be too personal, involved with sense response and devoid of "world-interest" or an appeal to the human spirit. He also reviewed MacColl's *Nineteenth Century Art* in the *Quarterly Review* and again in the *Saturday Review.*[20] In the *Saturday Review* article he attacked the "dehumanized character" of Monet's interests, on strictly ideological grounds. He compared him to Barye whose "power belongs to a higher nature and an intelligent imagination, working on a theme of real significance." He further noticed that in

> Monet the attempt to reduce the significance in things to lower all human interests in the art, and to cultivate the sensations of the optic nerve, is the mark of a man who is deficient in creative imagination, and not representative of the full human mind.[21]

The concern for the "full human mind" was again insisted upon by A.J. Finberg in his book, *Turner Sketches and Drawings* of 1910.[22] Finberg rejected the Impressionist vision, which is supposedly purely "cognitive" and "sense perceptual," in favor of one that relies more fully upon the union between the imagination and the external world. He believed that the Impressionist aim to "isolate the pure element of objective reality" is an untenable, if not an unworthy occupation. He stated at one point that it is the fault of modern art criticism that so much emphasis is put on the "primitive sense-factor in pictorial language" and on the idea that art ought not to attempt any kind of ideational articulation.[23]

Finberg's conception of art was very much different from that of Stevenson and MacColl, whose aesthetic he might be criticizing here. He believed that art is based on ideas and is a creation of the imagination, whereas for MacColl it was more the perceptual reaction to a visual stimulus.[24] It is important to understand that it is fundamentally an ideological difference of opinion that determined these varying attitudes to Impressionism. MacColl and Stevenson were born into a generation that considered acuity of perception, not necessarily the personality of the artist, the important ingredient in artistic creation. A few years later this stance was supplanted by a new emphasis on individuality and expression that would expect from the artist a revelation of his thinking and his emotional life in his work. Impressionism therefore, lost favor, along with the vague philosophical attitude on which its defense depended. It was replaced by Post-Impressionism, which was destined to have a

sustained influence on the English art world partly because of this new ideological demand for the expression of the mind and soul of the artist in the work of art.[25]

Roger Fry was primarily responsible, not only for introducing French Post-Impressionism into England, but also for defining Post-Impressionism as a movement held together by a unifying theory of art and for identifying the artists who supposedly subscribed to this artistic doctrine. However, before we consider the events surrounding Fry's two Post-Impressionist exhibitions in 1910 and 1912, it is necessary to investigate how the said Post-Impressionist artists were faring in England before their official entrance. In 1902 when contemporary English art was finding increasing support in London, Cézanne, the so-called father of Post-Impressionism, was virtually unknown. Those writers who were aware of him tended to minimize his role as just another artist associated with the Impressionists. Wynford Dewhurst, for example, in his *Impressionist Painting*, judged him, coming after Boudin, as a precursor of Impressionism. He detected sincerity in the artist's supposed absolute truth to nature, but viewed his work on the whole as crude and weak in color.[26] Even the most serious advocates of contemporary French art did not seem to appreciate Cézanne before 1910. Hugh Lane, a particularly discerning collector who helped establish a collection of modern French and English art in Dublin in 1908,[27] bought a Manet, a Renoir and a Monet from Durand-Ruel in 1905,[28] but he does not seem to have been interested in Cézanne.[29]

As far as I know, Fry was the only critic to have acknowledged favorably the Cézannes seen at the New Gallery in 1906.[30] In a review for the *Athenaeum*, attributed to him,[31] he emphasizes the simplicity, expression, harking back to the primitive in Cézanne's paintings, ideas which became the mainstay of Post-Impressionist criticism after 1910.

The other Post-Impressionists fared no better in England before 1910. The Neo-Impressionists were always considered suspect because of their scientific interests. Van Gogh was rarely mentioned, and the cult of primitivism had not yet made Gauguin a hero. The general attitude towards these artists was summarized by an anonymous author writing in the *Burlington Magazine* in 1908.[32] In a review of the International Society exhibition at the New Gallery, after gently praising Monet and Renoir, he continued:

> With the younger generation of French artists, however it would seem as if the movement is in the last stage of decay . . . In the picture of M. Paul Signac the method is reduced to the level of a mosaic of near briquettes of colour, with a result once more absurdly out of proportion to the labour spent upon it, while in that of M. Matisse the movement reaches its second childhood. With M.

Gauguin. who is placed hard by. some trace of design and some feeling for the
decorative arrangement of colour may still be found: with M. Matisse motive and
treatment alike are infantile.

Although there was no actual support for the Post-Impressionist
artists in England before 1910, an ideological change that was ultimately
to cause the rejection of Impressionism was in turn gradually preparing
the way for an acceptance of the next generation of French artists. If we
now take a look at developments in the English art world during the
months immediately preceding the first Post-Impressionist exhibition, I
think we can find further hints of the change that was about to take
place. If 1910 was not a highly unusual year, a series of specific events
did take place over the course of these 12 months which, reinforced by
aesthetic assumptions, helped prepare the way for the acceptance of Post-
Impressionism, and for Fry's developing formalist aesthetic, on which
many of the ideas related to Post-Impressionism were based. The events
of the year were an important publication and several key exhibitions.
These introduced to the public and particularly to the critics the
necessary set of criteria by which Post-Impressionist art could be
analyzed. By our standards today, these new criteria were more
sophisticated and relevant to explaining a work of art than the methods
employed by Degas' critics in the 1890s.

In January and February of 1910, Fry published in the *Burlington* a
translation of Maurice Denis' 1907 article for *l'Occident* on Cézanne.[33]
The assumptions in this article, to a great extent, determined subsequent
ideas about Post-Impressionism. In the introduction Fry mentions "this
new conception of art, in which the decorative elements preponderate at
the expense of the representative." The form-content issue was thus
introduced. Fry also enlarges upon the position, which Denis discusses,
of El Greco in relationship to Cézanne's art. He asks:[34]

> Was it not rather El Greco's earliest training in the lingering Byzantine tradition
> that suggested to him his mode of escape into an art of direct decorative
> expression? and is not Cézanne after all these centuries the first to take up the
> hint El Greco threw out? The 'robust art of a Zurburan and a Velasquez' really
> passes over this hint. The time had not come to re-establish a system of purely
> decorative expression; the alternative representational idea of art was not yet
> worked out, though Velasquez perhaps was destined more than any other to show
> the ultimate range.

The important issues are introduced here. First of all, it is implied that
the "robust art of Velasquez" did not contain the same serious concern
for form as did that of El Greco. Velasquez was the favorite of
Stevenson, who liked him for the same reasons that he liked the

Impressionists. Fry is implicitly rejecting the Impressionist conception of form. Secondly, the comparison between Cézanne and El Greco was a German invention; Denis probably got it from Meier-Graefe.[35] But the introduction of the Byzantine was peculiar to Fry and to the English interest at that time in early Italian, particularly trecento, art and its origins.

For Denis, Cézanne was the "simple artisan, a primitive who returned to the sources of his art." He was also, like Rodin, a symbolist, expressing himself by a "method which aims at creation of a concrete object," that is the direct confrontation with what is 'real' or permanent in the world. For his early statements about Post-Impressionism, Cézanne in particular, Fry borrowed a great deal from Denis, and perhaps indirectly from Meier-Graefe, and this condition became a consistent point of attack on the part of MacColl, for example, who objected to much of Post-Impressionist painting.

In the spring of 1910 several exhibitions were held in London that emphasized certain aesthetic and historical issues that would be relevant to the coming of the Post-Impressionist exhibitions. The International Society Exhibition at the Grafton Galleries, first of all, helped to establish an historical context for the new art. Manet was represented in the show, and his painting, *Ecco Homo*,[36] was given a great deal of attention by the press. The critics generally complained about the unconventional treatment of the subject matter. But one writer, although he had some reservations about the *Ecco Homo*, still found that it "has all the aspect already of an 'old master' — so authoritative in its directness and absence of *arrière-pensée* does it appear, and so immediate and simple is the appeal made to the onlooker."[37] It is to be noted that the title for the first Grafton exhibition was "Manet and the Post-Impressionists," and that one of the principles for organization of the show was the consideration of Manet as an old master in relationship to the young revolutionaries.[38]

A Japanese-British exposition held at Shepherd's Bush, also in the spring of 1910, helped to underscore the purely aesthetic justification for contemporary art. People found it easier to discover the importance of formal structure in oriental art, and, gradually, this criterion was extended to the work of the moderns. One critic, for example, cited the belief then in the air that the exhibitions of Chinese and Japanese art at the British Museum and at Shepherd's Bush were giving the English artist a good opportunity "for reform." The current idea was that "European art of the next generation, it is thought, is most likely to be fertilised from Eastern sources."[39]

Another critic, as a result of the Japanese exhibition, noted

similarities between oriental art and Italian primitive painting which again emphasized the aesthetic basis for a work of art.[40] He claimed that the English people's increasing knowledge and love of

> more primitive Italian painting has prepared our minds for the beauty of Oriental art and for some understanding of the principles on which it is based and now Oriental art will give fresh authority to those principles which we are discovering in the primitive Italians.

We should recall here Fry's analogies in the Denis article between El Greco, the Byzantine and, by implication, Cézanne.

What is apparent from an examination of these several pieces of critical writing is that during the months preceding the first Post-Impressionist exhibition an aesthetic and historical structure to explain the new art was being formulated in the minds of the critics. The form-content issue had fully matured, and concern for the decorative elements or two-dimensional structure of a painting was important to many people. Likewise, ideas about the primitive, oriental, proto-Byzantine and any other sources that could be discovered for the new formal characteristics created a great deal of interest and were to become mainstays of Post-Impressionist criticism.

The most important exhibition of contemporary art in 1910, prior to the first Post-Impressionist exhibition, was the selection from "Modern French Artists" at the Brighton Public Art Galleries from June through August. The exhibition was organized by Robert Dell under the patronage of M. Dujardin-Beaumetz, minister for fine art.[41] In the introduction to the catalogue, Dell offered an important summary statement of the aims of the young artists in which he seems to have depended greatly on Fry and Denis for his information. Because he somewhat oversimplified the situation, he proposed one of the first easily understood explanations of the modern French movement. He incorporated the Impressionists into a "genuine French artistic tradition," claiming their lineage to reach back to Claude, Poussin and to earlier French painters. (Subsequent defenders of the French artists would of course draw distinctions between the ancestors for Impressionism and those for Post-Impressionism.) He went on to criticize the overly analytic method of the Impressionists, for example, their visualization of color as an "infinity of contrasts." Cézanne and the Symbolists then come along and Dell noted:

> . . . Symbolist painting is primarily decorative, and we must not look in it for exact reproduction of nature or an attempt at such reproduction. Some of the Symbolists simplify to the furthest possible extent and even perspective disappears

in their pictures; they, thus, approach the Primitives who were, after all, the true realists . . .

Dell's introduction brought together most of the 'current jargon', soon to become the staple of Post-Impressionist criticism, with one important amplification. He suggested that "it is easy to understand how Symbolism has been the outcome of Impressionism, for the aim of the Impressionists was to do just what M. Denis says the primitives did." He assumed a smooth transition from Impressionism to the later artists, and after incorporating Impressionism into the tradition of French art, established the art historical development of French painting one generation closer to the present.

The press greeted the Brighton exhibition with mixed feelings. Either the critics completely misrepresented the art work exhibited,[42] or they expressed shock and bewilderment at the sight of so many bright colors and departures from Renaissance standards for representing objects found in nature. The most comprehensive view of the exhibition appeared in the *Times*.[43] The main theme of the article was the sacrifice of representation to expression on the part of these several movements, going under the names of symbolism, primitivism, intimism and neo-Impressionism. The critic remarked:

> Of all it may be said that their aim is rather to present a mental image, more or less controlled by theories, than to set down a direct impression of a real scene. They would first of all eliminate from their pictures all acts that are irrelevant to what they wish to express; and besides this they claim the liberty to deal as they choose with the facts that remain, still in the interests of expression. Perhaps, therefore, we should call them expressionists rather than impressionists . . .

The author seems to have had a firm grasp of the theoretical assumptions on which the new art was based, but he was less at home with the actual visual material. He complained, generally, of excessive simplification or crude handling of paint, probably criticism of the license taken with conventional modes of representation. For instance, he states that Gauguin, who was working in the primitive method,

> falls short of the great Italian primitives in the beauty of material; and this failing is common to many of the painters of the new movement. The roughness and untidiness of their paint will probably shock most spectators more even than their forms and colours . . .

Similar criticism of abrasive surface texture was also to be found in other reviews of the exhibition. The absence of conventional modelling, and

especially the intense colors and conspicuous outlines found in many of these works, were disagreeably unfamiliar to the viewing public.

The author went on to complain that

> . . . in modern conditions no painter can well attain to the mastery of a Titian or a Velasquez, that mastery which can make complete representation expressive. Therefore, the painters who have most to express sacrifice more of representation to expression, and that is the reason why they are so unintelligible to the public, who miss in their works those facts which they expect to find in a picture.

The issue of unintelligibility is an important one. It is inevitable that the public would have been bewildered on first exposure to a new set of formal conventions in art, and it is apparent that on the eve of the first Post-Impressionist exhibition the public still needed instruction in how to accept the 'new vision', which was not compatible with their accustomed perception of the external world. One of the main functions of the critic was to help educate the public eye, when, as in 1910, a new set of aesthetic criteria took over from the traditional ones that had previously made representation the end of art. This was the problem that confronted Fry and his colleagues when they attempted their introduction of Post-Impressionism into England in November of 1910.

The Post-Impressionist Exhibitions of 1910 and 1912

The two exhibitions of Post-Impressionist painting, organized by Roger Fry for the Grafton Galleries and held in November 1910 and December 1912, are landmarks in the history of the introduction of modern art to the British public.[1] The sheer number of paintings, sculptures and drawings available for inspection is important. But the lasting significance of the two shows is the result of the great interest taken in them by the critics, artists and academicians, an interest which led to a crystallization of ideas about the new art. The chaos and confusion that accompanied the introduction of the unfamiliar material was alleviated, for better or worse, by the establishment of a new critical language that could explain away in the new art problems like apparent distortion, bright unmodelled color or lack of subject matter. Even those who had been proponents of the French artists found in the constant defense of their work an opportunity to clarify their own ideas. Fry was, of course, the major spokesman. He himself had discovered the young French artists only a few years before. Therefore, his ideas about them were not fully worked out in 1910, and the changes in his critical thought over the two-year period, between 1910 and 1912, were crucial elements in the development of his formalist ideas.

However, it is not only Fry's critical defense of the artists that should be considered in relationship to the two Post-Impressionist exhibitions. The accumulation of comments and speculations in the daily press and art magazines was considerable, and it is just this large-scale commitment on the part of the critics, both pro and con which ensured an enduring interest in Post-Impressionism in England. The purpose of this chapter will be to examine the reception of the two exhibitions, including the subsequent application of Post-Impressionist concerns to other artists and to other art forms. The main ideas, which became the rallying points for the two exhibitions, can be instructively compared. There were some differences between the two exhibitions, conditioned by

time, available paintings and changes in taste.[2] There seems also to have
been a definite ideological change in the explanation given for the
general characteristics of Post-Impressionism, a change that was essential
to the more sustained attitude towards Post-Impressionism formulated
during these years. This shift in ideology was also important to the
development of some of Fry's scattered ideas about the necessary criteria
for judging a work of art into his mature formalist aesthetic.

> . . . The Post-Impressionists what are they but the feeble epigones of the
> Racinistes – that brave band of fighters who gathered around Quinte Septule after
> his flight from Paris . . . The term 'Racinistes', untranslatable though it be, is
> scarcely in need of definition. It happily designates the men inspired by a feeling
> of revulsion against the superficiality of modern art, nay, of the whole modern
> attitude towards the absorbing mystery of life. The Racinistes go to the root of
> things. They use, if I may be allowed to elaborate an obvious simile, the visible
> and tangible part of the tree – that is to say the trunk and branches and
> foliage – as a symbol for the expression of the far more significant hidden roots
> from which the tree draws nourishment and life . . .

The above quotation is taken from the introduction to the catalogue
for an exhibition entitled "Septule and the Racinistes," held at the
Chelsea Arts Club in December of 1910.[3] The exhibition was an obvious
parody on Fry's first Grafton show, "Manet and the Post-Impressionists"
which opened at the Grafton Galleries, on November 8, 1910. As a
consistent parody, the Chelsea show was not completely successful, since
the works which were submitted under fictitious names were too easily
identifiable to be in the style of some contemporary English artists.
However, the catalogue introduction by Robert de Mançognes (perhaps
P.G. Konody) points out some of the major critical objections to the
Post-Impressionist exhibition. The word Racinistes here means "getting
down to roots,"[4] and it is this earnestness and emphasis on a return to
purity of vision and personal expression which were particularly vulner-
able to attack by the press and the public.

The basic tenets of the new art were set forth in the catalogue
introduction to the Grafton show.[5] It should first be made clear that the
term Post-Impressionism meant literally the art *after* Impressionism and
was not reserved just for the generation of the 1880s in France. The new
movement was characterized in the introduction as a reaction against
aspects of Impressionism, its most objectionable characteristic being the
supposed obsessive interest in reproducing natural phenomena and these
artists' "passive attitude towards the appearance of things." As was
pointed out in Chapter I, it was this apparently scientific or empirical
concern that was unpopular. The Post-Impressionists, therefore, aimed
not at a passive reproduction of nature, but at "exploring and expressing

the emotional significance which lies in things." Manet was considered the father of the new art because of his revolutionary experimentation with formal conventions, such as simple linear designs and flat, unmodelled color, which allowed for the expression of what came to be considered the essential and permanent aspects of things. But the major protagonists were the artists of the next generation—Cézanne, Van Gogh and Gauguin.

The word "primitive" appears in the catalogue introduction no less than five times, and the idea it conjures up of side-stepping numerous prejudices and conventions for depicting objects as they appear, to express directly their 'essential reality', became a rallying point for those who defended Post-Impressionism. According to these spokesmen, because the history of western art until then had been that of new discoveries to render natural appearances visible, it was necessary to find new formal devices to express, not superficial, but 'essential realities'. It is here that ideas like "*synthesis* in design" are brought in to emphasize what has become the "expressiveness of the whole design," which is more important than the seemingly correct representation of the appearances of objects. The main justifications for the new art, however, were not formal. Impressionism was rejected on ideological grounds, and in turn, the new ideology was invoked to defend the Post-Impressionists. These artists, as they were represented in Fry's first Post-Impressionist exhibition, were the uncorrupted idealists, searching after reality, uninfluenced by their contemporary (mechanistic) world. The concern for a cohesive pictorial structure and the reduction or simplification of form was again only a denial of a concern for representational images.

The first Post-Impressionist exhibition further put forth some romantic ideas of artistic integrity, of the artist's alienation from his contemporary society for which he refuses to compromise his personal view of things.[6] It was to become the special task of the artist to reveal the most meaningful aspects of form and, by extension, of the external world. This concern for art was theoretically based and essentially aformal, and it has been pointed out that few of the paintings selected for the first Post-Impressionist exhibition, particularly the Cézannes, could be convincingly analyzed in formal terms. Cézanne was represented by 21 works, many from his early 'baroque' period.[7] Gauguin, and particularly Van Gogh, were well represented, especially in comparison with Seurat, who had only two seascapes in the exhibition. The romantic strain in French art of the 1880s was clearly shown to best advantage.

All attention was given to the older masters of the end of the nineteenth century, with arbitrary representation given to the next

generation of painters. Nicolson points out that no living artist was represented by more than 9 paintings (compared with Van Gogh, 20; Gauguin, 37). He also claims that those moderns were seen to best advantage whose work evidence a romantic exuberance. Therefore, the "savage Vlaminck" and the "romantic Rouault" were best represented.[8]

Matisse and Picasso, the two artists whom we now recognize as the leaders of the pre-war modern movement in France, were particularly misrepresented. Matisse had three paintings in the exhibition, two "unruly landscapes" (Nicolson) and the portrait, *La Femme aux Yeux Verts* (San Francisco, San Francisco Museum of Art). The latter painting, more than any other single work, seemed to inspire a host of negative critical comments — attacks on the apparent lunacy, crudity and perversion that the new art was said to represent.

The ignorance of Picasso, particularly of the Cubist phase, showed up the greatest weaknesses and misunderstandings in the planning of the exhibition. The two Picassos were a 1905 subject picture and a 1909 portrait which, though having geometrical qualities, Nicolson considers reminiscent of Cézanne and not representative of Cubist formal organization.[9]

The historical inaccuracies and prejudices that now seem apparent to us can be partly understood and excused if we consider the difficult task Fry and the executive committee had in organizing an exhibition that was to be the first major statement in England of the objectives of modern art. Fry was almost alone in being aware at all of what contemporary French artists were trying to do, and even allowing for his personal contacts with dealers in Paris, he must have had trouble obtaining all the paintings he wanted. We might recall the generally cold reception modern French art had met with in London during the previous 40 years or so.

However, one serious prejudice revealed by the exhibition, for which Fry was in part responsible, should be considered. The romantic bias offered the British public a distorted notion of what were the objectives of the Post-Impressionist artists. As will be seen later, most of the objections to the paintings were expressed in terms of their revelation of excess and hysteria on the part of the artists who painted them.[10] This romantic inclination, which is uncharacteristic of Fry's fully developed tastes and critical thought, must have been the result of his temporary flirtation with German art criticism and values at this time.[11] German criticism to date meant Meier-Graefe and his lengthy and impassioned discussions of some of the modern French artists.[12] There is no indication that Fry was otherwise influenced by late nineteenth-century

German aesthetic theory, for example, the teachings of Conrad Fiedler and Adolf von Hildebrand.

The influence of Meier-Graefe on Fry is understandable. In 1910 there were few extensive and positive accounts of the Post-Impressionists available.[13] The French artists of the 1880s, particularly Cézanne, were enthusiastically received by German critics and dealers long before they were recognized in England.[14] Fry could have looked to Meier-Graefe for moral support, if for nothing else. But there is also hidden among the German critic's extravagant claims and emotional judgments, particuarly about Cézanne, an emphatic defense of the artistic process, with which Fry might have been sympathetic. Meier-Graefe upheld the notion that art is a recreation of the permanent structure that underlies appearances.[15] This was a common enough idea in the nineteenth century, but German writers took especially seriously the ethical function assigned to art to expose 'reality'. For Fry, who consistently tried to establish a meaning for art greater than mere self-indulgence, the implication that the artist, with his clarified vision, exposes superficialities in the surrounding world, must have had great appeal.

If Fry were seeking a formal justification for the Post-Impressionist art, this too could be found in Meier-Graefe. Although Meier-Graefe never felt he had to give a precise visual description of paintings he treats, he nevertheless discussed paintings in formal terms. For example, with respect to Cézanne, it is not the artist's choice of subject that concerned Meier-Graefe, but his creation of a structural order that equals the external order he was trying to visualize. Cézanne's genius was his ability to translate the finest nuances of our perceptions of nature into multiple color relationships.[16] Thus, Meier-Graefe went to great lengths to describe the artist's system of color orchestration as his method of both formal organization and of rendering the chaotic natural world intelligible. The result is a very 'modern' notion of the artist's working method, even if Meier-Graefe arrived at his conclusions at the hands of late nineteenth-century German speculations about reality and perception and was quite far from what to us would be a familiar approach to the visual material.[17]

Fry could also have found in Meier-Graefe the common, late nineteenth-century association between three-dimensionality and the degree to which the artist is attempting to make a serious statement. Conversely, two-dimensionality was associated with purely decorative and amoral intentions on the part of the artist. As we shall see later, this distinction became important for Fry in later years. As it happens, Fry could find a similar differentiation between monumentality and flatness in an art historical tradition much closer to home. And I will suggest

later that it was his experience with Italian art and the English scholarly method developed to explain it that had the more enduring effect on him.

But in 1910 Fry was not that sure of himself, and he had not yet thought sufficiently about Post-Impressionist painting to incorporate it into a consistent art historical tradition, worked out for himself. A close inspection of Meier-Graefe's writings reveals that Fry could have found sufficient support for his ideas in the theories of the German critic. It does not seem to me possible to separate completely the so-called romantic approach to form in Meier-Graefe's writing from the supposed classical tendencies revealed in the essay on Cézanne by Denis (see Chapter I), which would have been Fry's other important source for ideas about Cézanne and Post-Impressionism. It is true that Denis emphasized austerity of style and restraint in the mature Cézanne as a reaction against the romanticism in his early work, whereas German writers always maintained a fondness for the emotional statements of Cézanne's first period. However, Denis' analogy between Cézanne and the Persian carpet weaver "who assembles colors and forms without any literary preoccupation"[18] is not unlike Meier-Graefe's descriptions of the web of color sequences that he claimed was Cézanne's distillation of matter as it is perceived through pure vision.

Unfortunately, for the moment, Fry also picked up the Germanic notion of an artistic tradition starting with Tintoretto, El Greco and Delacroix and leading to Cézanne and Van Gogh. This ancestry for Post-Impressionism seemed to imply that primitivism, synthetic design, self-expression — the watchwords for the new art — meant an orgiastic delight in flinging paint onto the canvas, an idea that was not at all in keeping with English taste for perceptible order.

One of the main themes in periodical criticism unsympathetic to the first Post-Impressionist exhibition was the vulgarity and lack of technical skill present in the work of these artists. Primitivism was understood to mean not innocence, but immaturity, or worse, lunacy. The term lunatic was a popular one for describing the artists exhibiting.[19] Robert Ross, in the *Morning Post* (Nov. 7), seems to have had particularly damning things to say about Matisse, Denis and "Flamineck." He also called Van Gogh a lunatic. And in the same newspaper, a lengthy series of correspondence related to the exhibition finds E. Wake Cook suggesting the need for a psychological look into the Post-Impressionists, and Walter Crane offering a left-handed compliment to the same artists by defending their 'barbaric' and childlike sincerity (Nov. 18). Childish ineptitude also became quickly associated with primitive honesty in the minds of the critics. Cézanne was often criticized because he was unskilled and crude

enough to draw thick black lines around his figures, in the manner of a fumbling child.[20]

As might be expected, Matisse and specifically his painting *La Femme aux Yeux Verts*, was under particularly heavy attack. The bold coloring and blatant denial of a natualistic image disturbed almost everyone. P.G. Konody in the *Daily Mail* (Nov. 7) considered the work perverse and associated it with child art. And an anonymous reviewer for the *Daily Telegraph* (Nov. 11) reminded his readers that this painting was also condemned when it was exhibited at the Salon d'Automne in 1909. Walter Sickert offered the most logical criticism of Matisse, in terms of a viewer who was uncomfortable with his chromatic structures and lack of chiaroscuro modelling. He objected to the "unrelated colors," disconnected lines, that is, the abrupt transitions he discovered in this color-oriented art. Sickert found Cézanne more palatable because the gradations in his paintings (particularly the early work Sickert was exposed to) seemed more subtle.[21]

The British public was disturbed by the ineptitude and the supposed cult of the irrational exalted by the first Post-Impressionist exhibition. But they were more fundamentally insulted by the apparent maligning of past art in favor of the new. For example, the critic for the *Connoisseur* remarked:[22]

> . . . They [Post-Impressionists] have discarded the accepted tenets of art as resulting in work too subtle and complicated to arouse the emotions and have gone back to the most simple and primitive forms of expression, those of children and savage races. The result is the negation of art . . . Art, as exemplified by a gracious sweep of line, rhythmic cadences of colour, qualities of tone, or even by the close observation of nature, would arouse the aesthetic senses and so weaken the appeal to the more primitive emotions, which it is the object of the Post Impressionists to evoke . . .

The critic for the *Spectator* objected that the sacrifice of past art and conventions for representing appearances, and the attempt to see and paint the world as it really appears, are also a sacrifice of beauty to this new realism. He made a further objection that the word decorative, invoked to describe the main objectives of the Post-Impressionists, was never adequately defined.[23] It is certainly true that one of the reasons for the rift between the public and the Post-Impressionists and their supporters was the lack of clarity with which the new language to explain the artists' intentions was presented.

Some critics suggested, not completely unjustly, that the rejection of technical advancements in western art since the Renaissance, implied in

the notion of primitivism, was an impossible ideal. In a letter to the *Nation* (Dec. 13), Michael Sadler claimed that the group's idea to get behind "the mass of conventional symbols and facile representation which has grown up since the Renaissance" is not a sincere one. He pointed out that there is a difference between thirteenth-century limits of skill and the self-conscious ineptitude assumed by the Post-Impressionists. Similarly, the anonymous *Times* critic remarked with respect to Gauguin (Nov. 7): ". . . Really primitive art is attractive because it is unconscious; but this is deliberate—it is the abandonment of what Goethe called the 'culture-conquests' of the past . . ."

Looking back with hindsight, we would conclude that the public, including the majority of critics who reviewed the first Post-Impressionist exhibition, had little understanding of what these artists were doing. We might also observe, today, that the exaggerated emphasis on the return to primitivism was necessary to counter the exaggerated and sometimes indiscriminate respect for High Renaissance art on the part of the British people.

But it was still mainly the responsibility of the supporters of the exhibition to find a way of making these artists comprehensible, and their method was not successful. Fry, who, as we shall discover, became in later years the apparent upholder of tradition and the wealth of artistic experience out of which Post-Impressionism developed, was himself perhaps too determined to make extreme comparisons between the old and the new in 1910.

However, in the search for weaknesses in Fry's presentation of the Post-Impressionists to the public, no one has ever mentioned his postscript defense of their work in the pages of the *Nation*. In three articles[24] he elaborated upon some of the issues in the catalogue introduction and answered some of the attacks of the critics. Now, suddenly, the tendency to exaggerate disappears, and the Fry whom we will come to know better later, the connoisseur of ordered, 'classical' compositions, is present. In the first essay he attempts to counter the objections that the Post-Impressionists were rebellious and anarchical by emphasizing their awareness of and dependence on the western tradition of art, which they must, however, reject, although not permanently. The attempt to go behind the

> too elaborate pictorial apparatus which the Renaissance has established in painting to the simpler, more direct methods of the Primitives is made to rescue art from the hopeless encumberance of its own accumulations of science, if art is to regain its power to express emotional ideas, and not to become an appeal to curiosity and wonder at the artist's perilous skill.

It is in the second article that Fry makes the necessary explanations that probably should have been available when the exhibition opened. He first admits that there were too many Gauguins, other Van Goghs would have been desirable to add, and Matisse and Picasso were minimally and unjustly represented. He then goes on to explain the work of the major protagonists. Cézanne, initially represented as the wild romantic, is transformed, in Fry's own words, into an artist possessing "a supremely classical temperament." Fry says: "His portrait of his wife has, to my mind, the great monumental quality of early art, of Piero della Francesca or Mantegna." And about Matisse he emphasizes his "beauty of rhythm, of colour harmony, of pure design, . . . his singular mastery of the language of plastic form." He reserves for Van Gogh, in comparison with Cézanne or Gauguin, the expression of the romantic temperament, revealed in his response to the wildest adventures of the spirit. If Fry had made these distinctions between classical and romantic earlier and had also drawn on the antecedents for the new art, as he does here with Cézanne, Post-Impressionism might initially have seemed more acceptable to the now generally hostile public.

In the third essay Fry touches on an interesting issue, the meaning of the word primitivism, which was ambiguously defined in the catalogue introduction. At one point there was a reference in the introduction to primitive art as the art of non-western cultures, which is less sophisticated, but more expressive than most European art. When in the *Nation* essay, Fry criticizes Robert Morley for his condescending comparison between the Post-Impressionist pictures and Benin art, he must have had in mind this association of primitive with non-western. However, there were also statements in the catalogue introduction which allowed for the association of primitivism with fourteenth-century Italian art. Therefore, in the same text the word was meant to both incorporate the experience of western art, albeit the formative stages of this art, and to deny this tradition in favor of one which generally meant barbarism to the British public. Because 'primitivism' was such an important watch-word in the explanation of the exhibition, this seeming ambiguity was one of the weaknesses in the presentation of Post-Impressionism.[25]

In the first of the three articles, at one point, Fry urges the spectator to look at modern art without preconceptions of what a picture ought to be. But pictures, in a situation like this, do speak louder than words, and the public was shown a biased sampling of Post-Impressionist art. Unfortunately, few probably read beyond the catalogue introduction or had sufficient concern to labor through the small print of Fry's more reasoned and explicit explanations in the *Nation* during the month following the opening of the exhibition.

The first Post-Impressionist exhibition was, however, not a failure. It was received with antagonism (some of which is understandable considering the unaccustomed appearance of the works), not apathy. The public and critics showed that they were curious, and there were a few positive and constructive appraisals available to sustain this interest.[26] People finally came away almost convinced that art no longer had to mirror nature as it has been doing since the Renaissance.

The "Second Post-Impressionist Exhibition" opened at the Grafton Galleries on October 5, 1912, ran until December 12, and then reopened for another month on January 4, 1913. The emphasis now had shifted from the older masters, Manet and Cézanne, to the moderns, particularly Matisse and Picasso, who had been so inadequately represented in the first exhibition.[27] The exhibition was also more international in character, a large number of the works coming from England and Russia. Accordingly, the introduction was divided into three separate prefaces. Roger Fry was the spokesman for the French group, Clive Bell for the English group and Boris von Anrep for the Russian group. We are mainly concerned with Fry's justification for the French artists, who were the current innovators in European art. He seems to maintain the Germanic ethical commitment when he again claims that the French artists are not interested in producing representational images, but in expressing "by pictorial and plastic forms certain spiritual experiences."[28] Otherwise, Fry talks much less about ideology than he did in 1910, when he emphasized the artists' right to self-expression and their rebellion against the callousness of past art.

Now Fry is more concerned with convincing the public that the work of art has an internal structure of its own and that this 'form' is what needs to be understood. Thus, Picasso tries "to create a purely abstract language of form — a visual music,"[29] and "Matisse aims at convincing us of the reality of his forms by the continuity and flow of his rhythmic line, by the logic of his space relations, and, above all, by an entirely new use of colour."

Cézanne was still acknowledged as the father of this generation of artists concerned with expressive form. Although Fry mentions that Picasso has had a great deal of influence on the younger men, it is apparent that he himself felt closer to those 'less abstract' artists who followed more directly in the footsteps of Cézanne, for example, Derain, Marchand and Lhote.

The most significant changes between 1910 and 1912, expressed in the preface on the French group, was Fry's attempt to define the "classic spirit" present in the art of the Post-Impressionists and "common to the

best art of all periods from the twelfth century onwards . . ."[30] He
further explains:

> I do not mean by classic, dull, pedantic, traditional, reserved or any of those
> similar things which the word is often meant to imply . . . I mean that they do
> not rely for their effect upon associative ideas, as I believe Romantic and Realistic
> artists invariably do.

The reader of the 1910 *Nation* articles would now not have been
surprised that Fry had in mind this definition and the attempt to link the
art of Poussin with that of the Post-Impressionists, which he does in the
next paragraph. What is not so clear is why suddenly the classic spirit
becomes synonymous with pure form, whereas it is implied that the
realistic or romantic artist is more interested in reproducing representa-
tional images without concern for compositional unity. If we read Fry
literally, distinguishing classical from Baroque or Romantic, we would
assume that he found seventeenth-century Baroque art, as well as the
early romantic Cézannes that he supported in the first Post-Impressionist
exhibition, lacking in formal meaning. This conclusion would not be
completely just. Therefore, we must understand the word classical to
have a very broad and flexible meaning. Simply, it became for Fry the
necessary characteristic of any art he considered successful in establishing
a harmonious relationship among structural elements (for example, space
and volume) in order to create a pleasing and expressive composition.

 But, no doubt, for the people viewing the second Post-Impressionist
exhibition, classical conjured up notions of reason, order, the continuance
of a great and civilized tradition of making art, that had its fullest
expression in the Renaissance. The heavier concentration on the Cubists
and other 'Cubistic' art, compared with the first exhibition, could have
been summoned as proof of this orientation. The inscrutable non-
representational forms in Cubist painting must have presented themselves
as a firm barrier between supporter and foe. But the hint of geometric
shapes, restrained colors, tonal nuances, suggestion of order that were not
apparent in the exuberant gestures and abrupt color contrasts that the
inexperienced public was confronted with in the first exhibition, must, on
the other hand, have inspired greater confidence in these artists on the
part of the 1912 public. Particularly those artists like Lhote, Marchand,
Flandrin, and Herbin, who remained faithful to a natural motif and who
were closer to codifying Cézanne than was Picasso, would have escaped
the earlier accusations of irrationality, lack of discrimination and lunacy.
The "romantic Rouault" was not present at all, and Matisse was better
represented without the emphasis on his vehement Fauve paintings.
Generally, structurally definable elements were more visible on the walls

of the Grafton in 1912 than they had been two years before. The same was true of the English contribution. Clive Bell talks about Duncan Grant and Fry himself, who were acknowledged followers of Cézanne, concerning themselves with simplified patterns of color and geometric shapes.

The critics, by no means unanimous in their praise for the second Post-Impressionist exhibition, nevertheless took it more seriously than they had in 1910. To some extent, they must have been influenced by a public more excited and curious and aware that the artists had born up well under the attacks hurled at them two years before. In addition, the works exhibited in 1912 showed more visible signs of care, reason and aesthetic purpose behind their execution. Cézanne was actually a respected old master now.[31] The willingness to accept his form as a means of expression indicated that attitudes towards the mirror image had changed greatly in the two-year period.

Some critics were now enthusiastically proclaiming that art follows its own demands for compositional structure and does not reproduce nature in a passive way. The critic "H.S." for the *Spectator* (Nov. 12, 1910), who had felt it "unjust to make Manet in any way responsible for the excesses of what are now called "Post-Impressionists," now thought it "unjust not to recognize the general sense of rhythm in the lines of the dancing figures with joined hands by M. Matisse" (*La Danse,* New York, Museum of Modern Art), although one may not find his work pleasing (Oct. 5, 1912). Even the most hostile critics now had to admit that although they found Matisse's paintings ugly, there was behind his work a seriousness of purpose and a genius for creating linear rhythms and for harmonizing beautiful colors.[32] The more sympathetic of the critics discussed at greater length his achievement as a decorative artist. The reviewer for the *Times* (Oct. 4) talked about the quality of paint in his work, *The Goldfish,* and after considering the rhythmical qualities of the composition in *Les Danseuses (La Danse),* made the analogy between his art and music. Similarly, P.G. Konody, in the *Observer* (Oct. 6), called Matisse ". . . a real master of superb decorative colour, rhythmic line and expressive simplification . . ." It is instructive to note that Konody, who was also writing for the *Daily Mail,* gave a very negative account of the last Grafton show in that paper, having considered the intention of Matisse childish and perverse (see page 21). It should also be made clear that although these critics acknowledged Matisse as an 'Artist', they found his work disturbing for the license he took with the human form and for his apparent indifference to human values.

Matisse received so much attention because of the great commotion he caused during the first Post-Impressionist exhibition; however, the

main attractions of this show were probably those artists hovering around Picasso, who were considered, sometimes erroneously, to be the successors of Cézanne. The *Times* critic's discussion of the paintings by Marchand, Lhote, Derain and Herbin offers clues to what was the main lesson to be learned from the second Post-Impressionist exhibition (Oct. 21). M. Marchand, he says, in his *Vue de Ville*

> . . . has represented certain facts very simply and clearly, and has combined them so that his design is lucid and, at the same time, expressive of the character of the place . . . M. L'Hote is more fantastic than M. Marchand . . . but here again (in his *Port de Bordeaux*) the simplicity and homeliness of the method give us confidence in the artist . . .

M. Derain's *La Fenêtre sur le Parc*

> is a picture in the great classical French tradition. It looks Post-Impressionist mainly because the artist has simplified all his forms further than any artist of the 17th century and because he has tried to keep his masses of paint alive rather than smooth . . .

Finally, M. Herbin "sacrifices everything to the representation of mass, and his design in *Le Pont Neuf* certainly has a startling lucidity. There never was a picture more easy to grasp."

Lucidity seems to be the key word in these descriptions. The critics liked looking at "easily graspable" pictures and easily definable shapes and forms, which permitted them to believe they could understand the underlying structure. They had given up the need for representational images and allowed simplified form an expressive power of its own. Thus, the work of Derain was incorporated into the "great classical French tradition." This tradition also signified reason and intellectual exercise to them. And the prominent geometricized forms in these 'post-Cézanne' paintings looked like the result of an analytical thought process.

The reaction to Picasso, the greatest 'geometer' of the group, was more complicated. It is probably fair to say that no one connected with the Post-Impressionist exhibition, critics or supporters, really understood his intentions, particularly in the Cubist paintings. The critics were bewildered by these extreme departures from the representational image. The consensus was that his complicated geometrical structures, sometimes referred to as jig-saw puzzles, were purely theoretical experiments, unintelligible to the viewer.[33] Picasso was accused of playing the scientist, who arranges and rearranges diagrams, devoid of any meaning, lacking an ethical commitment on the part of the artist.[34] The Post-Impressionists in 1910 were criticized for excessive self-indulgence. Now they were being told that they were too calculating and lacking in human

feeling. It is certain, however, that the latter criticism was less devastating.

Fry again chose the pages of the *Nation* in which to counter some of the criticism of the second Post-Impressionist exhibition.[35] This time, his rebuttal was limited to one essay. He points out that Cézanne has now become a "Great master," although critics of the new art in general would then claim that he is not a Post-Impressionist. He reaffirms the 'traditional' aspects of Post-Impressionist art, explaining that the concern for form and for its expressive, not descriptive qualities, is part of a universal and older tradition than any concerned with the imitative side of art. Fry praises Matisse highly for his powers of design, particularly his handling of pure, flat masses of color. He stresses that the artist is a 'realistic' painter because he always comes back to a definite thing seen.

Picasso, however, is less representational, and Fry reveals his own uncertainty. He says for example: ". . . as to his latest works of all those in which Picasso frankly abandons all direct reference to natural appearance, I confess that I take them to some extent on trust, a trust which is surely justified by his previous work." Fry calls Picasso "the most gifted, the most incredibly facile of modern artists," and tries to counter the criticism that he is a pure theorist by claiming the "nervous sensitiveness and delicacy" that characterize his work. But his general conclusion is that while Picasso's fertile imagination permits him to experiment with various artistic problems, his work, at this stage, remains incomplete, 'unrealized' and experimental.

Some of the critics agreed with Fry's appraisal of Picasso, and, indeed, applied the notion of experimentation and incompletion to Post-Impressionist art in general.[36] However, at the same time, they accepted the intentions of these artists as valid aesthetic investigations. The critics implied that they appreciated the present experiments and theoretical speculation and were waiting patiently for their maturity and complete assimilation into the tradition of western art. This attitude was very different from the one expressed in 1910, when the artists and their work were dismissed as lunacy.

Fry states, when he is trying to counter the persistent accusations that Post-Impressionist art is ugly, what in final analysis must be the inevitable relationship between a new artistic movement and the public, when these viewers are first confronted with unfamiliar visual statements:[37]

> They [critics] forget that every new work of creative design is ugly until it becomes beautiful; that we usually apply the word beautiful to those works of art in which familiarity has enabled us to grasp the unity easily, and that we find ugly those works in which we still perceive the unity only by an effort.

We can appreciate the depth of Fry's insight when we examine the gradual change in the attitude on the part of the British people to Post-Impressionism, during the couple of years after the initial impact made by the first Grafton show. As both an ideology and an artistic movement among men, Post-Impressionism became acceptable as the most recent means of artistic expression; and particularly as an ideology, it was invoked to explain multiple aesthetic experiences besides those of painting and sculpture. P.G. Konody, writing in the *Observer* a year after the first Post-Impressionist exhibition, indicated the direction in which artistic taste is moving:[38]

> Scarcely a year has gone by since Gauguin, Van Gogh, Cézanne, Matisse and their artistic kinship burst upon the peace of the land at that memorable Grafton Gallery exhibition which caused so much derision, amusement, indignation and exaggerated enthusiasm. Scarcely a year — but the battle is over and won, and Post-Impressionism has taken firm root among us. We have become so accustomed to it — and to the new jargon it has introduced into art criticism — that the exhibition of paintings by Paul Cézanne and Paul Gauguin is in no way bewildering and does not impress one as at all abnormal. Another year or so, and the intelligent public, including the enthusiastic apostles of Post-Impressionism, will be able to judge between the success and failure of this new art instead of accepting or rejecting everything indiscriminately . . .[39]

A few months earlier Konody had again called upon Post-Impressionism to explain the motivation behind a newly published art quarterly, *Rhythm*.[40] He maintained:

> Post-Impressionism has evidently come to stay. It has now its official organ in the shape of the new shilling quarterly, *Rhythm* . . . The title of the magazine is happily chosen, since a striving for a new synthetic, expressive rhythm is one link which connects the individual followers of the new movement . . .

On the one hand Konody defended the artists who have created a new visual language; on the other hand, he supported the concepts behind their work. He also referred to the new language that Post-Impressionism introduced into art criticism. This was an important factor in securing a permanent place for the new art in the minds of the British public. A critical vocabulary to explain new visual experiments is necessary to bridge the gap of incomprehension between art work and viewer. The new language is one with which we are perhaps too familiar today, the beginnings of formalist criticism — that language descriptive of the relationship among areas of color, the extension of space, and other structural elements, which avoids making reference to subject matter or to associations with the external world beyond the picture plane itself. The following analysis of an exhibition of Futurist painting in London in

1912, judging from the words used and the placement of the emphasis in the description, would not have been possible two years before:[41]

> Futurist pictures can be made according to recipe. You represent all the different planes in the flat, and then you disturb all their relations to each other, as if you had given them a jolt; your object being to express the sensation produced by the changes of swift and complex movement.

Some critics, justifiably, pointed out the exaggerated and indiscriminate use of the word Post-Impressionist to describe contemporary art and culture. For example, there was a lively comment on the misuse of the term by Huntly Carter in the *New Age*, an avant-garde periodical otherwise favorably disposed to the original Post-Impressionist artists and to their aesthetic. Picasso was praised in the pages of the *New Age*, even before the opening of the first Grafton show.[42] In a discussion of an exhibition of sculpture by Eric Gill, Carter complains:[43]

> In the precincts of that little shrine of art, the Chenil Gallery, some of the jobbing gardeners in the art criticism line have fallen to their usual occupation of labelling . . . To them Mr. Gill is a Post-Impressionist in sculpture. And Mr. Gill putting his head through the door, doubtless exclaims, 'Gentlemen, while you are at it, you might as well call me a post-Mohammedan, or even a post-office. If I am post at all, I am post-Gill' . . .[44]

The expanded meaning of Post-Impressionism was most ingeniously applied to art forms other than the purely visual arts. The London theater had enthusiastically and directly borrowed the new terminology in headlines like the following: "Post-Impressionist Shakespeare at the Savoy Theater: Characters in The Winter's Tale as presented by Mr. Granville Barker."[45] Huntly Carter, again, tells us more about what were the Post-Impressionist qualities of contemporary theater:[46]

> As a supplementary note on the 'Blue Bird' at the Théâtre Rejane, I may mention the conscious attempt to apply the new Post-Impressionist principles of continuity by (1) lines all composed to suggest rhythmical movement, (2) by colour distribution to suggest movement, (3) by space suggesting infinity, (4) by light and atmosphere suggesting mystery . . .

The Post-Impressionist 'urge' also extended itself to literature. Katherine Mansfield claimed that two of the Van Goghs in the first Grafton exhibition "taught me something about writing, which was queer, a kind of freedom or rather a shaking free . . ."[47] The two exhibitions also had a following among poets. Volumes of *Post-Impressionist Poems* and *Cubist Poems* appeared during the next few years.[48]

Huntly Carter wrote a book in which he attempted to explain the aesthetic principles underlying both the current drama and the current art. He maintained that the intention of the contemporary artist is "to promote the growth of the rhythmic conscience." The artist does this by "increasing recognition of the laws of unity and continuity underlying the scheme of the universe, and the power to see life as a whole and not in detached unrelated parts. The enormous importance of rhythm in life is already beginning to be felt . . ."[49]

What comes to mind here is the other avant-garde literary and art periodical, *Rhythm*, born in London in 1911. Post-Impressionism, and particularly Fauvism, were well publicized in its pages. The basic idea running through its articles was that all works of art must have a 'rhythmic structure', a relationship among parts that also suggests a harmony in the natural order.

We are now several steps removed from the understanding of Post-Impressionism as an artistic movement among men to its more general application as an ideology. People like Carter, Michael Sadler and George Calderon[50] were less concerned with giving accurate descriptions of artists' working methods than with looking to art for a glorification of human intelligence and sensitivity. This is why so much attention was given to self-expression as the new order of the day. We have seen that Impressionism was doomed in England because it lacked an ideology with which people could easily associate a higher purpose for art than technical proficiency. The eagerness to discover works of art that expressed these 'essential truths' meant that the first movement to come along that could make such ambitious claims might have a strong following.

Wallace Martin makes the point that the atmosphere in England around 1910 was one of optimism and excitement. The expectation of a "cataclysmic transformation in the arts" preceded its concrete expression in England in the forms of Post-Impressionism, the philosophy of Bergson, psychoanalysis, and Russian culture.[51] Martin likens this period of multiple cultural changes to the Renaissance. And another writer in 1911, revealing the emotional rather than critical expression of this rebirth, also defined this period around 1910 as the beginnings of a "spiritual Renaissance" in western art. John Murray, in a review of Laurence Binyon, *Flight of the Dragon*, praised the Chinese artist in terms by now familiar — his ability to perceive profundity in the world, to find the universal in the particular and to express "rhythmic vitality" in his art.[52] Oriental art is superior to western art because it is a product of the emotional life, revealing the aesthetic rather than the utilitarian qualities of objects. However, after the long period of decline following

the Byzantine era, up until the nineteenth century when artists had been concerning themselves with imitating superficial appearances, western art, he believed, was currently undergoing a "spiritual Renaissance."

We may not agree with Murray that artistic developments had taken such a depressing course for the approximately 1,000 years before 1900, but we do learn from him that in 1910 a tremendous importance was being placed on the anticipated lessons to be learned from the new art.

Therefore, when Post-Impressionism came along in November of that year, a segment of the population, hungry for a new ideology, was waiting to greet it and to affirm and publicize its tenets as the last word in artistic intentions.[53]

It does not detract from Fry's importance to admit that he was not solely responsible for making Post-Impressionism palatable to the British public. It is difficult to imagine the situation where one person, armed only with his own convictions, could effectively foist an aesthetic experience on a passive audience. Fry was in the right place at the right time. The willingness to accept new visual material preceded the first Grafton exhibition. The catalyst was also there to enrich and expand the new aesthetic in the months after the first Post-Impressionist art works were made available.

However, it is also true that the differing receptions given to the two exhibitions were not based simply on the passage of time. A better selection of works and a better presentation of the artists' concerns and of their place within the history of art made the Post-Impressionists that much easier to accept after the second exhibition. Picasso, for example, who remained inadequately spoken for in 1912, likewise remained a disconcerting mystery to the majority of viewers.[54]

Fry himself had begun to discover, during the two years that separated the two exhibitions, how to incorporate an idea of form relevant to contemporary art into the traditional vocabulary of western art. This concept of form, which assumes a similar concern for structure and composition in the work of the old masters as in the work of the moderns, became much of the basis for his formalist concerns and was the final note of legitimacy needed to make the Post-Impressionists acceptable as serious artists.

D.S. MacColl and Roger Fry:
Two Critical Stances

I have mentioned the name of D.S. MacColl on several occasions here in connection with the developments in the English art world during the last years of the nineteenth century. We can again turn to MacColl to explain further the historical and ideological context in which Fry developed his theories about art.[1]

Like Fry, MacColl was both an art critic and connoisseur, as well as a painter. Although he was born and educated in Scotland, he spent most of his working life in London, where he succeeded in writing art criticism for various major periodicals and in exhibiting steadily with the New English Art Club. He became an important defender of the arts in Britain and served terms as keeper of both the Tate and Wallace collections.[2] He also published several key works on nineteenth- and early twentieth-century French and English art.[3]

MacColl and Fry were roughly contemporaries and equally formidable tastemakers for the British public, but as artists and critics committed to promote styles of art with which they were most comfortable, they were destined to take up the cause of two different groups of artists. MacColl championed the Impressionists, and Fry launched the Post-Impressionists.[4] As we know, well into the twentieth century, the tendency was to see Impressionism and Post-Impressionism as opposed styles of painting, the latter being a reaction against the former. The differing opinions about art held by Fry and MacColl can often be attributed to their varying commitments to these artistic movements. Fry showed only a minimal appreciation of the Impressionists, whereas MacColl would have little to do with art after the 1870s in France, or after the generation of Sickert and Steer in England.

We are fortunate that MacColl was a vocal critic and that he aimed his attack on Post-Impressionism at Fry. His combined hostility and astuteness resulted in a body of criticism of Fry's writings that has helped

to point out some of the weaknesses and underscore most of the important points in Fry's theories. MacColl was by far the most determined and incisive judge that Fry the critic ever had. His interpretation of Fry's remarks offers us some clues as to how the 'formalist's' ideas were destined to be received. For example, even MacColl lays what I believe to be too great an emphasis on Fry's preoccupation with abstraction and on his supposed disregard of content. These are ideas that people have about Fry and about his formalism up until the present day. MacColl also reminds us how important it is to consider Fry's theories within the context of events in the English and French art worlds out of which they emerged. Fry's commitment to art after Impressionism becomes clearer when we understand MacColl's objections to his ideas based on MacColl's own faithfulness to Impressionism.

MacColl's first lengthy discussion in print of Fry's theories did not appear until 1912, the year after the first Post-Impressionist exhibition. However, we must initially take a brief look at his writings before that eventful date to see into what mold he was casting himself. While Fry was championing Giotto and some fifteenth-century Italians and was searching for a similar kind of solidity in the work of the moderns, MacColl was establishing his reputation as the firm supporter of the Impressionists. In 1896 he joined the New English Art Club, and in that same year he praised the Club's activities in the *Saturday Review,* particularly the work of two of its more famous members, Sickert and Steer.[5] Later, in 1901, he warmly praised the work of the French Impressionists, seen in an exhibition at the Hanover Gallery.[6] He was critical of Renoir, saying he had a "defective colour-vision," but was very appreciative of Monet.

MacColl's most significant discussion of the French Impressionists appears in *Nineteenth Century Art,* his impressive study of nineteenth-century art in England and France (see Chapter I, p. 6). It is particularly in his appended chapter entitled "The Spectral Palette" that he reveals his intelligent understanding of the work of the Impressionist painters. MacColl tries to dispel two notions—that the Impressionists tried to model their palette on the solar spectrum and that they were scientifically interested in creating the effect of optical mixture with their broken color. (He will have more to say later about the nature of Impressionist color, when he objects to Fry's understanding of the use of color by the Impressionists and by Cézanne.)

In a review of *Raeburn* by Sir Walter Armstrong, MacColl reveals how involved he was with the theory and method of Impressionist painting.[7] The *Raeburn* monograph was actually begun by R.A.M.

Stevenson, MacColl's mentor and one of the first English writers to put a significant emphasis on technique and painting method at the expense of the representational image. MacColl concedes that Stevenson's doctrine of 'direct painting' was sometimes misapplied and that in this instant, his analysis would have been more appropriate to the subject of landscape painting, particularly that of Corot, rather than to Raeburn. However, MacColl is mainly interested in Stevenson's theory itself. Says MacColl:

> That doctrine was the painting of objects in terms of material values, and the growing of detail out of a general ensemble by proceeding from the most important planes as determined by the impact of light to their minor subdivisions . . . (p. 230)

MacColl, here speaking for Stevenson, is defining the process of painting not as an intellectual activity, but as a direct response to a stimulation of the senses. This 'positivistic' approach, which lays stress on "material values," prepares the most likely frame of mind in which the Impressionist method can be accepted.

MacColl published his first set of objections to Fry's theories in 1912 in an article entitled "A Year of Post-Impressionism" that was meant to be a critique of the first Grafton show.[8] His initial attack was directed at "the eulogy on Cézanne by Denis," which he apparently assumed to have had an important influence on the organization of the first Post-Impressionist exhibition. MacColl takes issue with most of the principal ideas in Denis' essay. First of all, he does not like the definition of the term "classic" to describe Cézanne's art. Denis maintained that the classic painter imitates objects "without any exactitude and without any accessory interest of sentiment or thought . . ."[9] He organizes forms and colors without any reference to the natural image. MacColl objects vehemently and offers a lengthy discussion of why a balanced relationship between form and content, or as he calls them, "beauty and significance," must be provided for in a good painting.

In the search for inconsistencies in Denis' argument, MacColl questions Denis' claim that Cézanne was concerned only with the three-dimensional image. MacColl objects that an artist cannot ignore the two-dimensional fact of the picture plane and think only in terms of a space containing solid bodies: he must take into account both the flat surface and the ability of his medium to offer a sense of depth.

MacColl's argument seems sensible enough. He is able to point out the weaknesses in Denis' somewhat doctrinaire essay, which partially reduces the work of art to a mechanical structure. We must not forget, however, that MacColl is thinking as well of Fry when he offers his

objections. He will consistently attack his colleague for what seems to him to be Fry's obsessions with abstraction and solidity.

Returning to the necessary balance between two-dimensional and three-dimensional considerations which he demands for the work of art, MacColl uses the term "decorative" to refer to the two-dimensional pattern made by solid shapes projected on one plane. He implies then that this formal pattern, which takes into consideration the two-dimensional shape of the picture surface, can itself only be expressed in two-dimensional terms. He then points to what he sees to be a fault in Fry's reasoning in the introduction to the Denis article, where Fry refers to this new art "in which the decorative elements preponderate at the expense of the representative." MacColl protests that: "The apostle of the new art is absorbed, it appears, in the 'representative' side (the rendering of depth), and knows nothing about the 'decorative' (the planning of the surface)." Here is the origin of an aesthetic difference of opinion between the two writers. MacColl recognizes formal design to exist only on the surface of a painting. He considers any allusion to the third dimension to be primarily a reference to the representational image. He will accuse Fry of inconsistency for wanting to have the sensation of space and volume without any reference to natural appearances.[10]

Fry, however, nurtured on the solidified shapes of Italian quattrocento art, believes that a formal order can be created out of volumes and planes that allude to the third dimension, and, in fact, that this element is a more meaningful expression of form than a design which exists purely on the surface. It should be pointed out here that MacColl's objection that Denis did not sufficiently take into account the actual properties of the two-dimensional canvas when he discussed Cézanne's painting method, is not also applicable to Fry. The idea of the 'integrity of the picture plane,' which still flourishes today and for which Fry is usually given credit, derives precisely from his awareness of the tension between the flat surface and the three-dimensional image.[11]

MacColl's contention that reference to the representational image always accompanies the sensation of space becomes a more complicated issue. He is correct to point out that it is almost impossible to eliminate associations with content from pictorial structure. Fry too, shies away from abstraction devoid of associations. He is most contented with a work of art that derives its form from the natural order. Therefore, his "emotional elements of design," through which he tries to define the structure of a unified work of art, are elements which have significance because they derive from the necessary means through which the human being orients himself to the world around him. He defines mass, for example, one of these elements, in the following way:

> When the object is so represented that we recognize it as having inertia we feel its
> power of resisting movement, or communicating its own movement to other
> bodies, and our imaginative reaction to such an image is governed by our
> experience of mass in actual life.[12]

For Fry, the reference to the third dimension does not necessarily
demand the inclusion of specific representational images; for MacColl it
apparently does.

MacColl also voices some objections to Denis' analysis of Cézanne's
working method, and here we must credit MacColl's Impressionist bias
with attempting to correct what had become a slightly distorted picture of
the Post-Impressionists' aims on the part of their supporters. At this
time, Denis and Fry were both guilty of trying to make the Post-
Impressionists into total innovators who rejected their past. On the
contrary, MacColl, who was particularly sensitive to the art of the 1870s,
was quick, and, I think, correct, to suggest the relationship between
Cézanne's working method and that of the Impressionists. He first
points out that the abolition of tone in favor of color, which Denis claims
for Cézanne, "is not Post-Impressionism at all, but the Impressionism of
Turner and Monet." (p. 288) He is describing the condition whereby the
Impressionists, in order to create the brilliance through pigment that
simulates sunlight, leave out the lower range of values on the value scale,
thus using exaggerated hue contrasts, even for the deepest shadows.
"Monet's 'purple shadow' is as famous as Turner's vermillion. Our
'classic' therefore, is on the ground a pure impressionist."

MacColl secondly objects to Denis' claim that Cézanne was a
'deliberate designer.' He doubts that Cézanne produced forms born out
of a preconceived intellectual structure.

> What is fatal to the claim set up for him as a deliberate designer, creating eternal
> images out of the momentary lights of the Impressionists, is the fact that his
> technique remains that of the Impressionists, a sketcher's technique, adapted for
> snatching hurriedly at effects that will not wait . . . No one was ever further from
> logical 'classic' construction, if that is what we are looking for; none of the
> Impressionists was so uncertain in his shots at a shape. (p. 290)

MacColl, who is unconvinced of Cézanne's genius, perhaps exaggerates
the hit-or-miss quality in his work. But his description of what amounts
to an all-over working method and its origins in Impressionism seems to
be an accurate description of the way Cézanne worked much of the time.
We can imagine what a different picture we would have of the artistic
period beginning in the 1880s and leading into the twentieth century if
MacColl, instead of Fry, had been the critic to inaugurate it. Thanks to
MacColl, we would probably now tend less to read spatial illusion into

every pictorial image. However, on the other hand, our ability to understand formal order separate from verisimilitude and narrative content would also have been retarded. One of Fry's most important contributions to twentieth-century art criticism was his ability to define the formal qualities inherent in three-dimensional structure divorced from any associations with subject matter.

MacColl's criticisms of the first Post-Impressionist exhibition follow along the same lines as his objections to Denis' essay. For example, he notes the inconsistency between the explanation of the working method of the Post-Impressionists stated in the catalogue introduction and the earlier explanation of Cézanne's working method by Denis. MacColl points out that Denis claimed Cézanne to be a 'classic' painter, meaning "that there is a fine balance in his painting between the desires of the painter and the rights of the object painted; that he renders the object justly and finely seen." But in the catalogue introduction, self-expression and personal feeling were exalted above faithful representation of objects seen. MacColl concludes: "Personal feeling, then, is the note of the movement, and the 'Post-Impressionists' therefore, are not classic at all, but extreme Romantics." (p. 292)

MacColl finds another contradiction in the introduction to the catalogue. He observes that the writer, after stating that the Post-Impressionist artists were Romantics, primarily expressing themselves, rather than external objects, then abandons this thesis and presents an incompatible theory, "that they painted not appearances, but the Thing in Itself." (p. 292) We have hit a nerve as far as MacColl is concerned. At the heart of his disagreements with Fry is the issue of what subject matter is appropriate for the painter. MacColl, who, as we have already seen, is interested in "material values," in the tangible results of sense stimulation, does not think that essences and concepts of objects are possible subjects for the artist. He believes that the artist can only paint what already can be seen. However, the writer of the introduction is to some extent influenced by the claim on art to render the invisible, and, therefore real, visible, and this notion is incompatible with MacColl's ideas.

MacColl continues his attack on the supposed Post-Impressionist aim to paint what is real and permanent. Believing this task to be impossible, he then questions their abandonment of 'naturalism' in favor of a schematic and abstracted vision of the representational image. He accuses Fry and the artists he supported of arbitrarily suppressing chiaroscuro and perspective as a means of freeing themselves from the naturalistic image, but resulting for MacColl in a series of crude and distorted forms.

The emphasis on arbitrary abstraction seems to be the weakest point in MacColl's criticism of Fry's theories. Fry does not give up the natural motif as easily as MacColl suggests. Rather, he insists on the close scrutiny of nature, until the artist's imagination is sufficiently enriched to draw on this source alone.[13] We are left uncertain in either case as to what aspects of the natural motif each writer would consider appropriate to paint. We can probably agree with MacColl that the 'Thing in Itself' defies visualization, that essence of form which Fry apparently believed in 1910 to be the subject matter of art. However, MacColl's alternative, naturalistic image is also not clearly defined. It is unlikely that he believed in faithful imitation of objects. Furthermore, the chiaroscuro and perspective to which he attached so much importance are not key elements in the painting method of the Impressionists whom he supported. We must assume, then, that he was using this issue primarily as a means through which to criticize the Post-Impressionist paintings he did not like.

However, when MacColl again points out Fry's somewhat exaggerated reverence for three-dimensionality, he stands on firmer ground. He claims that Fry seems to think that the element that both links the pictorial image with the natural motif and also gives it its impact is the expression of solidity, and that this solidity is given its most tangible form by avoiding the usual visual tricks performed with chiaroscuro and perspective. It is true that revelation of the classic spirit and the visualization of what is 'real,' which were the positive qualities of a work of art for Fry at this time, were for him synonymous with the expression of three-dimensionality. The presence of solid and recognizable shapes seems to have been one of his requirements for a good work of art.

MacColl further suggests that the thick black contours and distorted angles of perspective that Fry believes enhance the effect of solidity in Cézanne's paintings, in fact, tend to flatten the shapes. Again, we must remember that MacColl was hostile to Cézanne and found his work clumsy. However, this suggestion, supported by his theory of Cézanne's all-over working method, is a valid one. Many of Cézanne's paintings, particularly the later ones, seem to exist more fully on the surface than Fry would recognize, since he equates meaning and success in art with volume and space.

MacColl's examination of Fry's ideas was not limited to a discussion of his defense of the Post-Impressionists in 1910. MacColl continued to scrutinize his colleague's more fully developed commitment to contemporary art. A brief consideration of what he had to say about Fry 10 years or so after the Grafton exhibitions is at this point a good

way to emphasize the importance of this early experience with modern art to Fry's developing concerns, and to introduce some of the issues which will be taken up in Part Two, when we look more carefully at Fry's critical theories, particularly at the origins of his interest in form.

MacColl continued his attack on Cézanne and on Fry's defense of him in 1928 in a review of Fry's book, *Cézanne: A Study of his Development.*[14] His appreciation of Cézanne does not seem to have increased and he voices objections similar to those he made in 1912. He still finds the artist inept and irrational, and cannot agree with Fry's claim that Cézanne remains faithful to visual sensation, while creating self-contained structures out of perceptions distilled from natural motifs.

. MacColl is again at his best when he attempts to analyze Cézanne's painting method within the context of his Impressionist training. He pounces on one of Fry's favorite phrases, "plastic colour," used to describe Cézanne's color orchestration. He assumes that plasticity becomes synonymous with solidity for Fry, but then objects that a sense of three-dimensionality cannot be obtained through hue alone, without tone. He retreats again to the Impressionists as an example of artists who sought to minimize the element of tone in favor of vivid color contrasts. But MacColl also notes that: "In so far as they [Impressionists] did that they reduced solidity; colour became more consciously colour and less plastic." (p. 268) MacColl says that Cézanne followed the Impressionists, making precisely the same sacrifice of solidity. It does seem true that Cézanne's experiments with light and shadow were influenced by Manet and that his "colour discrimination" was conditioned by the Impressionists, as MacColl noted earlier. (p. 266) We again return to the question of whether Fry and his followers were reading too much depth into Cézanne's paintings, in order to see him as a reactor against Impressionism.

MacColl then proceeds to correct what he believes to be a common misunderstanding among Fry and his English associates concerning Impressionist color, particularly as it is seen in relationship to Cézanne. He remarks that the dabs of reds, blues, and greens that one notices in an Impressionist painting are not

> 'divisionism'; the tints are not primary or 'pure' and thus are not intended to mix in the eye to produce a third. Nor are they 'broken colour', such as interlaced touches of allied tints, red and yellow to produce orange. They represent the lighted and shadowed facets of the stone-work; they are small 'planes' endued with 'plastic colour'. (p. 270)

Here MacColl and Fry come close to a common definition of plastic color as it is appropriate to both the Impressionists and Cézanne. The

term refers to color used as a primary means of creating form, not as a secondary adjunct to tonal or linear structure.[15] Both Fry and MacColl looked forward to twentieth-century experimentation with color, when it was proven by artists like Matisse that hue could supplant tonal structure. Fry, however, carried the idea much further, especially in his later writings. MacColl limited the potential of color structure to the flat surface, whereas Fry saw the possibility of using color in addition to create the tension between the surface and an illusion of three-dimensionality.

Through MacColl's discussion of Cézanne and of Post-Impressionism we have been given the rare opportunity to see the tenets of the new movement almost as carefully considered by a critic as by the movement's supporters. MacColl has presented us with the Impressionist side of Post-Impressionism, establishing some immediate roots for the art of Cézanne and his generation in the painting of Monet and Pissarro.

In 1919, seven years after the appearance of his article on Post-Impressionism, MacColl renewed his objections to Fry's theories and to his choice of contemporary artists. In a series of letters to the *Burlington*, MacColl discusses at length the ideas expressed by Fry in two articles on modern drawing recently published in that same periodical.[16] In the articles Fry maintains that the twentieth century is seeing a revolution in drawing, the freeing of the artist from the requirements of representational accuracy, which then permits him to attain new heights of design and personal expression in his work. The two 'Post-Impressionist' draughtsmen he chooses to illustrate this new style are Matisse and Picasso. Fry discusses what for him are the two modern methods of drawing – the structural and the calligraphic approaches. The latter stays close to one common definition, referring to the expression of temperament, the handwriting of the artist. Matisse, he says, creates the standards for modern calligraphy with his subtle linear rhythms. Structural drawing, however, possesses all the qualities of meaningful art that Fry seeks equally in painting. It eliminates all but the essential forms, evoking the idea of volume and mass versus the qualities of the lines in themselves. The result is the creation of a plastic construction, not representational validity. Both Matisse and Picasso reach the heights of this plastic drawing.

Most of the ideas that Fry had used to explain Post-Impressionist art are contained in these articles and, as might be expected, MacColl is ready with some of the objections he had previously raised. He initially attacks Fry's lack of respect for the representational image and neatly and clearly restates the process of Fry's reasoning, which he is going to test for consistency. The issue is a familiar one. MacColl claims that the

pure art that Fry defends deals only "with the beauty of lines set up among themselves, with no reference to the objects they represent or the ideas and emotions they convey." (Letter I, p. 204) However, this contempt for representation of the object is not consistent with Fry's reverence for the third dimension. Drawing for MacColl is concerned only with the beauty of line as it creates a pattern on the surface of the paper. Solidity, which he believes does not appeal to our sense of visual beauty, is not given in a line and can merely be inferred from it. He concludes that the only reason to allude to mass and solidity in a drawing is in order to make reference to the natural motif.

MacColl also made this attack on Fry's preoccupation with the third dimension seven years earlier; it is worth restating. Fry believes the illusion of depth, along with the creation of a two-dimensional pattern, to be an integral part of structural design in a work of art, whereas MacColl recognizes three-dimensionality only for its representational value. Although this disagreement kept the two critics far apart, MacColl, through his objections, has also helped to clarify a point in Fry's thinking which led to some misunderstanding in subsequent years. When he calls our attention to the problematic relationship between abstraction and the illusion of depth in Fry's writings, he in effect warns us not to exaggerate the role of pure abstraction in Fry's concept of formal structure. The tension between the surface and the extension into space may have more of a purely structural function than MacColl concedes, but it also prevents the total divorce of the pictorial image from the natural world by conjuring up sensations of gravity and spatial direction. Fry is aware of this ambiguity.

MacColl again raises the question of what is the possible subject matter for painting. He does not like Fry's philosophical justification for the pictorial image from which all sensuous qualities of the object are eliminated because they are only "accidents." From MacColl's vantage point, if all the visible qualities that identify a particular member of the species are eliminated to leave "pure substance," the resulting idea of form cannot be rendered visible. The two critics are in fact acting out the age old dispute questioning whether the artist can paint the 'real' aspects of existence, and, if he can, whether the true picture rests with a detailed imitation of appearances or with a distilled, generalized image that represents ideal form. MacColl and Fry were not philosophers, but their relative commitments to the senses and to the intellect suggest the varying ideological bases for Impressionism and Post-Impressionism through which this ideological dispute was reenacted in the latter half of the nineteenth century.

MacColl's lack of confidence in Fry's theory of modern drawing

partly stems from his dislike of the two artists Fry praises, Matisse and Picasso. As long as Matisse does not give up the representational image completely, MacColl does not like what seem to him to be the arbitrary distortions the artist works into his natural forms. This was also one of the most common objections to Matisse's paintings and drawings at the time of the two Post-Impressionist exhibitions.

MacColl has more to say about Picasso and Cubism (Letter III) Again, like the critics of the second Post-Impressionist exhibition, he interprets Picasso's work to be devoid of meaning, following only rigid guidelines for geometrical abstraction. From this he proceeds to a re-curring concern, questioning whether Picasso's drawings are as 'solid' as Fry implies. MacColl does not believe that any new conventions for rendering depth, such as the exposure on the surface of the unseen sides of a three-dimensional form, or the purposeful misapplication of per-spective, both methods supposedly used by the Cubists, can do anything but destroy the three-dimensional structure, as well as the surface pattern of a painting. MacColl calls this practice "pseudo-science."

It seems just to give Fry the last word in this ideological battle between himself and MacColl. He did on occasion attempt to counter MacColl's arguments, although with nothing like the frequency and intensity of his opponent. However, it should be remembered that Fry, as the arch supporter and even 'creator' of Post-Impressionism as a movement, was an easy target for criticism, whereas MacColl was by no means the only spokesman for Impressionism.

Fry's immediate rebuttal of MacColl's criticism in the three letters to the *Burlington* is not far reaching, but it is succinct and clear and tends to point out the weaknesses in MacColl's argument.[17] He notes that MacColl is mistaken in believing that he admires distortion for its own sake. He also suggests that the "significance and beauty," which MacColl, not Fry, prescribes as the necessary ingredients for a work of art, are elusive of definition and should therefore not be used as descriptive terms.

Fry's most important comment here is his acknowledgment that he personally had

> never denied the existence of some amount of representation in all pictorial art. I have always admitted the purely representative nature of the presentment of the third dimension on the flat surface of a picture. What I have suggested is that the purer the artist the more his representation will be of universals and less of particulars.

A careful reading of Fry reveals that he is here restating what had been his consistent attitude. However, abstraction had become the catch all

term, with a pejorative connotation, used to describe any departure from the representational image. Critics such as MacColl, who read formal structure purely as a matter of surface pattern, wanted to find a good likeness of the subject in a work of art. Therefore, the attempt by Fry to change the emphasis to formal structure inclusive of the sensation of three-dimensionality, while maintaining aspects of the representational image, seemed to them to indicate an exaggerated concern for abstract form.

Fry's final word comes in 1931, when he has the opportunity to review a recently published collection of MacColl's writings, which includes the essay on Post-Impressionism discussed earlier.[18] Fry's essay amounts to more than a review; it is a discussion of some of the basic differences of opinion between himself and MacColl. He writes:

> Here then, I take it, is the issue. Mr. MacColl regards all these questions of the situation of volumes in spaces as belonging to mere representation of a given situation, as being entirely accepted from Nature. Whereas I consider that it is largely by this deliberate, or perhaps sometimes unconscious, arrangement of these that the artist expresses and conveys his feeling, and I call this, design, meaning that this, if it is successful, obeys certain laws of rhythm and proportion exactly as the happy disposition of the 'crazy-quilt' pattern [MacColl's term for two-dimensional design] does, although these laws will be much more complicated and the effects more difficult to analyze. Indeed I think we can observe that since the Renaissance there has been a certain conflict between the claims of 'crazy-quilt' design and of design in depth. One might suspect that, with his belief that the 'crazy-quilt' is the only kind of pictorial design, Mr. MacColl would be the most fervent admirer of Henri Matisse.
>
> It is probably from this difference of view that our so totally divergent estimates of Cézanne's art arise. I believe that Cézanne did succeed by his peculiar, though perhaps unconscious, distortions, emphases or exaggerations of both volumes and spaces, in producing harmonies of a strangely moving kind, harmonies which impress us as having a profound import, though we are as little able to give any reason for that feeling of deep significance as we are with regard to a great piece of pure music: whereas for Mr. MacColl, Cézanne appears as merely a clumsy and unsuccessful recorder of certain appearances on Impressionist lines . . . [p. 9]

Here we are at the heart of the matter. MacColl, undeniably a perceptive and intelligent critic, helped explicate Impressionism so that the aesthetic justification for the painting style of these artists was made apparent. But essentially, he stopped seeing 'form' at this point. Fry was born into the next generation, and in his discussion of the Post-Impressionists, he was able to elaborate upon the aesthetic significance of a work of art in such a way as to look forward to most twentieth-century experiments with formal structure and the visual image.

Part Two

The Art Critic before Fry

Oscar Wilde's Gilbert maintains that we can go all the way back to the Greeks to find the necessary critical faculty utilized to describe works of art. But for our purposes, art criticism as a concrete and useful activity did not begin until the late eighteenth century in France. The lessening importance of art to Church and State and, likewise, the artist's loss of the sheltering patronage he once had, created the need for a new type of patron to defend the now vulnerable artist before his new, unmanageable audience, the public. The diminishing prestige of the visual arts also needed bolstering from a person sufficiently respected to exalt the aims of the artist before an increasingly skeptical audience. The man with a literary reputation, who was good with words, was the necessary choice for this new task.

Diderot appeared as the first art critic in the modern sense of the word. In 1759 he began writing his opinions on the work of his contemporary artists exhibited in the Salons. These writings were to inaugurate the tradition of critical commentary on newly appearing works of art that was to play a significant part in determining the course of art history in France in the nineteenth century. Diderot's nineteenth-century successors were also primarily literary figures who took an increasing interest in offering to the public their opinions on the art works of their contemporaries. Stendhal, Baudelaire, Gautier, and Zola were some of the men who were destined to establish art criticism as a necessary activity. Fry never mentions Diderot, nor any of these nineteenth-century French critics, and the content and style of his writings are very much different from that of his predecessors. But it was in nineteenth-century France that art critics gained a recognized place in society. They were called upon to release the work of art from the exclusive confines of the exhibition space and to bring it before the public for more general consumption. The transmission of visual ideas and experience through verbal language became the main function of the art critic. Fry attempts

a greater distinction between fact and fiction in his art criticism, but he inherits his assignment to explicate from Diderot and his successors.

Diderot introduced a type of truly exemplary art criticism.[1] His purpose was to rediscover the instructive value of a work of art. He was, after all, editor of the great monument to learning, the *Encyclopédie*. He assigned to art the function of teaching and instilling the ways of a morally healthy and useful existence. His ideal was Poussin, but he settled for Chardin and Greuze among his contemporaries, who at least represented honesty and moderation in their work. He railed against Boucher, whom he thought was misguided into painting his useless and extravagant fantasies. Diderot never questioned that his purpose was to find in contemporary art examples that would enhance the way of life in which he believed. He did not imagine that it was necessary to present a more impartially chosen sampling of the work of his contemporaries; never did he believe that the artist's activity is independently justifiable.

Nineteenth-century French art seems to have been a period particularly informed by ideologies and 'isms', and, likewise, nineteenth-century French art criticism was characterized by the conscious commitment of its greatest exponents to one theoretical concern or another. Stendhal and Baudelaire elaborated upon varying notions of Romanticism; Castagnary, Thoré and Champfleury championed the causes of Realism, Naturalism and the exaltation of modern life. We know how ambiguous and elusive of definition these theories have become, but to their supporters they represented the very real spirit of contemporary life. For Stendhal, Romanticism meant involvement and commitment to action; for Baudelaire, it meant reverent attention to the workings of creative genius. For either writer it took on tangible form as a way of life.

In most cases the commitment to an ideal was synonymous with the support of a particular artist. Baudelaire praised Delacroix; Courbet and then Millet were the great champions for the Realist and Naturalist critics. These artists had regained for themselves and for their profession the stamp of cultural heroism, and their supporters admired them as creative geniuses and prophets of change before their contemporary world. This does not mean, however, that these same critics felt the need to reproduce faithfully in words the works by 'their' artists. The artist was exalted for the ideas he expressed. Therefore, little attention was given to his individual style through analyzing the details of his working method. For example, Baudelaire canonized Delacroix, not so much for his own sake, but as the perfect embodiment of the independent creative spirit. He later turned to Constantin Guys for the expression of another stance, modernity, an ideal synonymous for him with Romanticism.

Similarly, Courbet's supporters did not discuss his individualism to explain the particular character of his art. They utilized it more generally to reveal the dignity and power of contemporary life.

These mid nineteenth-century critics were in love with words and committed to an ideal of modern life that determined the course of their art criticism.[2] They made no attempt to hide their prejudices or their personalities. They championed their own cause through words as much as they did that of the artist committed to the same ideology. We may let Baudelaire sum up the situation:[3]

> As for criticism properly so-called, I hope that the philosophers will understand what I am going to say. To be just, that is to say, justifying its existence, criticism should be partial, passionate and political, that is to say, written from an exclusive point of view, but a point of view that opens up the widest horizons . . .
>
> . . . The critic should arm himself from the start with a secure criterion, a criterion drawn from nature, and should then carry out his duty with passion; for a critic does not cease to be a man, and passion draws similar temperaments together and exalts the reason to fresh heights.

We may also consider Baudelaire's definition of art criticism to have carried weight in early twentieth-century London. The newer attention to individual styles and artistic method did not exclude the commitment to an ideal which would inform Fry's critical writings in a way similar to that which Baudelaire suggests. Fry was less dogmatic than his French predecessors in making his personal statement about what a work of art should mean. In many of his essays it is almost impossible to detect a personal bias. But he felt almost as strong a need as did Baudelaire to justify the creative act in aesthetic terms and, like Diderot or Stendhal, he associated an ethical commitment with the artistic process. Sometimes the ethical was confused with the utilitarian, and he spent a great deal of time trying to prove that a work of art has no practical value (understood as a negative quality). But we may certainly feel that he is most eloquent when he finds a harmony between aesthetic and ethical values, for example, in the work of Giotto. We owe to the nineteenth-century French critics the characterization and practice of art criticism as a vital activity, and the commitment to an aesthetic or ethical stance, which also informed much later criticism in the twentieth century.

Fry did not, however, inherit from the French his interest in the formal structure of a work of art as its primary justification for existence. It is true that the *l'art pour l'art* movement early in the century in France gained for the artist his independence as a creator, and Baudelaire

exalted the artist precisely because he does not depend on the dictates of society to determine the course of his work, but because he is himself a visual maker of ideas. The artist was therefore freed from the requirements to be useful to society, to meet obligations which are not purely aesthetic and inherent to his medium. This is a necessary step for becoming conscious of form. However, with the exception, perhaps, of the more analytical criticism of the Impressionists and Post-Impressionists at the end of the century, no French nineteenth-century critics talked about how the artist's ideas are rendered visible. Beyond making general statements that showed Delacroix to be a great colorist, for example, no writers talked specifically about how paintings are put together. Their descriptive language was confined mainly to the discussion of ideas and feelings brought out through subject matter and, perhaps, through such general compositional elements as light-dark contrasts, rich coloring and sweeping brushwork. Therefore, we must again scan the nineteenth-century horizon to find precedents for Fry's conscious interest in form itself.

Important to an understanding of the discussions of form in twentieth-century art criticism are the aesthetic theories developed in Germany during the latter half of the nineteenth century. The main figures in the movement, which I shall call 'German Formalism' for the purposes of this study, were Conrad Fiedler and Adolf von Hildebrand. Working in a philosophical framework that follows Kant, these writers claimed certain issues surrounding notions of perception and reality to be the special province for aesthetic speculation. Once it was decided that the enduring, 'real' nature of existence is not discoverable in the superficial appearances that our prejudices tell us are the reality of objects, the task was given to the artist, with his purer and keener powers of perception, to render the order of the universe, invisible to the average person, visible and comprehensible. Fiedler maintained that the artist is not a mere imitator, but an independent creator of form through his heightened perception and his powers of intellectual concentration.[4] The content for art directly depends on the answer to the question of how we perceive reality. It was discovered that the sources for our perceptions are not houses, trees, human beings. The identity of these objects is the result of our need to categorize and create symbolic names for appearances in order to make sense out of the world around us. We really see only hue and value contrast in varying intensities, and linear or spatial direction, according to our own gravitational orientation. We do not perceive bounded forms.

Earlier artists and aestheticians had made similar observations about the disparity between appearances and reality. But the greater emphasis

Fiedler and Hildebrand put on the perceptual process as the basis for artistic activity was the important step towards the establishment of an awareness of form that developed along with their ideas about perception. They believed that the artist does not imitate shadows of forms; he organizes the basic elements of perception into a structure that equals that of the natural order, and thus creates a real and original form. The notion of the artist as seer was based on this understanding that the artist creates an order, a reality that cannot exist in any other visible form.

It was then easy and logical enough to make associations between perceptual data and the elements of pictorial design. The keen-minded artist views the world in terms of areas of unbounded light and color. But the mere recording of sensations is not the meaningful activity. The creative artist possesses powers of intellectual control whereby he creates an order and structure out of the chaos of perceptions.

Hildebrand, for one, concentrated on the organizing principles that create form out of perceptual data.[5] As a sculptor, he spoke for the simplification of design, the paring down of shapes to their purest and clearest. He was mainly interested in translating the organizing principles in nature into a working method for the artist. The key to the process rested for him in understanding the visual values of space. The main task for the artist is to encourage a sensation of three-dimensionality. He can do this when he understands how we relate forms perceptually to one another in depth. Hildebrand believed that pictorial unity and a meaningful recreation of the natural order rest with this comprehension of spatial values. He notes:[6]

> The harmonious effect of a picture depends on the artist's ability to represent every single value as a relative value in this general conception of relief. It is only thus that his work attains a uniform standard of measurement. The more clearly this is felt, the more unified and satisfactory is the impression. This unity is, indeed, the Problem of Form in Art, and the value of a work of art is determined by the degree of such unity it attains. It is this unity which gives consecration to the representation of Nature. That mysterious satisfaction which we obtain from a work of art rests alone on the consistent application of this conception of relief to our three-dimensional impressions.

Thus Hildebrand introduced "the Problem of Form" into discussions about art and suggested that the core of the creative activity and responsiveness to the reality of the natural order is found in the relationship among compositional elements in the work of art.

Fiedler underscored this concern for formal structure. He insisted that in order to understand creative activity the critic of art must also learn to recreate the perceptual process undergone by the artist. It is not

sufficient to talk about the work of art as a *fait accompli*. Its meaning resides in the procedure whereby it was created, for the critic, in an analysis of its formal structure. Attention had shifted from romantic descriptions of the artist in relationship to society to a structural analysis of the work of art itself. And in Germany there appeared towards the end of the century writers about art like Julius Meier-Graefe, whose discussions of the process of artistic creation sound very familiar to twentieth-century ears.

It is not possible to prove any direct influence of Fiedler and Hildebrand on Fry, and it is for this reason that 'German Formalism' does not play a greater role in this essay. However, Germany had an important influence, both economically and aesthetically, on the developments in the European art world at the end of the nineteenth century, and the general infiltration of German aesthetic ideas into British thought is easily imaginable. Fry himself expresses specific interest in the writings of several Germans, such as Emanuel Löwy, Heinrich Wölfflin and Meier-Graefe. He did not like the German language and had to struggle to read it. But, in his more abstract musings, we may suspect that he was aware of the support these writers offered him. Two of his essays in particular, "The Artist's Vision" and "An Essay on Aesthetics," to be discussed later, deal with problems of perception and the attempt to find concrete structural principles to equal the aesthetic experience, which must have been conditioned, or at least encouraged, by contemporary German aesthetic speculation. Just as Fry's professional position as art critic was strengthened by precedents in nineteenth-century France, the Germans gave him the license to deal with the development of formal structure as the main and unique activity for the artist.

It was his native England that offered Fry the principal guidance in his development as an art critic. And in nineteenth-century England John Ruskin was the key figure in his heritage. The relationship between Fry and Ruskin is a complicated one. Fry acknowledged having read Ruskin, but later rejected him because the older writer's judgments were apparently too blatantly determined by moral concerns.[7] Fry could not abide Ruskin's belief that the artistic activity is not unique and independent, but is a function of everyday life and could therefore serve a utilitarian function.

For the moment, however, we must overrule Fry's objections and consider briefly what general ideas he might have learned from his elder. First of all, Fry could have derived his sense of commitment to an ideal from Ruskin. Ruskin accepted the educational nature of his profession enthusiastically. He saw in art, and in its promotion, the means to

counter the social evils, particularly the results of industrialization, that plagued England in the mid nineteenth century. Fry's generation, too, lived with the problems which were the result of industrialization. Fry's short-lived involvement with the decorative arts, the Omega Workshops, seems to have been a direct response to Ruskin's and to William Morris' similar attempts to fight mass production and the resulting degeneration of society.

More fundamentally, a like ethical consciousness seems to bind Ruskin and Fry together. Both men elevated the visual image to the powerful position of an idea, capable of imparting knowledge of the natural world.[8] Likewise, they insisted that a heightening of the visual sensibilities in artist and viewer is necessary to attain to the production and intelligibility of the meaningful visual statement. Fry would not believe so strongly as did Ruskin in a cause and effect relationship between clarified vision resulting in the satisfying visual image on the one hand and healthy moral action on the other. But he did grant that clear thinking and seeing and ethical purpose are required to produce good art. Fry and Ruskin also agreed that the creation of beauty, which is the artist's response to his visual perceptions, results in a satisfying emotional order. Now we can account for the surprisingly similar types of praise offered to Giotto by both critics (for Fry, early in his career). Ruskin speaks of religion generally, and Fry talks about the teachings of St. Francis,[9] but each writer considers the strength of the formal design in Giotto's frescoes to be immediately determined by the artist's religious and ethical values.

The differences between Fry and Ruskin are, of course, numerous, but they are not understood simply in terms of Fry's negative reaction to the moralistic tone that runs through Ruskin's writings. There are several more subtle theoretical differences that should be mentioned here. First of all, Ruskin believed in the primacy of the natural order. The artist, according to him, cannot improve on nature. He can only heighten his perceptions to the point where his imagination will be able to cope with and utilize the beauty of natural form. Ruskin was, therefore, suspicious of High Renaissance art, which was dependent on artistic conventions to construct the pictorial image.[10] Fry also maintained the importance of the natural motif. However, he did not consider all of nature intrinsically beautiful. According to him, it is up to the artist to select, organize, and, most importantly, to convert his perceptions of nature into the appropriate form dictated by his medium. Fry, therefore, considered conventions for rendering form crucial to the artist. They help him establish the integrity and uniqueness of the pictorial image, separate from the natural order.

Fry and Ruskin also disagree as to the facet of human experience to which the work of art appeals. For Ruskin, art was an affair of the emotions. For Fry, it appealed as well to the intellect. The enthusiasm felt throughout Ruskin's writings is partly the result of his direct emotional response to the visual image. Fry, too, believed in the possibilities of emotional impact, and thus he described the qualities that make up a satisfying formal order as the "emotional elements of design." But he left to the mind the powers of organization and comprehension.

We could continue searching for differences between Fry and Ruskin, differences which are often logically attributable to the varying historical and philosphical circumstances out of which they formulated their ideas. But in the end we must give Ruskin the credit for elevating the visual image to a point where Fry, too, could claim the type of impact it has as the reason for acknowledging the importance of the artist's work.

In addition to Ruskin, there were other thinkers later in the nineteenth century in England who helped to create a context for Fry's critical theories. The art for art's sake aesthetic, loosely anchored to the several decades beginning in the mid-1860s, was the spirit behind a new appreciation of art. Various painters and writers can be associated with the changing aesthetic attitudes. For our purposes, two names loom large – Walter Pater and James McNeill Whistler.[11] The personalities and ideas of these men varied greatly, but they had in common the belief that art is important for no other reasons than that it leads to the making of something beautiful, and because the creative act itself is important. Therefore, unlike the 'German formalists', they did not require any ethical justification for the work of art. Rather, they bent over backwards to deny the moral ties art had been saddled with by Ruskin and by the crusaders against the evils of industrialization.

Art for art's sake was a way of life to Pater. He believed that a heightened awareness of what is beautiful and totally divorced from the materialistic demands a sharpening of the senses into a receptive condition. His interest was confined to the beauty of form for which he did not need any ethical justification. For him, not unlike for Winckelmann a century before in Germany, the medium for expressing the power of artistic creation was the written word.[12] And like his more contemporary German writers, Pater tried to recreate in prose the type of impact made by a work of art. It is significant that, also like them, Pater made the distinction between the identity given to objects through language and accumulated experience and our immediate perceptual experience with the world around us, which reduces objects to a series of fleeting impressions – color, texture, odor.[13] He therefore acknowledged a

province for form outside the boundaries of identifiable objects and helped pave the way for the acceptance in England of non-representational content in painting as an alternative to imitative images.

But Pater did not attempt to analyze the structural order of a work of art as the tangible result of the artist's perceptual involvement with the world around him. He did not dwell on individual paintings, nor even on individual artists. He sought a general statement of beauty, and, likewise, his famous remark, "all art should aspire to the condition of music,"[14] was only a general aesthetic maxim and one he did not apply specifically to works of art.

Pater is important for the attention he drew to art as an independent activity and for the inspiration he offered young artists and writers who sat at his feet at Oxford. His prose was personal and idiosyncratic, and we do not find in his writings a guide for later art criticism also concerned with form.

It is perhaps not until 1885 that Whistler introduced the requirement for formalist art criticism into England. Ironically, his *Ten O'Clock Lecture*, delivered that year, temporarily silenced the critic at the same time that it offered some guidelines for his future activity.[15] Like Pater, Whistler believed in art for art's sake, in the self-justification for the work of art. But it is precisely because he believed that the work of art is independent and complete in itself, and because he was an artist, that he maintained that critical writing by those who have never experienced the like creative activity is bound to misrepresent the work of art. Whistler suggested that only the artist dare judge or interpret his own work, and so, for the moment, silenced the critical profession.[16]

Whistler implied that there is a special language or vocabulary needed to describe visual works, and that the critic, however much he proclaims the sanctity of artistic creation, does not succeed in his task if he does not recognize these essential distinctions between art and literature. At the same time that he reprimanded the Paters, Baudelaires and Ruskins for trying to make paintings into poetry, he hinted to a younger generation that its task was to find the necessary vocabulary to describe form in the visual arts.

It is perhaps no coincidence that Fry and many of his cohorts, included in this next generation of critics, were also artists, that they felt some requirement to preserve the visual properties of works of art they were discussing. It is not possible to pinpoint an exact influence of Whistler's ideas about art on Fry's writing, and we shall hear of several instances, later, when the younger writer seemed to be critical of his elder. But Whistler stimulated the awareness that art criticism should

become a more precise activity and that it should develop a descriptive language capable of recreating the visual image.

Art criticism in the nineteenth century was not a very exacting discipline, nor was it easily definable in its several versions in France, Germany and England. However, it was because of people like Baudelaire, Fiedler and Pater that art regained some of the prestige it had lost during the eighteenth century. These early critics established a new set of criteria to seek out meaning in a work of art. The conscious interest in form and in the creative process replaced the waning humanistic and religious significance once assigned to art and offered a new meaning to the visual image in the nineteenth century.

On the eve of the twentieth century, a specifically English concern for the visual qualities of art added a vital element to the tradition of art criticism that Fry inherited. The writings of D.S. MacColl and R.A.M. Stevenson marked the real beginnings of this tradition in its modern phase of development. Ideologically, MacColl and Stevenson differed considerably from Fry and his generation of Post-Impressionists. However, the concern for technique, for the actual making of a picture, was a significant link between these two groups, whom I shall call here the English 'Impressionist' and 'Post-Impressionist' critics. Together, Fry, Stevenson, MacColl, Laurence Binyon, and C.J. Holmes created much of the method for what would become formalist art criticism. All these early twentieth-century English writers were object-oriented, at least more so than any of the nineteenth-century critics we have considered. Their interest in the form and production of the work of art can partly be accounted for by the fact that they were often artists as well as critics. They were some of the important founders of the associations of contemporary English artists, the New English Art Club and its successors, the Camden Town and London Groups. Their paintings often reveal their critical preferences. For example, much of Fry's art work shows a marked influence of Cézanne. Likewise, in their criticism they were concerned, much more so than were Baudelaire, Pater or Meier-Graefe, with experiments with technique and structural organization. This attention to the object, undisguised by theoretical speculation, became a characteristic trait of modern English art criticism.

Another conviction the 'Impressionist' and 'Post-Impressionist' critics shared was a reluctance to accept any doctrines for the new art that sacrificed the classical and western tradition of learning in favor of the primitive. Part of this reluctance was due to a preference for the reasonable and the logically ordered, which generally characterized English thinking, as distinct from an immersion in the irrational and intuitive. An additional reason is the direct commitment many of these

critics had to the tradition of Renaissance art. Writers such as Fry, MacColl, Binyon, Holmes and Claude Phillips were keepers of national collections or art historians as well as critics of the contemporary scene.[17] Fry and Phillips were also instrumental in reviving the *Burlington Magazine* in 1903, always an important source for art historical studies about the old masters.[18] Most of these men, including Fry, wrote as much, if not more, about the old masters as the moderns. They could often be found discussing an obscure attribution problem in the *Burlington*, or reviewing the old master exhibitions at Burlington House for this journal or the daily papers. The commitment to Italian art in particular was strong, not to the 90s aesthetic cult of Botticelli, but to the ideas of classical form associated with the Renaissance.[19]

Fry's contemporaries among critics in England were also particularly concerned with a sense of tradition and a commitment to art historical form when they wrote about contemporary art, a result of their dual awareness of the art of the old masters and of the moderns. Many nineteenth-century critics had purposely rejected the past, apparently in order to do justice to their contemporaries. This was not the case in England at the beginning of the twentieth century.

If anything, early twentieth-century English writers about art were prone to offer historical explanations for contemporary work. Often the methods employed to this end were ingeniously adapted from other disciplines. For example, several thinkers appropriated the theory of evolution to art historical method.[20] Grant Allen, in one of these studies, *Evolution in Art*, attempts to apply the idea of use and disuse to the treatment of various themes in Italian art up to the Renaissance. He takes a theme and then traces it from Giotto onwards, trying to show the types of modifications and expansions along the way.[21] For another treatise, similar to Allen's, we have at our disposal the review by one of Fry's critic-contemporaries, which helps us discern the potential influence of such a study. Laurence Binyon, in his review of *The Evolution of Italian Scuplture* by Lord Balcarres, warns us against the over-application of the biological or evolutionary method to art.[22] But he concedes that there is a continuity which cannot be overlooked. He quotes from Lord Balcarres who believes: "Each school or century, indeed almost every thoughtful and mature work of art, is interrelated and represents a definite stage in relation to something which follows or goes before . . ." We can recall here Fry's final defense of the Post-Impressionists in 1912. The discovery of a coherent historical tradition to support the moderns became the final means of making their art acceptable.[23]

English art criticism, when Fry began writing, could be characterized by its sober, historical and, in a sense, conservative attitude

towards modern art. This cautiousness is a product of the desire to
tighten up the discipline of evaluating works of art. The close scrutiny of
the object seemed to demand a new, precise language that could
communicate *visual* ideas. Even the seemingly 'romantic' A.J. Finberg,
in *Turner Sketches and Drawings*, gives a great deal of attention to the
new art criticism. He writes:[24]

> . . . And the subject-matter of art criticism is essentially a form of communication,
> and therefore is concerned only with certain aspects of our 'world of discourse'
> with a view to the satisfaction of our intellectual requirements of coherency and
> consistency of thought, the terms and ideas used in our non-systemised everyday
> thought and language are certainly inadequate, and those in use in all the special
> sciences, though valid enough when confined within the limits prescribed by their
> initial assumptions, are no less unsatisfactory for our purposes.

Fry inherits from his nineteenth-century predecessors the task to
maintain the visual image and to uncover its importance for the twentieth
century. For this purpose he consulted a scholarly tradition of art
historical literature that had also influenced the writings of his colleagues
in England. He had his initial confrontations with the work of art at the
hands of the old masters, not at the hands of his contemporaries. Before
he attempted to formulate aesthetic theory, he studied how to be a
connoisseur, who, through careful scrutiny, could distinguish hands and
the peculiar stylistic traits of different artists. He also learned the
requirements for making historical judgments while removing his
personal feelings as far as possible from the object he was trying to
describe.

Inevitably, he formulated a preference for certain types and periods
of art, mainly the monumental forms created by Giotto and later
fifteenth- and sixteenth-century Italians. He distilled from the qualities
he found in these works a set of ingredients that he felt were necessary
to bring a work of art to its aesthetic completion. His main discovery
was the importance of artistic conventions, the importance of those
devices which make it possible for the artist to use his intellect to control
perceptual material and to translate it into visual images unique to his
medium.

Fry's formalism, then, is based initially on his accumulated
experience with individual works of art, which were creations of the past,
not of the time in which he lived. Therefore, unlike most of his
nineteenth-century forebears, he did not concern himself primarily with
the artistic problems relevant to his contemporaries. Events in the
English and French art worlds, as well as his tendency, encouraged by
his intellectual environment, to overreact against Impressionism,

conspired to make him the leading spokesman for the cause of 'modern' art, that is, art after Impressionism. But it should be remembered that his concept of the present in art included a knowledge of the past. He valued an awareness of artistic tradition because of the accumulated experience with ways of ordering form that it leaves at the disposal of the young artist. Fry's formalist priorities, which today seem like a peculiarly twentieth-century concern, are in a number of ways the restatement of Renaissance principles of design made suitable to the art of his contemporaries.

Roger Fry and the Old Masters

Fry's experience with the old masters and with traditional methods of artistic creation helped determine his basic requirements for structural unity in a work of art. He believed that a successful painting or sculpture is as much the product of learning and technique as it is of inspiration. He was therefore interested in the history of artistic conventions, those changes of style from one generation to the next that modify existing methods for creating form and for describing appearances. Our concern here is his discovery and analysis of these conventions, progressing from the early Italians to the masters of the seventeenth century.

The best way to begin a discussion of Fry's investigation of the old masters is with an examination of his 'credentials'. Even in his day, art historical investigations demanded a more rigorous methodology than criticism of contemporaneous art, which could, and probably should, rely on a more immediate response to contemporary life. Fry himself acclaims the need for the "Kunstforscher" to deal with art historical problems.[1] This emphasis on a 'scientific' approach to the study of art may perhaps reflect his background and schooling. After leaving his public school, Clifton, he went up to King's College, Cambridge. There, in the manner seemingly appropriate to his Quaker background and to the sober teachings of his jurist father, he took his first degree in science.

Fry's earliest encounters with art were, like those of most Englishmen, with the Renaissance Italians and, either through books or personal contact, with the men who talked professionally about them. He took his first trip to Italy in 1891 at the age of 25, and then met J.A. Symonds and Horatio Brown, the expert on Venetian painting.[2] While in Italy, he expressed an interest, new for this time, in the Signorelli frescoes at Orvieto. During his second Italian tour in 1894, as might be expected, he praised the work mainly of those masters of sculptural form, Masaccio, Piero, Pisanello, Raphael and Leonardo.[3] But it is particularly

significant that at this time Fry revealed an interest in Morelli's art historical method.[4] Both Morelli and the team of Crowe and Cavalcaselle were the standard bearers for art historical method at this time. And Fry, as yet hardly the great theoretician, was probably influenced by all aspects of their approach to the analysis of form and problems of attribution.[5]

The influence was enduring. In 1924, Fry wrote an article for the *Burlington* on "The Mond Pictures in the National Gallery." The essay is in praise of a collection which is ". . . the outcome of the Morellian movement . . ." He admired the austere style that informs most of the paintings from Botticelli (two austere post-Savonarola panels) to Signorelli, to Titian. He claimed that although Morelli's judgments were not always as accurate as Cavalcaselle's more instinctive reactions, ". . . the energy and eloquence with which he pressed his theories on the public and the appearance of scientific detachment and accuracy which it gave to his researches brought into the world of connoisseurship a new type of mind."[6]

Fry made several other European journeys before the turn of the century – a trip to Palermo and Naples in February, 1897, and another to Florence and Berlin at about the same time. He saturated his senses and his mind with Italian art. The most instructive information about these journeys and about the methods Fry employed to study and then analyze the art works he saw is contained in the series of detailed sketchbooks he kept during this period.[7] Without the extensive aid of photography, the historian at this time had to rely almost completely on his visual memory. Fry was fortunate that he could make coherent sketches of the works of art and the distinguishable characteristics he observed. Alongside these drawings he noted the prominent colors, the formal devices used by the artists, and was thus well on the way towards establishing categories for stylistic types and towards solving certain problems of attribution. Very much in the Morellian manner, he noted qualities of gesture and methods of describing anatomical detail which would distinguish one artist from another. Also, in anticipation of a fuller expression of his formal concerns, he observed stylized treatment of drapery, for example, the artist's tendencies towards angular, sharp-edged definition of folds, or his preference for smooth-flowing linear patterns. In the numerous altarpieces and early Renaissance paintings he looked at, always with problems of attribution in mind, he generally gave particular attention to methods of color orchestration, stylization of drapery patterns, and treatment of limbs. Thus, he observed "Bellinesque hands" in a Mantegna, or the style of a lesser known quattrocento artist that is "pseudo-Giotto." The guidance of Morelli,

that is, his involvement with the object and the particular style of the artist, is apparent here.

Fry was still the student, literally and temperamentally, when he was keeping these sketchbooks. Sandwiched in among the comments and sketches of seen art works are also notes on texts he has read.[8] The list of readings gives us some information about how he was preparing himself for his future role as historian-critic. He noted such authors and titles as Molmenti on Veronese and Tintoretto, Voight and Gronau on Bellini, Crowe and Cavalcaselle and Sir Charles Bell on *The Anatomy and Philosophy of Expression*. In an early letter to R.C. Trevelyan (Mar., 1898), he also mentions having read Walter Pater and makes a further comment on the potentials of art history he would like to see fulfilled. He remarks:

> I've just been reading Pater's *Miscellanies*. It is a pity he makes so many mistakes about pictures; but the strange, and for a Morelli-ite, disappointing thing is that the net result is so very just. What is wanted now in the way of criticism is someone who will make appreciations as finely and imaginatively conceived and take them into greater detail as well. Perhaps Berenson will get to this if he gets over his theories.

Berenson must have had a strong influence on Fry in these early years of his career.[9] Frequent letters passed between them and between Fry and Mariechen Berenson. They sought each other's advice about problems of attribution, especially during the first decade of the twentieth century, when Fry also was turning out numerous articles for the *Burlington* and *Athenaeum* on early Renaissance artists. Commentary in Fry's sketchbooks refers to Berenson's opinions of paintings that he had just seen. Because his interests shifted fairly early to modern art, Fry was not, as was Berenson, a key figure in the community of Renaissance experts in Europe.[10] But it is clear from a letter to Mariechen in 1904 that he was aware of, and was a silent partner in, the politics and disputes over method that plagued this group. He writes (Feb. 27, 1904):

> I have heard of a violent attack on you and B.B. by Bode, but haven't seen it yet. You are to be congratulated, for it has already brought about a revulsion of feeling here. Colvin, for instance is full of righteous indignation, and even the Burlington Fine Arts Club is murmuring against Bode.[11]

He concludes the letter with the following ironic comment, in light of his future ventures:

> Here the moderns are also squabbling, MacColl and Binyon in the *Saturday Review*. They dine here soon to smoke the pipe of peace.[12]

In 1904 Fry could sit back and observe all the disputes around him, but he was soon to become very much the active participant in the "squabble" among the moderns.

However, in the 1890s, Fry was so immersed in Italian art that he was able to offer various series of extension lectures during these years at Cambridge, Eastbourne, and Brighton on Florentine and Venetian art.[13] Here began the lecturing career that did so much to establish Fry's reputation as an art expert. He was able to draw huge crowds and on occasion filled to capacity the 2,500 seat Queen's Hall (destroyed during World War II) in London with people whom he could almost hypnotize into enthusiasm over Masaccio, Leonardo, Titian, and others. This early success was, however, a hindrance in later years when, for the majority of 'cultured folk' who attended Fry's lectures and put their faith in Renaissance remoteness and antiquarianism, his shift to the moderns was a bewildering and therefore suspect act.

Fry's writing career was also launched in the late 1890s. In 1899 he was appointed art critic for the *Pilot*. He went to the *Athenaeum* a couple of years later, and in 1903 he took part in the group effort to rejuvenate the *Burlington*, for which he became joint editor with Lionel Cust from 1909 to 1913. He began writing numerous articles on problems of attribution, iconographical schemes, stylistic issues — most pertaining to Italian fourteenth-, fifteenth-, sixteenth-century, Flemish and Dutch masters — and his reputation as an expert on the old masters was secured.

Fry's credentials were firmly established with the publication of his first book, a monograph on Giovanni Bellini.[14] He seems to show here a command of the method applicable to 'problem-solving' in Italian art. He emphasizes Bellini's sensitivity to nature, his ability to achieve atmospheric effects, and he introduces issues that will interest him consistently, such as the problem of rigid contour and the belief that imitation of nature means a controlled selection and arrangement of natural forms. It should be made clear that before the appearance of this monograph the primary sources for information about Bellini in England were Crowe and Cavalcaselle and Berenson's *Venetian Painting*. Fry's offering was a serious attempt to recreate the artist's development. He was cautious and restrictive, limiting the paintings he believed to be by Bellini to a relatively small number, compared with what has subsequently been attributed to him.[15]

Fry was fond of reconstructing historical situations into which works of art could be placed. In spite of his respected position as authenticator, he was less the connoisseur than the historian. At an early stage he involved himself with the history of the development of modern

Italian painting from the trecento onwards, and wrote a series of articles on that subject for the *Monthly Review.*[16]

The stand he took is by now very familiar to us. Modern art begins with Giotto. The particular religious concerns of the Middle Ages sacrificed form to "abstract symbolism." Art continued to develop in the east, but the west did not make any great strides until Nicola Pisano, perhaps not until Duccio.[17] Fry, in 1900, tended to sacrifice all pre-trecento art to Giotto. This perspective was to be altered in later years with his greater enthusiasm for the Byzantines.[18]

Fry states himself at the beginning of the first of these articles on early Italian art that he is expressing here "current theories on the subject with only a little aesthetic addition." In other words, these essays primarily reflect his command of the scholarly material relevant to early Italian art, no doubt supplemented by his own observations based on his Italian journeys.

However, the apprenticeship seems to end with the essay on Giotto.[19] This was Fry's first attempt to isolate the meaningful elements of a work of art, beyond the unique historical situation of the artist. It is an important document because it marks his initial involvement with problems of form, and introduces ideas which are the basis for his later critical theories. Among the selections of his writings published in *Vision and Design*, it is this essay that he chose to modify with a note explaining the changes in his thinking from 1900 to 1920. The essay mainly concerns Giotto's supposed paintings for San Francesco at Assisi. The issue here is whether formal expression in art is necessarily bound up with recognition of the dramatic idea. In 1900 Fry emphasized the relationship between Giotto's reaction to the heroic qualities of everyday life and to the teachings of St. Francis and the monumental and universal character of his forms. In simplest terms, he believed that Giotto was directly inspired by the story he was visualizing. The dignity of the ideas behind the images concerned him here, but he also took care to describe the images in formal terms. His method was very straightforward, not burdened with theory, and the influence of Morelli seems to come through. For the fresco, *St. Francis before the Sultan*, Fry analyzes Giotto's means of portraying the character of the sultan:

> . . . We find in the Sultan, indeed, the type for which Giotto showed a constant predilection – a well-formed massive body, with high rounded shoulders and short neck, but with small and shapely hands. As is natural in the work of an artist who set himself so definitely to externalize tension of a critical moment, his hands are always eloquent; it is impossible to find in his work a case where the gestures of the hands are not explicit indications of a particular emotion . . . [p. 152]

In discussing the Arena Chapel frescoes, Fry seems to be less constricted by problems of connoisseurship, since he assumes these paintings to be unquestionably by Giotto, and attempts to defend his belief in the coincidence between form and dramatic idea. Essentially, Giotto's frescoes were a stage performance for him, in which the potentialities of human emotion are expressed. For example, he says about the *Noli me Tangere*:

> This is a striking instance of that power which Giotto possessed more than any other Italian, more indeed than any other artist except Rembrandt, the power of making perceptible the flash of mutual recognition which passes between two souls at a moment of sudden illumination. [p. 166]

It was still composition and the general disposition of forms that carried the expressive idea for him. But it is significant that at this stage, the formal components were figures, human gestures, and not abstract shapes. He explains:

> . . . The painter, like Giotto, therefore, actually imagines in terms of figures capable of pictorial presentment, he does not merely translate a poetically dramatic vision into pictorial terms. To be able to do this implies a constant observation of natural forms with a bias towards the discovery of pictorial beauty. . . [p. 169]

It is this symbiotic relationship between form and content that Fry rejected in 1920, when he republished the essay. He would now prefer to have it that our reaction to pure form may be isolated from our reaction to associated ideas and that it is the form alone that provides the expressive power. (p. 131, note) However, the modification does not work here, because he has already described the nucleus of form in Giotto's frescoes to be figures and gestures, representational elements which inherently conjure up associative ideas. But the distinction may in fact never work. Fry scarcely tangled with abstraction. He always seemed to prefer ethical judgments which were based inevitably on elements associated with human values.

As final evidence for Fry's qualifications for talking about the old masters, his technical knowledge should be taken into consideration. His sketchbooks reveal that his tours of the Italian churches and monasteries, where he saw many of the works by the early masters *in situ* and in their elaborate frames, promoted his interest in the appropriate settings and frames for these early panels. The sketches of the altarpieces often include their total shape and the decorative appendages. This awareness of plausible settings must have helped him make judgments about style and authenticity. (See the figures on pages 68-73.) He also showed an

interest in techniques of restoration. He was very familiar with Cennino Cennini and actually engaged in restoration while he was employed by the Metropolitan Museums between 1906 and 1910. At Hampton Court, he also aided in repairing the Mantegnas in the early 1910s.[20] Fry was approaching his own ideal of the "Kunstforscher" who could apply solid historical and technical knowledge to the less tangible problems of isolating quality and temperaments in art.

Perhaps a more interesting result of Fry's first-hand acquaintance, both as painter and historian, with the technical requirements in art is his development of a preference for the qualities of tempera versus oil. He disliked the atmospheric haze and equivocal forms that oil paint make possible. He had been studying many early Italian panels and he liked the strong contrasts and positive statements that tempera demands. Therefore, in 1905, he wrote an article for the *Burlington* which is simply an account of the favorable characteristics of the tempera medium and, interestingly enough, a suggestion that its current adoption might improve the quality of modern painting.[21] He explains:

> Indeed, one may sum up the whole question of tempera as a medium by saying that whereas it is more difficult than in oil painting to produce any effect at all, it is yet far more difficult, almost impossible indeed, to produce with tempera those thoroughly ugly and uninviting surfaces which it requires profound science to avoid in the clayey mixtures of oil paint. It is not to be hoped that any change of medium, any technical recipes, could purify the mass of modern painting of its bad *ethos*, but nothing would be more likely to have a more restraining and sobering influence on our art than the substitution of tempera for oils as the ordinary medium of artistic expression.

It is clear that Fry's opinion of modern art was not very high at this time. But it is also apparent that the core of his sober, sometimes ascetic, criteria for a meaningful work of art is present here. Beauty, if it means prettiness, was always anathema. Reacting to a work of art is a cerebral as well as a sensuous experience. It is also important to note that the aesthetic implications here are couched in very practical, untheoretical terms. Fry is simply pointing out the relationship between the surface character of the finished painting and the medium used. Training in the connoisseurship of early Italian art left its mark on his commonsense critical approach and helped to restrain him in later years when he does on occasion plunge into purely theoretical speculation.

Fry did, however, also engage in aesthetic speculation during these beginning years, when he was still primarily interested in early Italian art. And his inspiration was one of the most intelligent of British artist-theoreticians, Sir Joshua Reynolds. Fry edited Reynolds' *Discourses* in 1905, appending his own comments to each section.[22] The intellectual

Figures 1 and 2. Pages from Roger Fry's Sketchbooks:
Sketchbook no. 3, Florence, S. Miniato al Monte

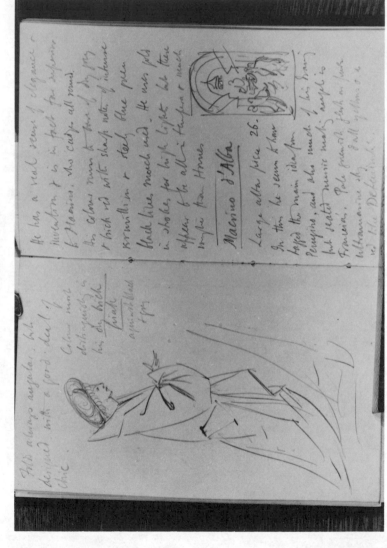

Figure 3. Pages from Roger Fry's Sketchbooks:
Sketchbook no. 16, Turin, Regia Pinacotheca

Figure 4. Pages from Roger Fry's Sketchbooks:
Sketchbook no. 16. Milan, Pinacotheca Ambrosiana

Figures 5 and 6. Pages from Roger Fry's Sketchbooks:
Sketchbook no. 27, Philadelphia, Widener Collection

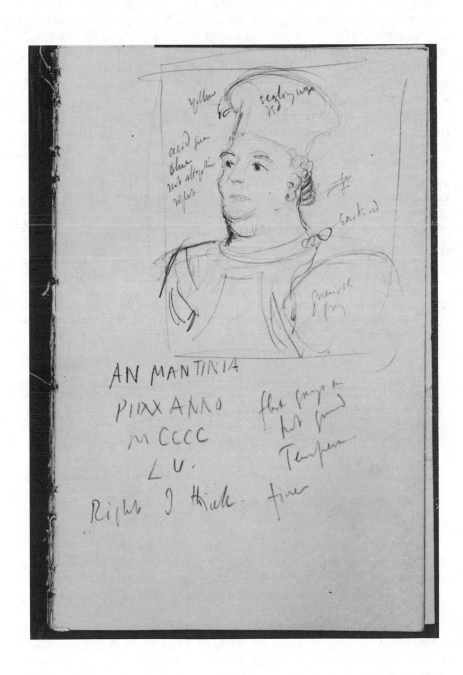

affinity between the two men is clear, even though there are some interesting points of disagreement, conditioned by the period of time that separates them. Reynolds believed that it is education and knowledge of style that make the artist. Fry will not go so far. For example, he believes in some innate qualities of genius, but basically, he, too, considers the substance of visual form to be a series of learned conventions, which are readjusted from generation to generation.

Reynolds' criterion for the work of art was not nature, but the demands of the cultivated intelligence. Fry, although he upholds the natural motif as the initial inspiration for the artist, agrees that the complete expression of a work of art is an exercise of the mind, thus available only to those conversant in its potential. He is very frank in expressing his own 'snobbism'. He praises Reynolds for offering a defense against the absorption of art into popular culture, which for Fry becomes a serious problem in the nineteenth century. He explains (Introduction to Disc. XIII, p. 347):

> With the social and intellectual emancipation of the lower middle classes the demand for crude sensational effects, for vivid appeals to a lazy curiosity and love of novelty, has become imperious . . . For this Discourse [XIII] Reynolds deserves to be held in reverence by all those who think that art is more than a relaxation from the serious cares of the money market.

It is amusing to note that Fry, especially early in his career, also ranked period and nationalistic contributions to the history of art according to subject matter and intellectual ambitions of the artists, although, of course, his hierarchy was not as explicitly stated as was Reynolds'. In an early critique of an exhibition of Dutch masters at the Burlington Fine Arts Club he remarked:[23]

> . . . this Dutch art . . . was the first art which emerged from the ideas of Protestantism and democratic freedom; and both ideas combined to narrow the scope of art and to *deprive it of the power of an elevated and poetical symbolization of life* . . . [my italics][24]

The last phrase might be a paraphrase of Reynolds. But Fry lived in the twentieth century, and it is only fair to note that he could appreciate the "lusty sensation," the adventurous commitment to the act of painting on the part of these Dutch artists, in spite of their supposedly niggardly aims.

Fry also finds in Reynolds an argument against the cult of the individual, dead with Whistler, he notes, of which he so disapproves. He is tired of the romantic claims on art, which make it a personal experience, out of range of a common and learned notion of style and

composition. Reynolds believed that art " . . . is a mode of expression of human experience . . . and that, however diverse the forms it might take, it depended on principles which were more or less discoverable in the great traditions of past masters." (Introduction, p. xix) This is as Fry would have it too. Compositional structure is not based on a private inspiration. It conforms to a set of conventional ways of organizing form, which have remained fairly consistent throughout all periods of art.

No wonder some of Fry's avant-garde contemporaries around 1912 considered him stuffy and pedantic.[25] His preoccupation with the past could hardly appeal to some of these rebellious younger artists, but his respect for tradition was not simply a conservative longing for security. The present in art (especially in 1905) meant to him anarchy, sentimentality, muddy surfaces, and, above all, lack of any formal purpose. Artists in the past, that is, before the nineteenth century, were at least minimally trained in methods of design, of proportioning the figure, and of orchestration of tones. At one point Fry upholds traditional standards more staunchly than did Reynolds. Reynolds, he notes, suggested the replacement of stylistic drawing at the Academy with drawing from the model, perhaps as a reaction against the stylization of method in French schools. The drawing from the model would offer the alternative of greater naturalism. Fry, however, maintains, as he also will later in his general comparisons between French and English art that

> . . . the value of teaching some style is apparent from the much higher average of craftsmanship that French art displays throughout the eighteenth and early nineteenth centuries. There is, perhaps, more chance of producing an artist by the teaching of a bad style than of none at all. [Introduction to Disc. I, p. 2]

We should take this early plea for style as the root of Fry's attachment to and concept of form. If the classic *disegno-colore* controversy could be modified to fit the peculiar issues that develop with nineteenth-century art, Fry would have to be placed in the *disegno* camp.[26] His concern, especially during the first half of his career, was with explicit design as the principal form-making element. The artist does not necessarily follow the recipes of Cennino, but he does organize his perceptions in linear terms. Fry will allow for color as a form-making element, but it is color programmed to follow the light and dark patterning, the strong figure-ground contrasts, used by the older artists. Later on, after he has become involved with Cézanne's working method, he does modify his demands for formal order to include sequences of orchestrated color, which are elaborations on the surface of the painting.

It is interesting, as a slight digression, to consider the points of disagreement between Fry and Reynolds. They include, more than

personal differences, the varying thinking during the two intellectual eras. Reynolds was very much concerned with identifying the characteristics of beauty, and how they may be translated into art. He was the eighteenth-century naturalist, accepting the natural order as the highest standard of perfection. He concluded that it is the common and enduring form (based on a theory of use and disuse) of the species that is the example of perfect natural beauty present for the artist to copy. But Fry, who had behind him the doctrines of Spenserian materialism, which he vehemently rejected, denied the dependence of art on nature. As far as he is concerned: "There is beauty and ugliness in nature, but it is we not Nature, who decide which is which." (Introduction to Disc. III, p. 43)

. More fundamentally, he had the experience of Darwinism and its impact on ninteenth-century thought available to support his reevaluation of Reynolds. During Reynolds' lifetime, he explains, it was still believed that there existed a divine archetype for each species. Assuming this archetype could be discovered, it was possible for the artist, through imitation of nature, to create perfect beauty. This belief, he notes again in the introduction to Discourse III, is responsible for the attempts since the Greeks at canons of proportion for the human figure. However, we no longer believe in divine archetypes, nor since Darwin, do we believe that the generalized form of what nature produces is always the most beautiful. He notes that Darwin and subsequent biological theories have proved that the organ best adapted to function is not always what we consider aesthetically pleasing.

In 1795, Reynolds predates the profound skepticism that affected England in the latter half of the nineteenth century, as a result of the menacing changes in society brought on by the Industrial Revolution. In the eighteenth century, there was little distinction between what was useful and natural, and, therefore, good. But from the second half of the nineteenth century onwards, the products of man's creativity and reasoning were greeted less enthusiastically, and, generally, that which had a primarily utilitarian function, was considered malevolent and unnatural.

The period of time that separates Reynolds and Fry is also reflected in their art historical judgments. Fry points out a limitation which affects all aesthetic assumptions in the *Discourses*, namely the view during Reynolds' time to which he subscribed "that classical sculpture was summed up in the *Apollo Belvedere* and the *Portland Vase* and that Italian painting began with Michelangelo and Raphael." (Introduction, p. xi) During the next 100 years horizons had broadened considerably to include Greek, as distinct from Graeco-Roman art, and also the medieval and early Renaissance periods.

Reynolds' notion of unity was also conditioned by this classical prejudice. Fry, in an otherwise uncharacteristic statement, cites as an alternative to Reynolds' unity through generalization, "the Rubens type of dynamic hooking up of forms," and the seeming multiplicity in a painting like Jan van Eyck's *Worship of the Lamb* (Ghent, St. Bavon). Although all the figures here are equally emphasized, he claims that the unity is achieved through content, through expression of the poetical idea. In a comment that could only have been made by him early in his career, he maintains that it is the intense imaginative satisfaction of finding all these nice people together that provides necessary unity. (Introduction, p. xviii)

Design, or the architectonic substructure that holds a painting together, is generally what counted for Fry. He agreed with Reynolds that the satisfactory image equals the generalized form of a species, because this would imply the simplest, structurally pared down and functional images would be the most expressive. As might be expected, of artists after Giotto he was in greatest sympathy with the fifteenth-century Florentine artists and their followers. Masaccio, Donatello, Mantegna, Uccello and Signorelli satisfied his desire for plasticity and austere, distilled forms. These were the artists, he notes, who, because of their high intellectual passion for abstract ideas, were impelled to study general principles underlying all appearances. "They refused to admit the given facts of nature except in so far as they could become amenable to the generalizing power of their art. Facts had to be digested into form before they were allowed into the system."[27] Fry realized the limitations for art derived from the scientific, versus the aesthetic, character of the perspective system or of the study of anatomy. But he believed far more in these tools for the intellectual control they exercise, than in the literal and, for him, indiscriminate, acceptance of appearances.[28]

Fry's enthusiasm for the Morelli-influenced Mond collection has already been mentioned. He appreciated the serious, non-decorative character of the paintings, based on the importance given by the artists to making a formal (plastic) statement. The panels by Signorelli and Botticelli had in common for him this elusive plasticity. He describes it in reference to a Fra Bartolommeo *Holy Family* (London, National Gallery) in the collection as follows: "The entire group is planned as a single plastic whole. The logic of its sequences is lucid and complete, the movements are freely three-dimensional, and it has the grave impressiveness which comes from such plastic design."[29] Admittedly, this is Fry speaking in 1924, long after he has experienced modern art, and when he has developed an almost too facile vocabulary, so that it is

difficult to determine the source for his interest in "plastic" design. But the seeds for his argument were also present as early as 1905, when he wrote an essay on Mantegna for the *Burlington*.[30] He maintains in this article that "Mantegna and Piranesi are the true interpreters of the spirit of Roman art. Mantegna went further; he even read nature in terms of the same relentless immovable architecture of bare line and incumbent mass . . ." He continues (p. 97):

> . . . We feel that Mantegna, by the negation of all the more brilliant and seductive qualities of paint, by the reduction of expression to its simplest terms of flat slightly contrasted tones, bounded by contours of the utmost purity and perfection, has found precisely the method to give to his figures their mysterious and spiritual life. We may feel the more certain that his instinct was right when we reflect that independently he hit upon almost identically the same technique, and the same general effect of tone, even the same quality of surface, as the great religious painters of China . . .[31]

The interest in the "mysterious and spiritual life" was not consistent throughout Fry's career, but the call for simplicity and for the "incumbent mass" is at the heart of his aesthetic theories. The issue becomes more complicated later when he cannot so readily accept the emphatic statement that the contour makes in bounding images. He will also have more to say about the possibilities of tonal and color contrasts. At this point, the work of art could be resolved for him into positive and negative space—the positive space being filled with clearly articulated volumetric forms.

Signorelli is another of the fifteenth-century Italians who lived up to Fry's standards. He often took the opportunity to discuss his paintings.[32] It is striking that in a 1914 article in which he analyzes a Signorelli panel of the Virgin, Fry uses some of the same language that he employed in 1905 to describe the architectonic quality in Mantegna's work.[33] ". . . Certainly there is nothing of the flattering or seductive qualities of the common run of Umbrian art[34] in this robust and audacious composition, in which everything is arranged as it were concentrically around the imposing mass of the Virgin's figure . . ." Fry's insistence in referring to a religious figure as an "imposing mass" is a good indication of where he will find dignity of expression in a work of art.[35]

In the same 1914 article Fry discusses another fifteenth-century Italian whose reputation as a 'pre-formalist' has endured throughout the twentieth century—Uccello. He describes a painting of *St. Georges and the Dragon* in which Uccello achieved aesthetic harmony through the severe simplification and distillation of natural appearances into an abstract construction of repeated geometric forms.

In Ucello's hands painting becomes almost as abstract, almost as pure as architecture. And as his feeling for the interplay of forms, the rhythmic disposition of planes, was of the rarest and finest, the most removed from anything trivial or merely decorative, (in the vulgar sense), he passes by means of this power of formal organization into a region of feeling entirely remote from that which is suggested if we regard his work as mere illustration. [p. 190]

It is possible that the twentieth-century interest in Ucello's hard-edged abstraction originated with Fry, in light of the following statement also from this essay:

This passion, then for an abstract and theoretical completeness of rendering led Ucello to simplify the data of observed form to an extraordinary extent, and his simplification anticipates in a curious way that of the modern cubists, as one may see from the treatment of his horses in the National Gallery battle-piece. [p. 188]

Even though Fry seemed to emphasize the cerebral nature of creating a formal structure, his enthusiasm for the conceptual character of Italian art should not be exaggerated. He was aware for instance, that an artistic convention like the perspective system could permit the artist to create his images without any reliance on direct perception. This total exemption for the artist from any experience with his senses was a condition he generally mistrusted. Fry defines the history of art as either " . . . a gradual discovery of how things appear to the eye or, on the other hand as the logical and internally necessitated evolution of a rhythm . . ."[36] One suspects, however, that he preferred ideally a balance between the two. It is certainly the combined sense of style and keen observation that he praises as a characteristic of French art. He claims that it was the one-sided naturalism of Impressionism that drove him to the study of the old masters in search of conscious structural design.[37] This statement is not completely accurate, since he seems to have been interested in the early Italians before the problems in modern art became an issue for him. But perhaps it is the sometimes seemingly obsessive intellectualization in Renaissance painting that sent him back to the study of his contemporaries to breathe some fresh air. One could then explain the following enigmatic statement about Signorelli in this light:

There is a consummate ease in the modelling of the forms and in the harmony of their movements, which reveals the highest sense of formal design that perhaps any artist has possessed. Signorelli's revolutionary gesture meant nothing to Raphael. Indeed, Signorelli had to wait for Rembrandt, or even Cézanne, to be fully justified . . ."[38]

And it was Cézanne, who, ideally, according to Fry, derived his condensed, constructed images from the motif itself.

The old masters, for Fry, were not completely blameless. In fact, according to him, we can go all the way back to Leonardo to find the source for the introduction of the sentimentality and formlessness that has ruined much nineteenth-century painting. It was Leonardo who added psychological illustration of dramatic themes to the possibilities of artistic expression. And Fry explains:[39]

> Now in so far as the movements' of the soul could be interpreted by movements of the body as a whole, the new material might lend itself readily to plastic construction, but the minuter and even more psychologically significant movements of facial expression demanded a treatment which hardly worked for aesthetic unity. It involved a new use of light and shade, which in itself tended to break down the fundamental divisions of design, though later on Caravaggio and Rembrandt managed, not very successfully, to pull it round so as to become the material for the basic rhythm.

Leonardo's extension of the possibilities of psychological expression had even more serious consequences. It eventually permitted the greater numbers of the public, who had no interest in, nor understanding of, the language of form, to become involved in the illustrative and dramatic content of the painting, aspects which for Fry were definitely not part of the expressive language unique to art. He had discovered a satisfactory relationship between form and content in the Giotto essay (1900), but even then he insisted that it is through the formal structure that the emotional statement is transmitted. Here, however, in his discussion of Leonardo, Fry is talking about dramatic content which, he believes, cannot so readily be translated into concrete images.

He continues this discussion in another essay on El Greco.[40] This artist, too, included the "melodramatic apparatus" of ecstatic gestures and fantastic lighting in his paintings. Fry, nonetheless, likes El Greco and maintains that he was primarily interested in creating form. He also sees the development of the Baroque idea of composition to be a positive step, one which he credits El Greco, as well as Bernini, with introducing into artistic expression. Like Wölfflin he considers the contribution of the Baroque to be the utmost possible enlargement of the unit of design, for example, the conception of the figure as a rhythmical unit made coherent by the lighting effects, gestures and fall of the drapery. This is in contrast to the Renaissance repetition of smaller units of design (Wölfflin's "multiplicity").

Fry seems to be under a vague German influence in another regard when in this essay he tries to distinguish the varying motivations behind Bernini's and El Greco's art. Bernini, he claims "expressed great inventions in a horribly impure technical language" (p. 210) because he

loved popularity and was too busy pandering to the superficial wishes of the crowd for showy virtuosity. El Greco, however, remained aloof from the public. His art was, therefore, purer and, Fry claims, more acceptable to the post seventeenth-century eye, because of its lack of compromises to popular taste. But the problem remained for Fry that there is a wealth of sentimental content in his paintings that delights the ordinary man who pays no attention to the formal design.

It is with the innovations of Caravaggio that the Pandora's Box of sentimental content was opened wide for artists to plunder. In an article on the Seicento,[41] Fry contends that there is a direct connection between the artistic form at the disposal of the artist and the kinds of sentiments he is most likely to express. He therefore disapproves of Caravaggio's defiance of the traditional methods of creating form, which resulted in the introduction of a less satisfactory means of expression to the members of the artistic profession. And he blames a great deal more on Caravaggio (p. 106):

> . . . but still, I think we may give to Caravaggio the honor of having been the first purely popular artist, the real founder of the Royal Academy, the Salon, and almost the whole art of the Cinema. For that, in fact, is what it comes to — it was in seventeenth-century Italy that that alternative tradition of popular or commercial art was first set up in open rivalry to the old tradition of the profession, a tradition which appealed to other sanctions than those granted by the gross public in recognition of the gratitude of its untrained instincts. And since the expression of sentimental and melodramatic emotion provides a slope down which the imagination glides without effort, this new tradition has been, and always, one supposes, will be, by far the greatest impulse to the manufacture of so-called works of art at any particular period.

Fry had made a similar point in the 1905 edition of Reynolds' *Discourses*, when he tried to defend the teaching of conventional methods of drawing to insure a level of stylistic proficiency and decorum. It is important to distinguish, as does Fry, between "respectable academicism" and "Royal Academicism." The former he would define as the respect for the use of the conventional vocabulary of art which has been developing and becoming enriched since antiquity. The latter is the stultifying, snobbish and uncritical reverence for these conventions and for the old masters who practiced them by artists who themselves have no sincere motivation. It is in fact this pedantry and obsession with virtuoso craftsmanship that would permit the alternative negation of past traditions to emerge as a welcome rallying point for artists.

Fry concedes to Caravaggio a talent for using light and shade formally, but he objects to what he sees as his mainly non-aesthetic objectives: verisimilitude as an end in itself and the use of startling

pictorial effects mainly for their shock value. One also suspects that Fry did not appreciate the swaggering, excessive personality of the artist himself, as his bohemian reputation seems to reveal him.

It is interesting to consider Fry's total conception of the Seicento, in the terms he uses to explain it in this article. He claims to have been "the first modern English writer on art to turn a friendly inquiring gaze towards the masters of the Seicento, whose names still re-echoed, but with a dying sound, at the end of the last century." (p. 95) Wölfflin, however, had also been talking about the Baroque and Fry's main contribution is that he modifies and expands upon the German's ideas. He is primarily concerned with Italian seventeenth-century painting, since he claims that Wölfflin considered the visual attitude of the seicento to be the special contribution of northern artists. Fry does not believe that Renaissance and Baroque modes of expression are so clearly opposed. Rather, he finds historical development a process of enrichment, each generation making some conscious use of the experiments of the generation before. He remarks about the Baroque (p. 102):

> It must be thought that the Baroque, in giving up tactile experience and confining itself to visual, lost thereby the sense of plastic relief; by a strange paradox it actually heightened the pictorial expression of mass and volume. For though it stated the facts of plasticity with less completeness, having of necessity abandoned an important means of discovering them, its increased understanding of purely visual indications actually increased its powers of exciting the idea of plasticity in the spectator. This suggests, I think, the existence of a principle which may be of great importance in any such aesthetic history of art as Dr. Wölfflin envisages, namely that when once artists have fully explored any aspect of nature they tend to retain this power even when they apparently neglect the means by which their predecessors arrived at that expression.

For Fry this theory is very important because it helps explain the seemingly more tactile Post-Impressionist reaction against the primarily visual experience of Impressionism. Unfortunately, however, the Baroque explorations of the visual field allowed for a dangerous weapon to be introduced into art when not subordinated to the aesthetic idea—the power of creating illusion.

Fry remains preoccupied with this problem of the introduction of (for him) irrelevant dramatic concerns into art. He is not against dramatic content when it is subservient to the formal structure. But he suspects that for the mass of viewers and, likewise, for the majority of artists, dramatic expression becomes the main interest. Thus, Giotto satisfies his need to locate formal harmony, but Rembrandt does not.[42] He is very restrictive in the number of formal elements, such as volume or line, that he will acknowledge. Light or chiaroscuro is one of which

he is wary, since it permits the expression of visual and illusive effects, which he believes hide to most eyes the absence of a sound formal structure. And Rembrandt, he says, conceived of form in a way as far as possible removed from the tactile drawing of the great Italians, that is, away from the expression of form as a continuous sequence of planes. For him, form only existed where it receives light, and, thus, it is really light-shadow contrasts that he was painting. Fry is not denying that in Rembrandt's hands the dramatic situation took on great meaning. But he is concerned that this talent is accidental, that Rembrandt's feeling for form and space, when he did succeed compositionally, was instinctive. Therefore, this sensitivity to form is not subject to rational analysis and is not reproducible. It is vulnerable in the hands of the lesser artist who also trusts only his instincts.

Fry is consistent. In 1905, in the edition of Reynolds' *Discourses*, he defended the perpetuation of conventions and rules for composition, which are particularly appropriate to the artist's medium. The creation of form, as he saw it, can be defined by the various principles of design. Dramatic expression and the effects achieved through the maneuvering of light and shade, are elusive, not subject to precise analysis and, therefore, suspect. His lack of sympathy with the Impressionists comes to mind again. Although he could not criticize them for pandering to cheap sentimentality, he was skeptical of their preoccupation with light, which he seemed to associate, judging from his comments on Leonardo, Caravaggio and others, with the potential vulgarization of art.[43]

Fry had a final bone to pick with the general course of artistic development in the West, since the Renaissance. At the same time that he praised the appeal to the intellect and to man's higher faculties, he also bemoaned the overly anthropocentric character of western art. For one thing, the constant preoccupation with man in relationship to his environment distracts the artist, he believed, from objective observation of the world around him. He therefore maintained that the Negro, or Chinese artist, unencumbered by this restriction, attained more easily to a unity exclusive to the work of art itself.

Claude is one particular artist who Fry believed suffered from this anthropocentric orientation in western art. He praises Claude's orchestration of tone masses in his paintings, his ability to capture the pastoral and ultimately civilized quality of the natural environment. He was not so much concerned with truth to nature as with the manipulation of abstract symbols, or conventions to arouse a mood of pastoral delight, a motivation of which Fry approves. But Claude is vulnerable where his art is deliberately false to nature, because it must accommodate man's

desires. Says Fry:[44]

> . . . His world is not to be lived in, only to be looked at in a mood of pleasing
> melancholy or suave reverie. It is, therefore as true to one aspect of human
> desire as it is false to the facts of life. It may be admitted that this is not the
> finest kind of art — it is the art of a self-centered and refined luxury which looks
> on nature as a garden to its own pleasure-house — but few will deny its genial and
> moderating charm . . . [p. 231][45]

The question arises of whether Fry presented a chronologically
accurate picture of the development of the language of formal expression,
from the early Italians up to the twentieth century, or whether he tended
to impose on the older artists the aesthetic concerns he found in the
moderns.[46] His initial immersion in the art of the Italians seems to
indicate that he had sufficient opportunity to come to firm conclusions
about their work long before he experienced Post-Impressionism. We
can again return to the important early essay on Giotto to see that Fry
probably developed his concepts of the way form works with varying
artists in chronological order, seeing the modified reassertion of the
principles of design he had discovered in Giotto, Masaccio, and Uccello
in the work of the moderns.

He describes the value contrasts in two panels which he says were
commissioned from Giotto by Cardinal Stefaneschi for the high altar of
St. Peter's. Fry claims that the organization here is based on orches-
tration of tones.

> Here, however, Giotto shows that power which is distinctive of the great masters
> of paint, of developing a form within a strictly limited scale of tone, drawing out
> of the slightest contrasts their fullest expressiveness for the rendering of form. . .
> [p. 159]

Fry's basic assumption is a very 'modern' one, that the picture plane is a
world unto itself on which a unifying principle of design, here value
structure, is being explored. But he makes this observation at the same
time that he discusses the importance of dramatic content. If perhaps
hue were substituted for tone, we would also have a workable description
of the organizational structure for a Cézanne. And why not? The
principles of design remain constant, only the emphasis on the parts of
the vocabulary varies from generation to generation.

In a footnote appended to this particular discussion of Giotto's use
of tonal contrasts, he describes a historical situation in which artists at a
given time are either more concerned with the exact reproduction of
naturalistic effects or more interested in the intellectual construction of
an abstract system, through which the natural data can be filtered. He

notes that Giotto's assumption of an abstract system of tonal harmony

> is to be distinguished from that conscious naturalistic study of atmospheric envelopment which engrossed the attention of some artists of the cinquecento: it is a decorative quality which may occur at any period in the development of painting if only an artist arises gifted with a sufficiently delicate sensitiveness to the surface-quality of his work. [pp. 159–50]

Fry obviously prefers the decorative quality, which, for example, is the sensitivity he will discover in Cézanne as well as in Giotto and in some quattrocento artists. He is more critical of the cinquecento naturalism which is, of course, the preoccupation he finds reasserted with the Impressionists.

Fry's discussion here of Giotto incorporates some of the language and ideas which he will use in his later considerations of the moderns. This is as it should be. For Fry, the history of art from 1300 to 1912 approximately showed a continuous development based on standards and conventions established in the early Renaissance. He discussed the various modifications of these standards, but it is unlikely that he would have believed in revolutionary movements that deny their heritage. He demonstrated this concern for tradition when he described the work of the Post-Impressionists, and his interest in artistic conventions becomes more apparent in his fuller discussions of how formal structure is utilized in the work of these artists and in that of the other moderns. Therefore, it is now time to consider specifically Fry's aesthetic theories and to make a more detailed study of his ideas about those nineteenth- and twentieth-century artists to whom his matured formalist aesthetic was most often applied.

Fry's Concern for Form:
A Further Consideration

Since the two Post-Impressionist exhibitions of 1910 and 1912, Roger Fry's name has appeared constantly as that of a pioneering champion of art after Impressionism, the integrity of the picture plane, the purity of the medium, and other related formalist concerns. Formalism as a critical approach to art is usually considered applicable only to modern painting and sculpture. That formal structure (coherence of color, value, space) could be the primary justification for a painting was an unthinkable idea before the nineteenth century. And only in the latter half of that century were ideas about art for art's sake and pictorial design extensively verbalized by artists and critics. Therefore, Fry, who was primarily interested in the way a painting is put together, has been firmly associated with the modernists by both his detractors and admirers.[1] It is true that he was responsible for verbalizing Cézanne's working method better than anyone had done before him (1927); he was also unwittingly responsible for much of the critical language applied to the post-Cézanne generation, especially to the Cubists, by later writers. He championed Matisse, tried to understand Kandinsky, and generally, with his authority, helped to formulate the rules for twentieth-century abstraction.

Fry was nonetheless 44 years old at the time of the first Post-Impressionist exhibition, and he does not seem to have been greatly interested in contemporary English and French art before that time. The period he spent in Paris in the 1890s studying at the Académie Julian would have provided him with ample opportunity to familiarize himself with and take up the cause of the modernists well before 1910. However, the circumstances in the art world and his prevailing personal interests did not conspire to make him the critical defender of contemporary art at such an early date. His first loves were the early Italians, the fourteenth- and fifteenth-century artists, who appealed to him for the firm three-dimensional form and strong figure-ground

contrasts in their works. He wrote enthusiastically about Giovanni Bellini, and particularly about Giotto, long before he had ever heard of Cézanne. Therefore, an analysis of his formalist concerns involves a dual task. We have already fulfilled one of these by investigating his early prejudices regarding the old masters, particularly the Italian primitives, about whom he had developed very firm ideas long before he began to tackle his contemporaries. It is now necessary to analyze what he had to say about the moderns and how he brought to bear on their art a carefully, and slowly, formulated set of aesthetic criteria for judging a work of art.

Fry wrote to his father in 1893 from Cambridge:[2]

> I have been reading a *History of Aesthetics* by Bernard Bosanquet which explains Aristotle's art criticisms in a most interesting way by showing that $\mu\iota\mu\eta\tau\iota\kappa o s$ [sic.] which had always puzzled me does not mean 'imitation' literally which indeed one might have guessed from his calling music the most mimetic art, but I had never dared to translate it any other way and consequently failed to make anything intelligible out of the view . . .

Fry showed an early and subsequently consistent interest in aesthetic problems, from the time he first became concerned with the arts. The reading of Bosanquet and particularly his concern for the problem of mimesis is important, because here begins a long-term preoccupation with the relationship between art and nature.

The meaning of imitation in art, that is, the terms by which the artist copies what he sees, is one of the oldest aesthetic issues, but it seems to have taken on new dimensions in the late nineteenth century, when representation versus abstraction became a particular issue for contemporary art. The discussion among the moderns took shape in one of two ways. The theory of art for art's sake, which denies any representational or ethical function for art, was one doctrine invoked to explain purely visual appeal. The other related theory does ascribe a definite ethical function to art, one that involves the artist's ability to apparently reconstruct the permanent and therefore 'real' structure underlying natural appearances.

Fry, with his sober, sometimes puritanical attitude to art, subscribed partly to the latter theory, especially in the period around 1910, but his own contribution to the theory of imitation (and to be fair that of some other English critics schooled in a like manner) adds a third dimension. Art for him had an ethical function. Experiencing a well-constructed, intelligently organized series of forms, which are also a direct result of some powerful feeling on the part of the artist, is an uplifting experience. A tasteful design for wallpaper or for the decoration of a tea room in a

railway station suggests a rational, ethical thought process at work,[3] whereas vulgarity, excess, and sloppiness in design imply a similar mental condition and are also a bad influence on the viewer.[4] On a less tangible level, Fry diligently railed against the type of art, for example nineteenth-century salon paintings, which seemed to play on moral weakness and sentimentality in the viewer and which he would maintain were devoid of any powerful feeling on the part of the artist.

But as heir to the English art for art's sake tradition, inaugurated by Whistler and Pater, Fry was by no means advertising a general and didactic purpose for art. On the contrary, he was perhaps overly preoccupied with the elitist notion of the aesthetic experience, available only to the intelligent and to those schooled in the workings of form and the potentialities of the artist's medium. Form, that is, the digestion and transposition of visual material into an independent, self-contained artistic construction, was for him the means through which the artist's message is carried to the viewer. Form is not, however, mere surface prettiness, for which he attacked Whistler's theories.[5] Nor is it any absolute statement about truth and permanence in the natural world. He believed instead that there is a simpler human need for abstract beauty, which is fulfilled through the right distribution of elements in the formal structure.[6]

The crucial beginnings for all this theorizing about formal relationships and why they are the stuff of art is Tolstoy's essay entitled "What is Art?" (1898). Fry discusses Tolstoy's theories and acknowledges their influence on his own thinking in his 1909 "Essay on Aesthetics," which is his earliest, and perhaps most coherent, exploration of the subject.[7] Tolstoy maintained that the subject matter of aesthetics is not beauty existent in nature, but the expression of emotion. The artist does not aim merely to decorate a surface with pleasing shapes and bright colors, nor with images of ideal human form. His task is to render visible the powerful feelings that result from his perceptions. Tolstoy, therefore, was freeing art from its restricted meaning as a purely self-indulgent activity. This idea, invoked by the supporters of the theory of art for art's sake to define the artistic process, was one Fry, too, found morally reprehensible. Fry could not, however, agree with Tolstoy beyond this point. For Tolstoy it was not the transmission of emotion that is significant, but the responsive act that is the reaction to this feeling. Although his theories might seem to deny his own fictional writings, which do not necessarily inspire particular moral acts, he ascribed to art a specific moral and utilitarian function. But Fry would restate: ". . . Morality, then, appreciates emotion by the standard of resultant action. Art appreciates emotion in and for itself . . ." (*V&D*,

p. 27) It is here that he also parts with Ruskin, who, he maintains, permitted the imaginative life, that is the creative spirit, to subserve morality.

Because of his desire to explain the unique but significant character of the aesthetic experience, Fry has often been taken to task for trying to separate form from content in painting.[8] This criticism is not completely warranted. In his more abstract and philosophical essays he did make a point of trying to isolate the creative act, which is not and should not be coerced by economic, social and political motivation.[9] This does not mean, however, that he denies the validity of representational subject matter in painting. He ends his closing essay in *Vision and Design*, which is a reliable summary of the evolution of his thinking, by admitting his own reservations about the possibility of defining the "aesthetic emotion" in purely abstract terms.[10] This is one of the rare occasions on which he attempts to explain "significant form."[11] Fry writes at the end of "Retrospect": "Any attempt I might make to explain this [aesthetic emotion] would probably land me in the depths of mysticism. On the edge of that gulf I stop." (*V&D*, p. 302)

In fact, Fry rarely tackled purely abstract painting. It is true that in later years he modified his early interest in the dramatic element, that is, in the significance of narrative. He will at the end of "Retrospect" claim that a fusion of the aesthetic emotion and dramatic emotion in appreciating a work of art is impossible. Concern for the dramatic idea can only detract from careful scrutiny of the formal design. Yet near the end of his life, in a lecture delivered in Brussels, he reasserts the possible compatibility of the two experiences.[12] And this latter thesis may be considered the one most consistent with his feelings about art throughout his life. He constantly relied on a dialogue between pure intellectual construction and reaction to natural phenomena as the inspiration for the work of art. He insisted, for example, that Cézanne (his chosen alter ego) could fulfill a composition only when he had been initially stimulated by the natural motif. The "transformation" of perceptual material into digested aesthetically satisfying form is what really preoccupied him in his aesthetic speculations.[13]

Necessary to an understanding of how sense-reactions to the natural world are transformed into art is an appreciation of the perceptual process itself. Fry's judgments about the nature of perception in both artist and public are some of his most astute observations.[14] Two things concern him—the required condition that the artist receive his stimulus from perceived phenomena and the nature of this vision before the external world. This vision is of a special kind. In the "Essay on Aesthetics" he defines its exceptional clarity, because of the artist's freedom from the requirements of responsive action.

In another essay, "The Artist's Vision,"[15] Fry tries to define the peculiar characteristics of artistic vision. Normal vision, according to him, is linked in various stages with a sense of purpose. We do not see; we identify objects in order to adapt them to our needs. There are then several stages of aesthetic vision, wherein objects are apprehended for their own sake, because they allow for some sensuous or intellectual pleasure. The ultimate degree is the creative vision through which the artist contemplates his surroundings as inspiration for his work.

The unique character of the creative vision for Fry is that the artist, in contemplating his surroundings, does not need at all to identify objects. Because he is completely detached from the "meanings and implications of things," the whole field of vision becomes for him just the coherence among tones and colors, which transcends the boundaries of objects themselves. He notes that

> . . . in so far as the artist looks at objects only as part of a whole field of vision which is his own potential picture, he can give no account of their aesthetic value. Every solid object is subject to the play of light and shade, and becomes a mosaic of visual patches, each of which for the artist is related to other visual patches in the surroundings . . .[16]

There are no identifiable forms, no figure-ground distinctions, no perception of depth. The latter are intellectual constructs which are later integrated with this pure, raw visual material to create a work of art.[17]

There are obvious deficiencies in this theory of artistic vision. Fry went perhaps too far in trying to isolate the quality of artistic perception. It is probably because of abstract speculations such as this one that critics assume he had boxed himself into a corner, trying to isolate pure form. It is also the type of vision he required for the artist that seems to indicate his sole concern to be abstraction versus representation. These ideas existed for him mainly in theory, not in practice.

We must also ask: Was Fry really attempting to analyze a psychological process, or was he making assumptions based on the completed painting and the way he chose to see it? His description of the mosaic visual field sounds a great deal like one of the images he created of the successful work of art. The analysis is more credible when applied to Cézanne's working method than to the actual way in which we perceive the world. However, this discussion of tonal sequences, of chromatic variation, still seems to be the most sophisticated discussion to date of the way the artist works out his composition through his perceptions. Whatever the limitations in Fry's theory, it is true that perceptual activity does vary. It is possible to discover a complete, pleasing landscape scene without isolating all the visible elements.[18]

Perhaps Fry should not have attempted to define the visual process, but herein also lies one of his contributions to the articulation of the artist's working method.

Another interesting implication, of which Fry was aware, arises from the attempt to isolate artistic perceptions. In particular, the modern artist who has so completely detached himself from a utilitarian function for art has widened the gap between his one comprehension of his work and that of the public. Fry, who was both artist and critic, proved himself very sensitive to the need to educate the public eye. In the essay, "Art and Life,"[19] he traces the history of the relationship between artistic concerns and the social and economic concerns of society, concluding that they rarely coincide, and then only by accident. "It is one of the rarest good fortunes for an artist to find himself actually understood and appreciated by his contemporaries, and not only that, but moving alongside and in step with them towards a similar goal." (*V&D*, p. 6) Fry's particular interest is the relationship between the modern movement and life. He cleverly observes that the Impressionists, in trying to describe new effects of atmospheric color, endowed painting "with a quite new series of colour harmonies, or at least of harmonies which had not been cultivated by European painters for many hundreds of years." (*V&D*, p. 10) The ordinary man at first objects to these unfamiliar effects which clash with his limited vision based on the recognition of objects for practical purposes. But after looking at these pictures, he is in time forced to accept as artistic representation a new vocabulary, and thereby, he also begins to acquire a new tolerance in his judgments of works of art. Fry's basic definition of the history of art, emphasizing this particular problem, is a good one and new for his time. He comments:

> From this point of view [talking about Cézanne's working method] we may regard the history of art as a perceptual attempt at reconciling the claims of the understanding with the appearances of nature as revealed to the eye at each successive period.[20]

Fry keenly evaluates the problem of familiarizing the public with a work of art, although he does not always assume that the breach is so easily filled. Again, in "Art and Life," he further implies that the new, purely aesthetic criteria, based on the rediscovery of structural design (the maturing of art after Impressionism), call for the educated intermediary, namely the critic, to offer instruction in the new vocabulary.[21]

Fry's speculations on the character of perception overlap his fascination with non-western art. For us, today, the primitive mind and the type of art it produces has become an obsession. But in Fry's

generation the admission that art could be produced outside of the western Graeco-Roman tradition indicated a degree of open-mindedness, even if historical accuracy was not the rule. For example, in the essay, "The Art of the Bushmen,"[22] the interesting problem of the relationship between concept and appearances (the same problem taken up in "Art and Life") is explored. Fry is trying to account for the coherent naturalistic images characteristic of Bushman art. His thesis, adapted from Emanuel Löwy, is that man's first (or first man primitive) confrontations with his environment are conceptual, rather than perceptual. He develops symbols for the mental images he has created of things. Gradually, the concepts take on a greater likeness to appearances, that is, become more perceptual. However, Bushman art, the product of a primitive culture, seems to contradict this thesis. Bushman drawings, like those of Paleolithic man, reveal initial sensitivity to natural appearances and the power to transcribe pure visual images, without the intervening concept. Fry attempts to explain this apparent anomaly by claiming that the 'naturalism' of the Bushmen indicates their familiarity and rapport with their surroundings. He concludes that they did not need to develop any further intellectual skills to cope with their environment, and, therefore, remained a primitive society.

In the same essay Fry also establishes the familiar parallel between children's and primitive art. The child, too, first draws the heiroglyphic forms he has developed to cope with natural appearances. A child's definition of drawing is quoted: "First I think, and then I draw a line round my think." (*V&D*, p. 96)

The essay on the Bushmen was written in 1910 and is apparently free of the particular attachment to primitive art as being naive and therefore sincere. But in later essays Fry seems to contradict himself. In "Children's Drawings," on an exhibition at the Omega Workshops, he proposes a similarity between child art and primitive art, based on a like psychological attitude.[23] ". . . The primitive artist is intensely moved by events and objects . . . and his art is the direct expression of his wonder and delight in them . . ." He would further claim that it is this sincerity and intensity that account for the "inevitably rhythmical form" and the expression which becomes beautiful. Especially towards the end of his career, Fry tries to isolate a quality called "sensibility," which he would define as the artist's powerful emotional response to actual appearances, accounting for the energy and meaningfulness in his art. The thesis of the 1917 essay is part of the same attempt to equate directness and honesty of reaction with vitality in art. In another, later, essay on "Children's Drawings,"[24] he proposes again that children who are not yet schooled in the conventional modes of drawing show the possibility of

direct and sincere response to the visible world. But this suggestion that the naive, untutored mind is best capable of self-expression, although a common enough one at the time, seems to negate his more consistent belief in the necessity of intellectual control over the form a work of art assumes.[25] It is probably Fry the self-conscious man and artist speaking when he regrets the anthropocentric character of western art—the obsession with the importance of human form, intellectual and physical. For example, he attributes a plastic sense in the Negro sculptor (his ability to conceive of form initially in three dimensions, without relying on the bas-relief, that is, figure-ground structure) to his freedom from the tendency to enoble physical form. He will sacrifice beautiful limbs and musculature to a coherent artistic structure.[26] Like many other people who have looked longingly at the primitive world, Fry was painfully aware that the long cultural tradition he had inherited is sometimes intimidating.

The various aspects of Fry's theories of perception seem to discourage any simple explanation of his formalist criteria. He never succeeded in isolating form from animated subject matter, although at times his convoluted arguments about form as the unique and special province of art would make one assume that he had no other interests. Many of his ideas took root around one of his favorite topics—the lack of formal structure in Impressionist painting. This, again, is no new idea. It had become a concern in France soon after the first exhibitions of Monet's and Pissarro's paintings. But Fry's predicament is a particular one, revealing his ambivalent attitude towards contemporary art.

He cannot dismiss the Impressionists, because they represent a movement that revolutionized the requirements for pictorial design, particularly chromatic structure. As has been noted before, they demanded of the public a new tolerance for visual appearances by making the process of seeing a self-conscious act. Yet if this is a revolutionary concern, Fry claims in the next breath that in the desire to bring the forms of art closer to the representation of appearances, the Impressionists came at the end of a movement that had been going on since the thirteenth century, although it has been losing ground since the 1870s.

Fry, in harmony with the thinking of his generation, is questioning the fundamental assumption that art aims at representation. He also seems to be downgrading the importance of the perceptual process that he had analyzed so carefully on several other occasions. He defines the "pseudo-scientific and analytic method" of the Impressionist painters as the reduction of the "artistic vision to a continuous patchwork or mosaic of coloured patches without architectural framework or structural coherence."[27] But are not these the same words he uses to define the

process of creative vision? And again, in the Bushman essay, he equates the Impressionist aesthetic, which these artists adopted partly from the "perceptual" Japanese, with the attempt to get back to that "ultra-primitive directness of vision." Here, however, he does not brush aside this motivation. The contemporary artist, he notes, has two interesting possibilites before him: "whether he will *think* form like the early artists of European races or merely *see* it like the Bushmen." (*V&D*, p. 97)

It is probably true that Fry could not make any structural sense out of Impressionist painting because he did not know where to look for it.[28] It is a vulnerable point of history that styles and philosphies fall in and out of favor. Fry's generation could not comprehend the chromatic surface structure that Monet offered.[29] They were prejudiced towards a 'hard-edged' architectonic structure and strong figure-ground contrasts. Therefore, we find Fry continually attacking the amorphous character of Impressionist paintings. It is interesting that he frames his attack in quasi-aesthetic terms. It is not the structure itself he is questioning, but the scientific concerns he considers to be their motivation. As late as 1922, in an article on French nineteenth-century art, he objects to Monet's obsession with effects of light and atmosphere.[30] He claims that even in this area, Matisse has surpassed him with a less direct attack, attaining more nearly the quality of sunlight with his means of design.

Fry was critical of any art associated with the Impressionist pictorial structure, or, in his terms, lack of pictorial structure. In an anonymous book review in the *Athenaeum*, that I am attributing to him, of *Sir Henry Raeburn* by Sir Walter Armstrong, Fry attacks not so much Raeburn as the attitude towards painting being expounded.[31] He is, of course, attacking R.A.M. Stevenson, the arch critical supporter of Impressionist painting, and the initial author of this monograph on Raeburn. He criticizes the "doctrine of direct painting, evident brushwork, and of correct rendering of values. . ." He implies that this doctrine is too limiting. It is devoid of emotional content, and therefore meaning, because it calls upon the creative imagination to put into effect only a few technical rules.

In his own terms, Fry's insensitivity to Impressionist painting can be accounted for by the fact that he was not accustomed to perceiving the world with their vocabulary. He saw receding planes, volumetric forms and value contrasts. We finally come to a description of form as he perceived it in the work of those modern artists whom he did like. The process of reacting to external appearances was extremely important to him, but these reactions had to be fitted within an intellectual scaffolding that turns them into a self-contained artistic structure. He would have liked to think there are uniform guidelines for how this

transformation takes place. Therefore, in the 1909 "Essay on Aesthetics," he established a set of aesthetic criteria, based simply on what he believed are human requirements for satisfying sensations and for the stimulation of emotions. These he believes are, first of all, order, based on unity, whether symmetrical or successive. The "emotional elements," which he then goes on to define, are based on the essential conditions of our physical existence. They are rhythm of line, which appeals to the sensations accompanying muscular activity, mass associated with our necessary gravitational orientation, and space, the fundamental relationship we feel between ourselves and everything around us. Then there is light, to which in our need to identify detailed changes in our environment, we have become particularly sensitive. Color is the final component in the formal structure of a work of art that he mentions. It is significant that he claims color to be "the only one of our elements which is not of critical or universal importance to life and its emotional effect is neither so deep nor so clearly determined as the others."[32] Here he seems to be admitting a degree of insensitivity to color, which is at times corroborated by the attention he gives to it in discussions of works of art. Color becomes a more important formal component for him in later years, but generally, Fry's interests are in volumetric form and clearly perceived structural elements. These effects are more often than not achieved with calculated tonal contrasts.

Fry's choice of component elements in structural design have by now been reissued in various primers of art appreciation. They seem arbitrary, but it would be hard to find alternatives. Again, as in his discussion of the perceptual process, he assumes an identity between the form a work of art takes and man's need to organize his perceptions in a certain way. The partly moral sense that accounts for his preoccupation with sensibility and with powerful emotional responses is also probably behind his insistence on this category of physiological necessity.[33] Art was an elitist occupation for Fry, but he could somehow never give up the idea that it performs some ethical function, gratifying an almost instinctive need in people.

The need for art is satisfied through formal design. Who are the artists who meet this requirement? Seurat, Kandinsky, Matisse, Picasso, Denis, Marchand and, of course, Cézanne, are some of the moderns whom Fry accepted. It should be noted from the start that although Fry lived until 1934, he never became involved or even familiar with artists younger than Picasso, with the exception of perhaps some British contemporaries. One should immediately suspect the grounds for assuming his support of abstraction, when all the art he appreciated (with the exception of Kandinsky's) firmly maintained representational elements.

In an essay written in 1924, "La Peinture Moderne en France," which is essentially a digest of accepted ideas, Fry praises the moderns — Picasso, Matisse, Bonnard and others — simultaneously claiming their heritage from Cézanne.[34] Today we would not accept such an easy transition, but it does tell us where to look for Fry's theories, namely, in his analysis of Cézanne's working method. Fry's main thesis in his monograph on that artist is that Cézanne needed the inspiration of the natural motif to initiate his formal composition.[35] The clumsiness of some of the early "Baroque" paintings is the result of his attempt to compose monumental imaginative works in the style of Rubens, without any reference to the external world. Cézanne's method then, and the ideal one in Fry's thinking, was the organization of "the infinite complexity of appearances by referring it to a geometrical scaffolding . . ." (*Cézanne*, p. 70) Or in terms that are reminiscent of the subject matter of the last chapter, Fry invokes Vasari to support Cézanne. "Vasari would certainly have expressed it by saying that this was life itself, and no mere imitation, which may be another way of expressing Cézanne's idea that the artist is the means by which nature becomes self-conscious . . ." (*Cézanne*, p. 71)

For Fry, Cézanne was the 'primitive'. Here the term takes on a somewhat different meaning from its reference to the Bushmen, that is, to non-western cultures. Primitive here means first. "Primitive simplicity" is the return to the methods of the first artists who concerned themselves with form — for Fry's purposes, the Byzantines, the Italian primitives. Primitive is also the opposite of Baroque, of exaggerated gestures and appeal to the emotions, which Fry thinks got Cézanne into trouble in his early compositions when he tried to imitate Delacroix. Primitive is, therefore, in part classical. Fry does in fact apply to Cézanne's paintings categories that are consistent with our understanding of classical form and which are very likely derived from similar categories defined by Wölfflin.[36] For example, in *Still-life with a Cinareria* (Paris, Pellerin Collection), we find the "utmost parallelism of the objects to the picture plane." He outlines a system of architectonic rigor, of symmetry and of the full amplitude of volumes in space.

But Fry's main concern is Cézanne's method of creating a deep and coherent space in which the volumetric forms are secured. It is not the simple bas-relief construction that he believes defines Renoir's method of projecting depth. He is concerned with Cézanne's technique of constantly shifting planes and the tension between the identity of forms on the surface and their recession into depth. The decisive factor is the character of the contour. Fry's fascination with the nature of line and

with ways of delimiting form, which he discusses also in several essays on drawing, is one of the most interesting aspects of his critical thought. The drawn line, he explains, is the means by which we read contour, and it is defined by its rhythmical gesture on the surface of a painting.[37] However, the true character of the contour, or the boundary separating three-dimensional forms, is that it is constantly disappearing from the surface into depth. We perceive the contour "passing away from the eye at right angles to the plane of the paper, and from the point of view of the evocation of the plastic relief of the volume it is the fact of its disappearance that is important . . ." (*Transformations*, p. 200) And it is Fry's thesis that the imagination is deeply affected only by "plastic form," not by two-dimensional images on the surface. He then concludes: (*Transformations*, p. 201)

> . . . It is one aspect of the eternal conflict in the graphic arts of the organization on the surface of the picture and the organization as an ideated three-dimensional space occupied by volumes. The conciliation of these two opposing tendencies, accomplished by innumerable different devices at different periods, may be said to be the material of any intimate technical criticism of pictorial art.

Here more than anywhere, Fry sounds completely modern, identifying the formal problems which will preoccupy the artists and critics who are heir to his thinking. It is interesting that the notion of disappearing planes, according to Fry, goes all the way back to Pliny, whose citation of an earlier Greek critic Fry picks up.[38] This critic maintained that "to paint the edges of bodies and express the disappearing planes is rare in the history of art. For the contour must go round itself and so end that it promises other things behind and shows that which it hides."

The problem of contour versus volume is more fully explored in the essay on Cézanne. The dilemma for Cézanne, with his strong feeling for volumes and masses (Fry's ideal), was how to suggest the recession of planes into the picture space when these planes are reduced to drawn lines on the surface. Furthermore, because we often perceive the edges of forms with particular clarity, the eye is constantly brought back to the surface of the canvas. The contour, therefore, becomes an obsessive problem for the artist, who, like Cézanne, is concerned with plastic form. Rembrandt, also, according to Fry, refused to make too emphatic a statement of the outline of bodies. He would use lines in and around the contour to suggest direction, doing anything to avoid arresting the interplay of planes.

It is this interplay of planes that concerned Cézanne. It is worth

quoting extensively how Fry describes his solution: (*Cézanne,* p. 50)

> For the pure Impressionists the question of the contour was not so insistent. Preoccupied as they were by the continuity of the visual weft, contour had no special meaning for them: it was defined more or less – often vaguely – by the sum of indications of tone. But for Cézanne with his intellectual vigour, his passion for lucid articulation and solid construction, it became an obsession. We find the traces of this throughout in this still-life [*Compotier*, Paris, Collection M. and Mme. René Lecomte].[39] He actually draws the contour with his brush, generally in a bluish grey. Naturally the curvature of this line is sharply contrasted with his parallel hatchings, and arrests the eye too much. He then returns upon it incessantly by repeated hatchings which gradually heap up round the contour to a great thickness. The contour is continually being lost and then recovered again . . . The apparent continuity of the contour is illusory, for it changes in quality throughout each particle of its length. There is no uniformity in the tracing of the smallest curve . . .

This description is not completely clear, but Fry has taken on a difficult task – to explain how the sensation of solidity can be most convincingly transformed into a pictorial image, while preserving the unique character of the two-dimensional design. This is the task that supposedly also confronted the Cubists. And I think it would be possible to find in Fry's discussion of Cézanne the roots for the particularly analytical critical language that still haunts Cubist painting today – ideas about shifting planes, self-conscious edges and, generally, the introduction of a specifically structural vocabulary into the discussion of painting. It is significant that Fry's artist contemporaries criticized him mainly for being too analytical. C.R. Nevinson thought that he was snobbish and ultra-civilized; and Mark Gertler (one of the artists Fry admired) believed his approach to Cézanne to be too intellectual.[40]

As for Cubism, it is ironic that Fry never seemed to appreciate its intentions. Picasso was a great artist, but he discussed him unmethodically. He never fully analyzed the Cubist phase in his work, and also rarely mentioned Braque.[41] He saw the trend they initiated to be towards total abstraction, which always puzzled him. The following, therefore, is an interesting historical judgment on Fry's part:[42]

> Probably if we could view the whole of this movement from a historical distance we should see this specifically Impressionist movement as an excursus; it would appear as a loop in the curve of pictorial tradition – a somewhat similar loop to that which has been described in our day by the Cubist movement. This loop would be seen to have had important reactions on the main curve, but to have returned again to it.

Returning to Cézanne, we discover that Fry was not content to see him simply anchor volumetric forms in space. His desire for verisimili-

tude demanded a closely worked out network of interrelated forms, his rhythmic sequence of planes. And the smallest formal units in the case of Cézanne are color variations. "His colour is the one quality in Cézanne which remains supremely great under all conditions . . ." notes Fry. (*Cézanne*, p. 13) He is in fact extremely perceptive in his discussion of color here, explaining that Cézanne modulated color in small washes of various hues in the attempt to translate nature's changes of tone into changes of color. This is "plastic colour" as Fry defines it in another essay written at about the same time.[43] Where color had traditionally been used as an adjunct to form, achieved through drawing and chiaroscuro, it is here an expressive form-making element. Cézanne had chosen color transitions over changes of light and dark. Fry remarks that ". . . he found certain colour sequences which expressed directly these sequences whenever they approach the critical phase of the contour of a volume and in his water-colours he often confines himself to a statement of them . . ."[44] Fry also notes that he got much of his concern for the "plastic expressiveness of colour" from the Impressionists. He secures the tradition handed down from the generation of the 1870s to that of the 1880s, a more plausible connection than that which is constantly being made later between Cézanne, the innovator who broke with the past, and the Cubists, who in fact relied on a somewhat different chromatic structure.

Fry discusses the Impressionists very intelligently here. Consistent with his awareness of artistic traditions, he explains that when they started out they were interested in Leonardo's laws for the exploration of atmospheric color, that is, for the orchestration of tones and the diffusion of neutralized light, which is the exact opposite of the 'primitive' notion of strong oppositions of local color. However, they were using pure primary colors and eventually certain bright colors were exaggerated and underlined so that the outcome, prompted by their concern for brilliance, was a series of rich color contrasts. But it is the same old story: the Impressionists' extreme preoccupation with atmospheric effects did not allow for the appearance of volumetric forms within the picture space. The alternative development was left to Cézanne, who showed the same concern for a rhythmically articulated surface, but when noting scattered points in his composition (the "all over" working method), he concerned himself mainly with the sequences of forms that best produced structure, those contours and contrasts that underscore plasticity.

In the essay on color Fry further discusses the history of the use of color from Cennino onwards. He is obviously pleased that the initial idea of color as a less important decorative adjunct gives way to its

independent and at times primary position as a form-making means of expression. This attitude is surprising, remembering the 1909 "Essay on Aesthetics" in which he claimed that color, which is not critical to life, offers the least commanding emotional effect, when compared with the other compositional elements — space, light and shade, and so on.

The art of Cézanne, then, was for Fry (and for a whole generation among his contemporary artists and critics) the absolute criterion by which "realization" in a painting is judged. Cézanne secured volumes into a tightly organized picture space, acknowledging the self-contained, unique character of the two-dimensional surface. These were Fry's ideals. But who are the heirs to this method? They are a mixed group. As we have seen, Fry was not able to understand the Cubist objectives; at the same time, he sometimes exalted artists now long forgotten, a typical situation for the critic. At the end of the article on "Plastic Colour," when he has completed his analysis of Cézanne, Fry discusses the work of Simon Lévy, a contemporary whom he sees working out the potentials of structural color. Lévy, he claims, is the devoted student of Cézanne, and his discussion of his paintings sounds very much like an analysis of the older artist's working method. But, then, where is this artist today?[45]

Renoir is one of the moderns about whom Fry spoke most convincingly from the vantage point of comparing him with Cézanne.[46] He liked Renoir but believed that he accepted a simpler method for indicating depth. Renoir's planes recede uniformly by gradations (tonal) from the high light towards the contour. He seems to be describing the traditional method of using shading to indicate sculptural relief. He concludes that

> . . . the picture tends thus to take the form of a bas-relief in which the recessions are not into the profound distances of pictorial space, but only back, as it were to the block out of which the bossed reliefs emerge, though, of course, by means of atmospheric colour the eye may interpret these recessions as distance. [*V&D*, p. 270]

This is clearly in marked contrast to Cézanne's method of suggesting endless recessions of planes with the most complicated interwoven texture.[47]

Seurat is one artist whom Fry overlooked early in his career, around the time of the two Post-Impressionist exhibitions. Then later on he acknowledges his oversight and begins to talk enthusiastically about the artist.[48] His ambivalent attitude can probably be explained. He should always have admired the heiratic structure of Seurat's paintings, and this is indeed what he praises now.[49] He repeatedly likens Seurat to Poussin, finding in them an equivalent concern for carefully

proportioning the picture plane so that everything falls into place according to harmonic principles. For instance, in discussing *Les Poseuses* (Merion, Pennsylvania, Barnes Foundation), which he in the end finds a bit too rigid, Fry attributes the multiple poses of the single figure to Seurat's concern for expressing proportion and direction in a tightly knit system. He writes:[50]

> The main idea of the composition is of two long uprights, one the central nude, the other the seated nude prolonged into the two upright figures of the "Grand Jatte." The picture is thus divided exactly into two equal halves, a bold application of Poussin's favorite practice . . . This right-hand half has, instead of a third upright, a pyramid into which the seated figure is almost forcibly fitted . . . But Seurat felt the need of an analogy in the left-hand half of the picture, to the pyramid in the right, and has made the model's right leg stick out so as to be almost exactly in with the left-hand side of the pyramid in order to do so . . .

Since Fry's day many critics have pounced on Seurat, as well as Cézanne, with diagrammatic schemes. Fry was being very 'modern', and here is another instance (like the premonitions of Cubist criticism in the Cézanne essay) of the unconscious making of a pattern of formal language that would live on. The discussion of halving pyramids, balance, analogy, could be applied, for example, to Mondrian. But for Fry it is significant that these are not simply abstract patterns. It was the expressive quality he found in Seurat's careful constructions that interested him. The landscapes, which he seems to have preferred, offered him designs of specially conceived spaces filled by specially interpreted luminosities and color vibration. But the illusion of infinite depth in them, the play of atmospheric effects that have associations with natural appearances, were probably the initial means by which he was attracted to the paintings. And in another essay he praises *La Parade* (New York, Metropolitan) for the transmutation and stylization of every day life through the repetition of simple forms.[51] The reference to nature remains strong for Fry.

I believe, however, that Fry was probably more willing to recognize surface structure later in life and that this is why he suddenly discovered Seurat.[52] There is a great deal of depth in Seurat's compositions, but there is no volume and tonal modelling as these have been traditionally represented since the Renaissance. Even at this late point, Fry emphasizes the linear structure in his discussion. But he also proves his awareness of the chromatic structure. He talks, for example, about a particular characteristic of the pointillist method he has observed. Tones that appear indistinguishable close up become strongly contrasted when viewed at a distance. Thus Seurat can have it both ways — a tightly

constructed, unaccented surface, and the illusion of deep space, the ideal two-dimensional/three-dimensional harmony.

It is difficult to determine precisely how interested Fry was in color. But it is likely that his awareness of its formal value came no earlier than the end of the 1910s, and probably not until the 1920s, when he wrote *Cézanne,* his essay on "Plastic Colour," and when he discovered Seurat. As has been pointed out several times before, in 1909 ("Essay on Aesthetics"), he gave to color the least power of expression.[53] In 1909 he was still closely involved with the Morellian tradition; in 1920 he had become the critic of contemporary art and was being exposed to more and more of it. Fry developed a strong liking for Matisse, which he often tried to justify in terms of spatial illusion and atmospheric effects he discovered in his paintings. But surely the rich color contrasts and linear arabesques on the surface of his paintings must have been the qualities Fry first noticed. It is plausible then, considering his perceptions about the chromatic structure in Cézanne's and Seurat's work, that if Fry had been exposed afresh to Impressionist painting in the 20s he might have appreciated it more.

Some general conclusions can be drawn about Fry's critical interests from the types of artists he chose to sympathize with among the younger and lesser known moderns. These artists, many of whom were included in the two Post-Impressionist exhibitions, are, logically, members of the first generation of 'Post-Cézanneans', of whom there are more than enough. Maurice Denis, an acknowledged admirer of Cézanne, is one of his favorite artists. In an early article, he praises Denis' "plastic perfection," his method of translating from the actual tones of nature to the "appropriate visual symbols." He is also praising this method at the expense of the pleinairists.[54] He does, however, vindicate the Impressionists by acknowledging that although Denis' feat contradicts their method, it could not have been accomplished without their experiments.

And in a later article Fry praises the now almost forgotten Jean Marchand, whose heiratic simplicity and honesty he puts in the category of the "French classic spirit."[55] Marchand, whom he says has much in common with André Derain, relies on clarified and distilled forms to describe only what he sees. He served an "apprenticeship" under Cubism, where he learned how to analyze complex forms and make lucid visual statements about them. Again Fry is dwelling on the necessity for dealing with actual appearances, the ordinary things of life — ". . . a loaf of bread or a hat left on the table, a rather vulgar French château restored by Viollet-le-Duc with a prim garden and decorous lake, a pot of aspidistra in a surburban window . . ." (*V&D*, p. 280) Fry had a particular liking for still-life elements and a dread of visionary subject

matter, which is also conspicuously absent from Marchand's own paintings. Denis' paintings, however, do involve symbolic imagery, but in the form they assume, the component parts still have firm roots in natural circumstances, for example, the landscape setting or the characteristics of peasant existence.

To what was Fry reacting? For one thing, he reveals his preference for 'hard edges', clearly bounded forms, which can be distinguished within the network of surface textures and receding planes. The recognizable relationship between these simplified shapes and natural forms must be what he found comforting. It is interesting that Fry concedes to Cézanne in his late landscapes the right to retreat further from the natural motif and from a clearly articulated architectonic structure, but for other contemporary artists and for himself, he insists on the presence of these clear constructions. His own painting very often suffers from the too self-conscious and analytic attempt to define and proportion each structural element, not a surprising fault in the paintings of a critic.[56] He notes at one point that he could sympathize with and imagine himself painting like Corot or Claude, but the imaginative power of Cézanne was in part beyond his comprehension.[57] The reference to naturalistic forms, albeit in their 'transformed' state, is therefore a support, a scaffolding to insure the recognition of sincere motivation on the part of the artist where this could be questioned.

Fry meant it in 1909 when he defined the emotional elements of design in terms of their appeal to basic physiological needs and elementary perceptions. He, therefore, never gave up three-dimensionality, which is a point of contact with the natural world, as a crucial component in a successful design. Inevitably we come to Fry's attitude towards complete abstraction, which is not a real problem because he rarely discussed it. It has already been pointed out that he "stops on the edge of that gulf" when he gets to it in the concluding essay to *Vision and Design*. He discussed the abstraction of Picasso only in connection with his drawings,[58] avoiding the whole subject of the relationship between form and representational images in the Cubist paintings. He seems to have been hoping that art would move no further away from the object than it had up until 1912.

There is, however, one artist, Kandinsky, whose non-representational art Fry took on. The Russian painter must have remained somewhat of a mystery; his works were scarcely seen in London. But Fry decided to tackle the improvisations in a review of the 1913 Allied Artists' Association exhibition in London (where Kandinsky had first exhibited in England in 1909). This time he exhibited three paintings. One was a landscape in which, according to Fry, ". . . the disposition of

forms is clearly prompted by a thing seen . . ."[59] In the other two, however, ". . . the forms and colours have no possible justification except of rightness of their relations." He calls them "visual music," but significantly he offers no more detailed description of how they work. He only concludes by saying that he ". . . cannot any longer doubt the possibility of emotional expression by such abstract visual means." He never talks about how these paintings are organized, and one suspects that he is not quite sure. His reactions are probably sincere, but isolated, not incorporated into his critical machinery.

The impression given so far is that Fry's discussion of the moderns was confined exclusively to foreign, and mainly to French, artists. Certainly, much of his day-by-day periodical criticism considered his contemporaries in England, whose work he followed closely both as a critic and as an artist sometimes exhibiting with them. For instance, he offered much praise to Mark Gertler, whom he considered a talented artist. However, these comments add little that is new to his formalist theories.

It is more interesting to consider what he had to say about earlier, mainly nineteenth-century English artists. Here we see his nationalistic prejudices at work. Two of Fry's least satisfactory books are preoccupied with a search for national characteristics in art. One of these takes up English paintings, and in this work he almost totally denies the English any talent in the visual arts.[60] He states his case rather firmly: ". . . since the whole issue at stake is that of a plastic feeling in pictorial expression," British art is ". . . primarily linear, descriptive and non-plastic." He is complaining that these arists had no feeling for three-dimensional form, nor the energy to probe appearances in order to extract that form. There is also a moral tone here, reminiscent of Ruskin. But Fry comes out at the opposite pole from the older critic when it comes to one key figure, Turner. For Ruskin, Turner's paintings expressed his sincere and powerful reaction before nature. Fry finds them superficial. He claims that Turner never took the time to contemplate or react before a motif; he was too busy planning pictures. He sees in them "little else but local colour put on in vague splashes and dabs not bound together by any such consistent idea [Impressionist principle of consistent observation] . . ."[61]

Fry was being consistent to his own established criteria. He was condemning apparent total abstraction, which seemed to him to be devoid of feeling or perceptions on the part of the artist, and is, therefore, just a self-indulgent playing with paint on the surface. He liked Constable, therefore, because of his truth to nature, "his discoveries of significant moments in his visual life." That is, he stayed with the

motif and probed it for meaningful statements. It is interesting that Fry calls Constable a colorist, since the artist seems to have relied on a tonal, rather than a chromatic, structure for his paintings. He talked himself of the importance of chiaroscuro. Is Fry thus, at least in this instance, revealing a concern for color which is in fact an interest in the play of light and shade?

The non-plastic, linear qualities of British art greatly disturbed Fry. Turner was essentially playing games on the surface of the canvas, and so was Whistler. In an article which I believe to be by Fry, he attacks Whistler's elitism and idea of the beautiful, which demands the severe limitation of the gamut of tone at the expense of solidity and mass.[62] What Fry sees as his interest in a "tasteful presentment of appearances" is superficial, literally does not probe beyond the surface in the direction of permanence and essential character. He notes: ". . . And yet it has surely been the mark of the greatest art to penetrate beneath particular appearances to character, and then return to appearance for the mode of expressing what that discloses." If Fry is speaking here, then we have some proof of the ethical value he attaches to art.[63] He is speaking in analogies—three-dimensionality equals enduring form; two-dimensionality or surface, records appearances, the perceptible components of form. The compositional structure is a dialogue between the unseen permanent form and our perceptions of it.

Whistler is criticized because he does not probe beneath the surface, because his elegant theory of art for art's sake is so totally hedonistic. However, Fry does not forget to thank him for the purity and style he brought to art in England, so often devoid of discretion and aesthetic justification. Whistler exaggerated the autonomy of the visual arts, but where it had been barely recognized before.

Similarly, early in his career, Fry criticized Walter Sickert, who was heir to the experiments of both Monet and Whistler.[64] Sickert, he contends, was only interested in establishing beautiful tonal and color contrasts according to the rules of nature. He did not go further towards establishing the rich pattern, the internal structure that is the province of the uncompromising artist. Significantly, later in his life, in "Retrospect," that essay I have already mentioned in which he offers some perceptive self-criticism, Fry regrets having praised Wilson Steer and Walter Sickert less than they deserved. He attributes this oversight to his preoccupation with architectonic form as it has been defined by the Italian Renaissance masters. This initial blindness to Steer's paintings is proof once more that only 'later' Fry becomes sensitive to the potentialities of changes in tonality and color contrasts on the surface, that is, to the potentialities of the medium itself.

Fry's criticism of Beardsley is consistent wth his basic dislike of flatness. Beardsley's "mistake," however, was not an obsessive interest in the tonal effects of nature. He represented the other side of the Whistlerian aesthetic of which Fry is suspicious – the self-indulgent art for art's sake concern for prettiness and elegance. The ". . . love of pure decoration, the patient elaboration and enrichment of the surface, the predilection for flat tones and precision of contour, the want of the sense of mass and relief, the extravagant richness of invention . . ." indicate a sensibility devoid of enobling ideals.[65] Fry concludes, no doubt thinking of Beardsley's personality as it would be revealed in his art:

> But if we are right in our analysis of his work, the finest qualities of design can never be appropriated to the expression of such morbid and perverted ideals; nobility and geneality of design are attained only by those who, whatever their actual temperament, cherish these qualities in their imagination.[66]

Was Fry being unduly harsh on the artists of his own country? His generalizations are probably too sweeping, as would be the case with any attempt to make categorical statements about national temperament. However, most people would agree that the British sensibility and their artistic energy have been primarily directed towards literary expression, just as the Italians and French at certain periods applied all their energy to visual expression and made paintings, sculpture and architecture educational tools, as well as their main outlets for self-aggrandizement. Sir Joshua Reynolds, whom Fry greatly respected, testifies to the British artistic predilections. He was an intelligent theorizer, who verbalized the bases for artistic creation as Fry would have them.

Fry is more vulnerable when he tries to establish national characteristics among the artists he does admire, the French. The French, he would maintain, tend towards incisive observation of their environment, with the additional ability to organize their sensations "plastically."[67] This is the ideal balance. The Italians, for example, have a more one-sided instinct; they are the greater conceptual organizers. Fry appends to this vision of the French a positive moral quality of honesty and sincerity. He will, for example, praise artists like Chardin and Courbet because they painted what they saw, because they reacted to the world around them, even though, with the younger artist, the power of "plastic unity," the ability to interpret and transform experience, was lacking.

But what Fry was mainly interested in was establishing a series of unique criteria by which most French art may be defined. He hit upon the "classic spirit" as the basic characteristic – the tendency to see form, order, and composition in appearances. The guiding spirit was Poussin,

who accepted the challenge of concentrating on formal harmonies. In Fry's eyes, the careful arrangements of form also kept Chardin from becoming prosaic and sentimental. With this sense of form, of the emphasis on horizontality and on restrained gestures, Fry also liked Ingres, whose emphatic surface compositions he could easily have bypassed. But Ingres was a "designer"; he distilled appearances into form. "He throws over one by one all the brilliant notations of natural form in the studies [drawings], and arrives bit by bit at an intensely abstract and simplified statement of the general relations."[68] This is the usual Fry talking. He liked Degas, who was the heir to Ingres' concerns for the carefully defined contour, although he believed that in his late paintings there is a shifting emphasis to planar structure. Degas, too, concentrated on formal relations with the added value that, unlike Ingres he always returned to nature.

In many ways, Daumier was Fry's ideal artist, at least early in his writing career, because of his powerful forms that are particularly expressive of nobility and honesty in contemporary life. We are reminded of Fry's references to degradation in the drawings by Beardsley, which made him skeptical about the breadth of the artist's imaginative powers. Surely in both cases his aesthetic judgments were influenced by ethical considerations.[69]

Fry also found ethical as well as aesthetic reasons to praise the early work of Manet and to reject his paintings done under the Impressionist influence.[70] He liked Manet when he was "in sympathy with the Old Masters" and portrayed a feeling for decorative arrangement with his strong oppositions of flat unmodelled tones. Then he succumbed to the revolutionary experiments of the Impressionists and betrayed his sense of design to their less secure chromatic structure. Here, Fry includes a moral judgment—Manet's mistake was that he succumbed to popular opinion and did not remain true to his own "poetic vision."

Much to Fry's dismay, the classic tendencies in French painting have occasionally been challenged by romantic excursions into the world of visions, history painting and "aesthetico-political" commitments. The main protagonist is Delacroix, whom Fry believes to have been overrated. He notes perceptively that his "pictures are coloured, rather than great orchestrations of colour."[71] Fry does not see any evidence that he has taken his division of tone beyond the method of colour orchestration he probably learned from Rubens.[72] This is a fair criticism in view of the muddied, not at all colorful, appearance that many of Delacroix' paintings project. Fry's comments about colored color were prompted in particular by his reaction to Delacroix' paintings in St.

Sulpice, which he visited in 1921, and at that time, judged the paintings "pretty beastly."[73]

We would probably feel today that Fry's attempt to derive a set of national characteristics from the work of the great French masters was not successful, and that generally, the stylistic peculiarities he identified in paintings by Poussin, Chardin, or Manet do exist but are intelligible independent of any meta-aesthetic theory invoked to explain them. However, the concern, which he reveals here, for the perpetuation of a set of standards, of a tradition, is extremely important for an understanding of his ideas and of his influence on his contemporaries. Fry's defense of the moderns was based not on notions of avant-gardism, a break with the past, but on a belief in historical continuity, in the accumulation of perceptions and knowledge.[74] In his position as respected historian of the old masters, he used this historical perspective to explain new experiments. In this way he helped justify the Post-Impressionists by setting them into the framework of the continuing history of art. Where, for example, the French critics from the mid nineteenth century onwards were interested in exalting the new, often offending the public with their sacrifice of the old masters, Fry's circle in England made less of a distinction between art historical expertise applied to established art and criticism of contemporary art.[75]

Cézanne and Uccello or Signorelli, Seurat and Poussin — Fry liked to make these casual connections between the old masters and the moderns. He was not imposing himself on the younger artists by claiming that they in every case actually studied the work of the old masters. Rather, if a great respect for the language of artistic conventions can be considered the basis for his formalist aesthetic, then he was just acknowledging the constant resurgence of this vocabulary. The concern for plastic form, for the articulation of monumental images in space, reached a high point in the quattrocento, and Cézanne was partly heir to this tradition. Fry proposed an additional lineage of artists interested primarily in the effects of light, from Leonardo to Caravaggio to the Impressionists. He also recognized the amplification of design-making potentials with the Baroque enlargement on the Renaissance idea of formal order. Therefore, probably influenced by German writers, who dwelt on such syntheses, he saw the seemingly adverse conceptions of both Poussin and El Greco combined in the work of Cézanne.

Fry might more appropriately be termed an historian, rather than a critic of modern art. He himself admitted that it was the search for the type of structural design with which he could sympathize that drove him initially away from the moderns and back to the Italian Renaissance, and that the formal expression he found there perhaps overly influenced him

when he returned to judge the work of Cézanne and his followers.[76] It is this constant dialogue that he maintained between the art of the past and the work of his contemporaries that identifies his important contribution to the history of art criticism. Fry has had many followers among critics who have adapted his language and theories to discussions of current artistic concerns. But we may feel closer to him when in the presence of historians like Sir John Pope-Hennessy and Sir Kenneth Clark. For example, in Sir Kenneth's work we find that respect for the past in art, based on an attachment to the Italian Renaissance, which profoundly marks the nineteenth-century British tradition. In Sir Kenneth's televised *Civilization* we are as close as we can be to Roger Fry's lectures in the Queen's Hall.

Notes

Chapter I

1. *The Year's Art* is an annual concordance, compiled by A.C.R. Carter, of paintings and graphic work sold and exhibited in England.

2. Durand-Ruel had made several abortive attempts to introduce contemporary French art into England. In 1896, D.S. MacColl, the English critic and champion of French art, bemoaned the fact that Durand-Ruel would not bring a Manet exhibition, currently on view in Paris, over to London. MacColl notes ". . . but M. Durand-Ruel shakes his head and reminds me of how two years ago, he tried us with a Puvis de Chavannes, a Delacroix, and other pictures, and vainly essayed to interest, not only our public, but eminent directors of galleries and other leaders of taste." See D.S.M., "Manet," *SR*, 82(1896), pp. 621-22.

3. Frederick Wedmore, *Fortnightly Review*, 33(1883), pp. 75-82.

4. According to William Gaunt: "The real title was not *l'Absinthe* but *Au Café*. It depicted a man and a woman sitting at a café table with glasses before them—a scene not at all unusual in the French capital nor necessarily lacking in decorum. In fact the man was a skilled and respectable engraver, M. Desboutin, relaxing quietly and pipe between teeth, contemplating the agreeable spectacle of the street. The drink in the tumbler before him was, actually, nothing more harmful than black coffee. The woman with him was a well-known model." See William Gaunt, *The Aesthetic Adventure* (Harmondsworth: Penguin Books, 1957), p. 162.

5. *Ibid.*

6. Moore eventually tried to retract his original condemnation. In his second statement he argued that it is not the sociological, but the formal, painterly issues which are relevant in a discussion of the painting. However, in his diligent effort to clear Desboutin's name and to reinterpret the action in the café, he still seems to have been carried away with the narrative sequence. See George Moore, *Speaker*, 7(1893), p. 343.

7. To be fair, in 1901, the summer exhibition of the Royal Academy, which then had Sir Edward Poynter as its president, was still the great art event of the year in England, and Sargent was probably the most popular painter in the nation. Simon Nowell-Smith, ed., *Edwardian England, 1901–1914* (London: Oxford Univ. Press, 1964), p. 331.

8. Another writer also emphasized the importance for Monet of the 1870 trip to London with Pissarro and the subsequent influence on him of Turner. See "Modern French Art," *The Quarterly Review*, 185(1897), pp. 360–90.

9. R.A.M. Stevenson, *Velasquez*, ed. by Denys Sutton (London: C. Bell and Sons, 1962), introduction.

10. A contemporary of MacColl, Walter Sickert, writing in the *English Review*, restates the same problem in terms reminiscent of the controversy that surrounded Manet's *Déjeuner sur l'Herbe* three decades before in Paris. He notes: "Oddly enough, our insular decadence in painting can be traced back, I think quite surely, to puritan standards of propriety. If you may not treat pictorially the ways of men and women, and their resultant babies, as one enchained comedy or tragedy, human and *de moeurs*, the artists must needs draw inanimate objects – picturesque if possible . . . I would not advise a British painter to depict a scene dealing with anyone lower in the social scale, than, say, a University Extension lecturer and his financée, or to set his scene in a *lokal*, as they say in Germany, less genteel than a parlour, or to costume it otherwise than in 'Faultless evening dress'. National dispensation, on the other hand, by a paradox worth noting, is gladly given to pictures representing Cleopatra or Messaline, possibly because these ladies' dossiers are not present to the minds of critics 'on this side of the Channel' – ominous, emphatic and almost threatening phrase." See Christophe Campos, *The View of France: From Arnold to Bloomsbury* (London: Oxford Univ. Press, 1965), pp. 167–68.

11. Paintings by Sisley, Renoir, Pissarro, Monet, Manet, Courbet, Raffaelli, Delacroix, Daumier, and Gérôme were some of those to be seen in the French section. Corot and Millet were particularly well represented, as were the Barbizon artists as a group.

12. Frank Rutter, *Art in My Time* (London: Rich and Cowan, 1933), p. 69.

13. On view were 38 paintings by Boudin, 10 by Cézanne, 35 by Degas, 19 by Manet, 55 by Monet, 13 by Morisot, 49 by Pissarro, 59 by Renoir, 36 by Sisley.

14. *Daily Mail*, Jan. 17, 1905, p. 3.

15. *Daily Telegraph*, Jan. 14, 1905, p. 9.

16. D.S.M., *SR*, 99(1905), pp. 411–12.

17. This is a reference to the Whistler Memorial exhibition then being held at the New Gallery.

18. Laurence Binyon was an influential critic, Keeper of the British Museum and an authority on oriental art.

19. Laurence Binyon, *SR*, 105(1908), pp. 589–90.

20. *Quarterly Review*, 199(1904), pp. 80–99. *SR*, 97(1904), pp. 202–3.

21. MacColl answered Binyon in two *SR* articles: 97(1904), pp. 166–67, and 97(1904), pp. 233–34. MacColl's priorities were, of course, formal, whereas Binyon's were thematic. In the first article MacColl takes strong exception to Binyon's comparison between Monet and Barye. And in the second he reveals his progressive, optimistic view of history, pointing out that the Impressionist technique was not meant to be a rejection, but an addition to "the accumulation from former times. It is a new instrument, meant to be used discriminantly."

22. The interest in Turner was in itself a conscious alignment with that type of art which takes a romantic and idealistic view of the world, versus that more concerned with sense response. It is to be remembered that in the early studies of Impressionism in English Turner was identified as a precursor of Monet and Pissarro. But his classical subject matter and free play of the imagination were at the same time contrasted with their supposed scientific vision.

23. A.J. Finberg, *Turner Sketches and Drawings* (London: Methuen and Co., 1910), pp. 64 and 122.

24. MacColl would have also agreed that art is a creation of the mind and that it relies on structure and composition. But by 1910 a distinction, which was to some extent artificial, had developed between two opposing aesthetic views. Art was either mental construction or physiological process; it could not be both at once. The former view, with which Finberg would be allied, was taken by its critics to be literary and subject matter oriented, and likewise the latter, of which MacColl would be a spokesman, was objected to for making use of motor response, that is, the lower human faculties.

25. Post-Impressionism is defined here precisely as it was by Fry's first Grafton exhibition in 1910, "Manet and the Post-Impressionists," when the term was first used. The major artists attached to the movement were Cézanne, Gauguin, Van Gogh, Seurat and the successors to this generation in France, England and Russia. The central figures in the controversy over Post-Impressionism were Gauguin, Van Gogh, Cézanne, Matisse, and Picasso.

26. Dewhurst, *Impressionist Painting*, p. 16.

27. Sir Hugh Lane had been working for several years to establish a gallery of modern art in Dublin. In 1904, to promote interest, he arranged an exhibition at the Royal Hibernian Academy. The nucleus of the show was his own collection of contemporary art. He also borrowed a substantial number of paintings from Durand-Ruel and Staats-Forbes. In 1908, the Dublin Municipal Gallery of Modern Art was finally opened. Included among the French paintings were works by Monet, Manet, Degas, Pissarro, Renoir and Vuillard. See D.S. MacColl, "A Modern Gallery in Dublin," *SR*, 98(1904), pp. 696-97. Also see D.S. MacColl; "Lessons from Dublin," *SR*, 105(1908), pp. 168–69.

28. The paintings are Manet, *Portrait of Eva Gonzalez;* Renoir, *Tuileries;* Monet, *Snow Scene at Vétheiul.* See MacColl, "Lessons from Dublin," p. 168.

29. Cézanne was also not really appreciated in Paris in 1905. Frank Rutter, recalling his own feelings about Cézanne at that time, says his opinion was the same as that

of Durand-Ruel senior. Cézanne, they believed, "had done some quite good still-lifes, but he bungled nearly everything else." Rutter, *Art in My Time*, p. 112.

30. Fry had been taken to task for not noticing Cézanne earlier, especially in 1905 when his paintings could have been seen at the Grafton Galleries. In 1906, his praise was still reserved. He considered Cézanne's powers of expression and his ability to crystallize the concerns of the 'imaginative life' limited.

31. *Ath*, 79(1906), pp. 56–57. I am attributing this article to Fry. The articles in the *Athenaeum* were published anonymously by several critics. C.J. Holmes, for example, was writing concurrently with Fry. It is therefore impossible to determine positively which essays were by Fry. The art criticism between about 1900 and 1908, generally, seems to reflect a uniform way of thinking. However, at this time, I believe that the article mentioned above is particularly representative of Fry's ideas and characteristic of his writing style.

32. "The Last Phase of Impressionism," *Burl*, 12(1908), pp. 272, 277.

33. Maurice Denis, "Cézanne, I and II," trans. Roger Fry, *Burl*, 16(1910), pp. 207–19, 275–80.

34. *Ibid.*, p. 207.

35. Julius Meier-Graefe, a German art critic and contemporary of Fry, was one of the earliest supporters of modern French art.

Benedict Nicolson considers Meier-Graefe and Denis to have had differing understandings of Cézanne's art. Denis, he believes, upheld the tendency towards abstraction in modern art, while Meier-Graefe maintained its expressionist tendencies. It is true that Denis generally spoke for the classic element in Cézanne's paintings, whereas Meier-Graefe exalted the romantic. However, some ideas traceable to the German seem to have crept into Denis' essay. This would be logical enough, since around 1905 Meier-Graefe was one of the most important and influential spokesmen for modern art. See Benedict Nicolson, "Post-Impressionism and Roger Fry," *Burl*, 93(1951), pp. 10–15.

36. This appears to be the painting, *Christ Mocked*, now in the Art Institute of Chicago. However, neither of the following catalogues record the painting as having been in the International Society Exhibition: P. Jamot and G. Wildenstein, *Manet, Catalogue Raisonné*, 2 vols. (Paris: Beaux Arts, 1932); Philadelphia Museum, *Edouard Manet, 1832-1883*, Catalogue by Anne Coffin Hanson (Philadelphia, 1966).

37. *Daily Telegraph*, Apr. 5, 1910, p. 9.

38. P.G. Konody, in his review of Théodore Duret, *Manet and the French Impressionists*, also established Manet's position as an acknowledged master, whose art, like that "of all reformers who advocated truly visual principles, was based upon sound tradition . . ." See *Observer*, Jan. 30, 1910, p. 4. It should be noted that Konody was not at all sympathetic to any of the young artists who exhibited at the International Society Exhibition in April. For example, he considered

Denis' *Maternité Italienne* "a wretched performance," condemning the "repulsive colour-scheme."

39. E.M., *Illustrated London News*, July 2, 1910, p. 28.

40. *Times*, May 6, 1910, p. 4.

41. Some of the artists included were Rouault, Degas, Renoir, Monet, Vuillard, Matisse, Marquet, Denis, Cross, Signac, Gauguin, Serusier, Bonnard, Vlaminck, Redon, Friesz, Luce. I believe that this was the first time to date that no Barbizon paintings were included in an exhibition of modern French art in England. One critic notes: "Wisely, there has been no attempt at any sustained representation of the admirable Barbizon school, which in a hundred ways and on a hundred occasions, has been sufficiently illustrated already." See *Observer*, July 1, 1910, p. 14.

42. Both of the local Brighton papers found the most significant painting in the exhibition to be Louis Edouard Fournier's *The Burning of Shelley's Body*. See *Brighton and Hove Society*, July 7, 1910, p. 3286. *Brighton Gazette, Hove Post, Sussex and Surrey Telegraph*, June 11, 1910, p. 5.

43. *Times*, July 7, 1910, p. 12.

Chapter II

1. The two exhibitions have been well documented. Their various contents and ideologies have been discussed. I shall, therefore, be summarizing much of this material, referring where relevant to more detailed accounts of content, organization, by the following authors: Douglas Cooper, *The Courtauld Collection* (London: Univ. of London, Athlone Press, 1954). Nicolson, "Post-Impressionism and Roger Fry."

2. These conditions have been carefully analyzed by Cooper and Nicolson.

3. I am grateful to Benedict Nicolson for making me aware of this exhibition. *Ibid.*, p. 13, and Interview, March 1970.

4. From the introduction to the catalogue for the Chelsea Arts Club Exhibition.

5. The introduction was written by Desmond McCarthy, from notes by Fry. See *Cooper*, p. 51.

6. Ruskin as well, reacting against the effects of the industrial revolution, believed that the real artist visualizes the profound truths found in the natural order. Fry, in 1910, came close to the older critic, whom he otherwise rejected in later years.

7. Nicolson attempts to identify some of the Cézannes exhibited. They include the following entries in Lionello Venturi, *Cézanne, son art, son oeuvre*, 2 vols. (Paris: P. Rosenberg, 1936): Cat. Nos. 198, 254, 273, 402, 489, 538, 669, 702. See Nicolson, p. 13, note 16.

8. *Ibid.*, p. 13.

9. *Ibid.*

10. Cooper maintains that as a result of the first Post-Impressionist exhibition the Fauves and Cubists were never properly understood in England. See Cooper, p. 54.

11. Nicolson notes, as further evidence for Fry's commitment to Baroque exuberance in 1910, that in addition to his preference for the romantic early Cézannes, Fry had proposed "expressionism" as a possible alternative title for the exhibition. See Nicolson, p. 12.

12. Fry would certainly have known Meier-Graefe's *Entwicklungsgeschichte der Modernen Kunst* (1904), which was almost immediately translated into English and reviewed in translation in the *Athenaeum*, 82(1909), p. 204, possibly by Fry himself. He might also have known the 1907 *Impressionisten*. This was never translated into English, but we know that Fry had a reading knowledge of German. The first monograph by Meier-Graefe on *Cézanne* did not appear until 1910. Interestingly enough, Fry reviewed the English translation (by J. Holroyd-Reece) of the final version (1928) for the *Burlington*, 52(1928), pp. 98–99.

13. Various studies of the Impressionists in English had been appearing since the 1890s (see Chapter 1, pp. 5-7). But I can think of no major study of the Post-Impressionists, likewise in English, before Fry helped to popularize these artists in Britain.

14. By 1914 several major works dealing with the Post-Impressionists, including Meier-Graefe's *Cézanne,* has appeared in Germany. There were also: Fritz Burger, *Cézanne und Hodler* (Munich, 1913). Max Raphael, *Von Monet zu Picasso* (Munich, 1913). Werner Weisbach, *Impressionismus,* 2 vols. (Berlin, 1911). Large collections of Cézannes, such as that of Paul Cassirer in Berlin, had already been formed in Germany. And Cézanne's work had been seen on at least 20 different occasions in various art exhibitions in Germany before the outbreak of World War I.

15. Jacqueline Falkenheim, "Julius Meier-Graefe on Cézanne," Departmental Paper, Yale, 1968.

16. *Ibid.*, p. 44.

17. On one occasion when he does talk about a specific painting, Meier-Graefe describes a Cézanne landscape, *La Route Tournante,* in the following way: "The colourist constructed counter-movements from tones in the grey wall, tones in the yellow of the road. He invented in the right portion of the wall, towards the background, where a shadow falls, the grey house which looks over the wall, and he strengthened the grey surface with blue and created here a substantial point of resistance for the eye which travels downwards. Eventually, at the end of the road, he invented the red-edged roof, which is the deeply seated eye of the picture. It catches our gaze and masters it playfully, buoys it up and drives it into the mass of green, a fertile meadow, and then our vision strays no longer, but sucks up the powerful nutrition offered it." Julius Meier-Graefe, *Cézanne,* trans. J. Holroyd-Reece (London: E. Benn, and New York: C. Scribner's Sons, 1927), p. 43. Quoted in Falkenheim, p. 58.

18. Denis, pp. 213–14.

19. Alfred Thornton claims that in 1913 the doctors at Bedlam held an exhibition of patients' drawings "to prove that Matisse and the rest were victims of mental derangement probably due to absinthe." An interest in psychoanalysis, growing around the time of the two Post-Impressionist exhibitions, could also have been responsible for this association between insanity and the artist's state of mind. Alfred Thornton, *Diary of an Art Student of the Nineties* (London: Sir I. Pitman and Sons, 1938), p. 87.

20. Henry Holiday, "Correspondence," *Nation*, 8(1910), p. 539.

21. Sickert's comments are revealing of the attitude of an Impressionist, who was used to valuing a painting in terms of a tightly knit surface of infinite dabs of paint, recording minute tonal or chromatic variations. He was therefore, best as a critic when he was discussing the relationship between Impressionism and Post-Impressionism, since this relationship had been somewhat oversimplified by the organizers of the exhibition. For example, he pointed out that the Impressionist artists did not exclusively and passively copy on the spot from nature and that their interests were not limited to the search for effects of color. A great deal more searching for design and structure went on in the studio, their aims being not so different from Cézanne's. See Walter Sickert, "Post-Impressionists," *Fortnightly Review*, 95(1911), p. 85.

22. *Connoisseur*, 28(1910), p. 316.

23. H.S., *Spectator*, 105(1910), pp. 797–98.

24. *Nation*, 8(1910), pp. 332–3, 402–3, 536–37.

25. What was partially missing here was a full and meaningful enough discussion of primitivism, one that recognizes what non-western and trecento art – both understood to be the product of societies that *precede* the full flowering of western civilization – were seen to have in common.

26. For some positive or semi-positive reviews see: *Pall Mall Gazette*, Nov. 7, 1910, p. 1. P.G. Konody, *Observer*, Nov. 13, 1910, pp. 9–10. J.E. Blanche, "Public Opinion," *Morning Post*, Nov. 30, 1910, p. 5. C.J. Holmes, *Notes on the Post-Impressionist Painters, Grafton Galleries, 1910–1911* (London: P.L. Warner, 1910). Sickert, "Post-Impressionists," especially on Gauguin.

27. Nicolson, p. 14.

28. Roger Fry, "The French Post-Impressionists," preface to the 1912 Grafton Exhibition catalogue, rpr. Roger Fry, *V&D* (Cleveland and New York: World Publishing Co., Meridian Bks., 1966), pp. 237–43.

29. Nicolson points out that this description of Picasso's art as "visual music" reveals a misunderstanding of Cubism, born out by other of Fry's attempts to come to terms with this phase in contemporary French art. His analysis here is perhaps more faithful to Matisse's *La Danse*, also in the exhibition, or even more appropriate to

the experiments of Kandinsky, which Fry would have seen at the Allied Artists' Association exhibitions in 1909, 1910 and 1911. Nicolson, p. 15.

30. As we shall see later (Chapter VI), Fry attempts in a late work, *Characteristics of French Art*, to define this classic spirit as a unique quality running through all French art.

31. G.R.H., *Pall Mall Gazette*, Oct. 4, 1912, p. 10.

32. *Ibid.*, and E.M., "Art Notes," *Illustrated London News*, Oct. 12, 1912, p. 542.

33. See *Observer*, Oct. 6, 1912, p. 6. *Times*, Oct. 4, 1912, p. 9. A.J. Finberg, "Post-Impressionists at the Grafton Gallery," *The Star*, Oct. 8, 1912, p. 4.

34. The accusation 'scientist' brings to mind the criticisms of the Impressionists by an idealistic generation suspect of any art that is devoid of human content and which seems to reinforce a materialistic ethic. It is, therefore, no coincidence that Finberg, an 'Idealist', in his analysis of Turner (see Chapter I), was one of the critics who saw Picasso's art to be little more than jumbles of diagrams that are entirely meaningless.

35. *Nation*, 12(1912), pp. 250–51.

36. See Claude Phillips, *Daily Telegraph*, Oct. 5, 1912, p. 9.

37. Fry, *Nation*, 1912, p. 250.

38. Konody, "Cézanne and Gauguin at the Stafford," *Observer*, Dec. 3, 1911, p. 10.

39. A comparison between Konody's attitude here and his very negative criticism of the first Post-Impressionist exhibition (see pp. 21, 26) makes plain the change that had taken place within a year.

40. Konody, "Rhythm," *Observer*, July 16, 1911, p. 7.

41. "The Futurists, review of an exhibition at the Sackville Gallery," *Times*, Mar. 1, 1912, p. 11.

42. Victor Reynolds, "Reaction as Progress," *New Age*, 6(1910), pp. 7–8.

43. Huntly Carter, "Art," *New Age*, 8(1911), pp. 404–5.

44. For other criticism of the mis-application of the term 'Post-Impressionism', see: "Denis, Serusier, Laprade, Desvallières at the Goupil Gallery," *Times*, Jan. 18, 1912, p. 4. P.G. Konody, "International Exhibition at the Grafton," *Observer*, Apr. 23, 1911, p. 6.

45. *Illustrated London News*, Oct. 5, 1912, p. 396. The headline accompanied pictures of costumed characters from the new production. The presentation was praised for its 'modernity' expressed through the quick and lively succession of scenes.

46. Carter, "The Indépendants and the New Intuition in Paris," *New Age*, 9(1911), pp. 82-83.

47. Quoted from Anthony Alpers, *Katherine Mansfield* (1954), in Wallace Martin, *The New Age Under Orage* (Manchester: Manchester Univ. Press, 1967), p. 135. Martin further claims that the influences of the exhibition can also be found in stories Miss Mansfield wrote during the year following its opening. He cites as an example the following descriptive passage from "The Journey to Bruges," *New Age*, 9(1911), p. 402: "The sky was indigo blue, and a great many stars were shining: our little ship stood black and sharp in the clear air."

48. Reference to Horace Holly, *Creation: Post-Impressionist Poems* (London, 1914) and Max Weber, *Cubist Poems* (London, 1914). See Martin, p. 135, note 2.

49. Carter, *The New Spirit in Drama and Art* (London: Frank Palmer, 1912).

50. Calderon enthusiastically reviewed the first Post-Impressionist exhibition for the *New Age*, 8(1910), p. 89. Reference Martin, p. 132, note 2.

51. Martin, p. 131.

52. John Murray, rev. of *Flight of the Dragon: Essay on the Theory of Art in China*, by Laurence Binyon, *Ath*, 84(1911) pp. 428–29.

53. Wallace Martin sums up the situation this way: "The immediate and most important effect of Post-Impressionism on sensitive members of the contemporary audience . . . was to give them a visual shock which changed the appearance of other works of art and the world itself. Some attempted to find an aesthetic theory which would clarify the relationship between Post-Impressionism and post-Renaissance art as a whole. John Middleton Murry explained Cubism by relating it to Plato's theory of forms; others found in Post-Impressionism the triumph of self-expression over external impressions, of individuality over reality. . ." Martin, p. 134.

It is important to note that no clear distinction was being made in 1910 to 1912 between the new art as a revelation of objective reality *or* as an expression of emotion and individuality. The muddled relationship between these two apparently contradictory claims was to live on in much theoretical discussion of modern art throughout the first half of the century.

54. Picasso was mainly being praised in the pages of the *New Age*, where his 'uncovering of essential truths' was enthusiastically received. However, although the *New Age* was able to barometer the intellectual mood of the period, it remained an elitist publication, expressing ideas even more 'avant-garde' than those of Fry and the Bloomsburies. It was the organ for the more doctrinaire intellectual camp, consisting of people like Ezra Pound, T.E. Hulme, Wyndham Lewis and John Middleton Murry.

Chapter III

1. For a further discussion of this issue see my article, "Roger Fry versus D.S. MacColl: An Alternative View of Modern Art," forthcoming in *The Art Quarterly*.

2. Dugald Sutherland MacColl (1859-1958) was born in Scotland and educated in Glasgow and London. He was a member of the English and Scottish Royal Watercolour Societies and of the New English Art Club. He became an art critic in London, writing successively for the *Spectator*, the *Saturday Review* and the *Week-end Review*. He was also the editor of the *Architectural Review* from 1901 to 1905, Keeper of the Tate from 1906 to 1911, and, keeper of the Wallace Collection from 1911 to 1924. MacColl was instrumental in the founding of the National Art Collections Fund and the Contemporary Art Society.

3. *Nineteenth Century Art*, with a chapter by Sir T.D. Gibson Carmichael (Glasgow: J. Maclehose and Sons, 1902). *Life Work and Setting of Philip Wilson Steer*, cat. by Alfred Yockney (London: Faber and Faber, 1945).

4. The age difference between Fry and MacColl is also important here. MacColl was sufficiently the older critic, having started writing around 1890, to have come on the scene when French and English Impressionism (Sickert and Steer) was the accepted contemporary art in London. His preference for these artists must therefore have been partially conditioned by the prevailing taste.

5. *SR*, 82(1896), pp. 539–40.

6. D.S.M., "Impressionists in London," *SR*, 91(1901), pp. 106–7.

7. D.S.M., rev. of *Raeburn*, by Sir Walter Armstrong, *SR*, 93(1902), pp. 230–31.

8. D.S. *MacColl*, "A Year of Post-Impressionism," *Nineteenth Century*, 71(1912), pp. 285–302.

9. Denis, p. 214.

10. We must in part attribute MacColl's emphasis on surface pattern to his experience with Impressionism. The dissolution of solid form through light in many Impressionist paintings gives the texture and web of color variations on the surface of the canvas an unprecedented emphasis.

11. See, for example, Fry, *Cézanne* (New York: Noonday Press, 1960), pp. 49–50.

12. Fry, "An Essay in Aesthetics," publ. originally in the *New Quarterly*, 1909, rpr. *V&D*, pp. 33–34.

13. See, for example, Fry, *Cézanne*, p. 70.

14. "Cézanne as Deity," (1928), rpr. *Confessions of a Keeper and Other Papers* (New York: Macmillan Co., 1931), pp. 260–72.

15. See Fry, "Plastic Colour," in *Transformations* (London: William Clowes and Sons, and New York: Bretano's, 1926), pp. 213–24. See also Fry, *Cézanne*, pp. 39, 65, 69.

16. Fry, "Line as a Means of Expression in Modern Art," *Burl*, 23(1918), pp. 201–8, and 24(1919), pp. 62–69.

 MacColl, "Correspondence: Mr. Fry and Drawing," *Burl*, 24(1919), pp. 203–6, 254–56, and 25(1919), pp. 42–46.

17. Fry, "Correspondence: Mr. MacColl and Drawing," *Burl*, 25(1919), pp. 84–85.

18. Fry, "Observations on a Keeper," rev. of *Confessions of a Keeper and Other Essays* by D.S. MacColl, *Burl*, 60(1932), pp. 97–100.

Chapter IV

1. For a recent discussion of Diderot's art criticism and that of several nineteenth-century French critics, including Stendhal and Baudelaire, see Anita Brookner, *The Genius of the Future* (London: Phaidon, 1971).

2. Linda Nochlin makes the interesting point that the term 'avant-garde' could not be applicable to the revolutionary intentions of mid nineteenth–century French art. Courbet and his supporters were rebels only to the extent that they wanted to reform their contemporary society. They were involved whole-heartedly in affecting a change and did not stand apart, feeling estranged from the values and desires of their contemporaries. See Linda Nochlin, "The Invention of the Avant-Garde: France, 1830–80," in *Avant-Garde Art*, ed. Thomas B. Hess and John Ashberry (London: Collier-Macmillan, 1968). pp. 1–24.

3. Charles Baudelaire, "The Salon of 1846," in *The Mirror of Art*, trans. Jonathan Mayne (London: Phaidon, 1955), p. 43.

4. See Conrad Fiedler, *On Judging Works of Visual Art*, trans. Henry Schaefer-Simmern and Fulmer Mood (from the original, *Ueber die Beurteilung von Werken der Bildenden Kunst*, 1876), (Berkeley: Univ. California Press, 1949).

5. See Adolf von Hildebrand, *The Problem of Form in Painting and Sculpture*, trans. Max Meyer and Robert Morris Ogden (from the original, *Das Problem der Form in der Bildenden Kunst*, 1903), (New York: G.E. Stechert & Co., 1907).

6. *Ibid.*, pp. 83–84.

7. For a comparison between Fry and Ruskin, see: Graham Hough, "Ruskin and Roger Fry: Two Aesthetic Theories," *Cambridge Journal*, 1(1947-1948), pp. 14–27.

8. See *The Art Criticism of John Ruskin*, ed. and with an introduction by Robert L. Herbert (New York and Garden City: Doubleday, Anchor Books, 1964), Introduction, p. xi.

9. See Graham Hough, *The Last Romantics* (London: Gerald Duckworth and Co., 1949), p. 28. Hough considers here Ruskin's discussion of Giotto. Fry's treatment of the same artist will be considered in greater detail in Chapter V of this essay.

10. *Ibid.*, p. 6.

11. For a discussion of Fry in relationship to the art for art's sake writers, see: F. M. Godfrey, "Rebirth of an Aesthetic Ideal; an essay on three masters of art appreciation: Pater, Wilde and Fry," *Studio*, 135(1948), pp. 150–51, 182–85.

12. Pater's major essays on art include: *Studies in the History of the Renaissance*, 1868; *Appreciations*, 1889; and *Miscellaneous Studies*, 1899.

13. Walter Pater, conclusion to *Studies in the History (of the Renaissance)*, in *Paths to the Present: Aspects of European Thought from Romanticism to Existentialism*, ed. Eugene Weber (New York, Toronto: Dodd, Mead & Co., 1960), pp. 198–200.

14. From *Studies in the History of the Renaissance*, ref. Hough, *The Last Romantics*, p. 163.

15. Whistler delivered his *Ten O'Clock Lecture* in February, 1885, at the Prince's Hall in London. See Gaunt, *The Aesthetic Adventure*, p. 134.

16. Whistler's dislike of the critical profession certainly increased during his famous confrontation with Ruskin in 1878. Ruskin, referring to one of Whistler's *Nocturnes*, then on view at the Grosvenor Gallery in London, accused the artist in print of asking 200 guineas for "flinging a pot of paint in the public eye." Whistler then sued him for libel. He won his case, but he was essentially ruined financially as a result of it. Although the trial broke Ruskin's absolute power as 'tastemaker' in England, more people seemed to rally to his support than to Whistler's. The artist thus swallowed a new dose of bitterness to augment his hatred of all those people he considered parasites, because they hovered around and lived off the work of artists. *Ibid.*, pp. 98–124.

17. MacColl served as Keeper of the Tate and Wallace Collections, and Phillips was at one time Keeper of the Wallace Collection. Holmes and Binyon, respectively, served as directors of the National Gallery and the British Museum.

18. C.J. Holmes recalls the circumstances surrounding the renewal of the *Burlington* as follows: ". . . That delightful artist Mrs. Fry [Roger's wife] was deeply, almost too deeply interested in the crisis. Her enthusiasm, and her delicate wit had helped, I think, to make the Berensons consider whether they might not take the predominant part in reviving the magazine. But when the predominance seemed likely to extend to criticism as well as to finance, I became apprehensive. Friends like Claude Phillips and other English writers of repute, not to mention such authorities as Bode in Berlin, would not exactly welcome a Berensonian dictatorship, and the job of the nominal editor would be no bed of roses . . ." By the end of 1906, C.J. Holmes and Robert Dell were chosen as joint editors. C.J. Holmes, *Self and Partners (mostly self): Being the Reminiscences of C.J. Holmes* (London: Constable & Co., 1936), p. 214.

19. For a discussion of the history of the Botticelli cult in the nineteenth century, see: Michael Levey, "Botticelli and Nineteenth-Century England," *Journal of the Warburg and Courtauld Institutes*, 23(1960), pp. 291–306.

20. For a discussion of the application of Darwinian evolutionary theory to art history see: Peter Fingsten, "The Theory of Evolution in the History of Art," *College Art Journal*, 13(1954), pp. 302–10. Vladmir Weidlé, "Biology of Art: Initial Formulation and Primary Orientation," *Diogenes*, 17(1957), pp. 1–15.

21. In an earlier work, *Physiological Aesthetics*, Allen tried to prove the extreme thesis

that our artistic tastes are based on physiological need. The classical preference is for smooth surfaces, harmony and symmetry. The 'savage' is fond of sharp colors, whereas civilized man leans towards nuance. Allen reveals a prejudice in favor of western art. He also believed in the progressive theory of art history, where we have moved upwards from the primitive, through the antique, to the "perfection" of four types of pleasure in "modern post-Raphaelite painting."

22. Laurence Binyon, *SR*, 109(1910), pp. 297–98.

23. A direct application of evolutionary theory to Post-Impressionism appeared in an *Observer* article in 1910, basically antagonistic to the new art. The author criticizes the claims of Post-Impressionism that reject tradition for a return to archaic expression. He says: "In art tradition is the equivalent for Heredity, Individuality for the evolutionary force. And it is scarcely necessary to prove that there is an equivalent for Natural Selection and for the Survival of the Fittest. An absolute breaking away from all tradition is as impossible as the spontaneous generation of a new species . . . The strange thing is that the extreme champions of Post-Impressionism have no patience whatever with the followers of normal evolution on traditional lines, whom they call 'respectful plagiarists' and worse things, but they hail the copying of a mummy-case or of a Polynesian stone idol as a daring innovation or an epoch-making force . . ." *Observer*, Feb. 5, 1911, p. 4.

24. Finberg, *Turner Sketches and Drawings*, p. 143.

Chapter V

1. "Art and the State," in *Transformations*, p. 54.

2. Virginia Woolf, *Roger Fry: A Biography* (London: The Hogarth Press, 1940), p. 65.

3. *Ibid.*, p. 91. Also Denys Sutton, ed., *Letters of Roger Fry*, 2 vols. (London: Chatto & Windus, 1972), vol. I, p. 10.

4. Fry spoke of this interest in 1894 in a letter to Basil Williams, friend of Gustave Frizzoni, who was a disciple of Morelli. Sutton, *Letters*, vol. I, p. 10.

5. In a letter to Mariechen Berenson, Fry notes: "My *Quarterly* article has, I hear, roused the fury of Strong because he thinks I give the honour of inventing scientific criticism (such as it is) to Morelli instead of Crowe and Cavalcaselle. It shows how impartial I have been because all my prejudices are in favour of Cavalcaselle. However, it is fatal to be impartial . . ." Sutton, *Letters*, vol. I, pp. 188–89.

6. Fry, "The Mond Pictures in the National Gallery," *Burl*, 44(1924), pp. 234–46.

7. I am indebted to Mrs. Pamela Diamand, Roger Fry's daughter, for permitting me to study the contents of these sketchbooks, which are in her possession.

8. It is amusing to discover in one sketchbook a diligently diagrammed pattern of German verb conjugations, obviously set down by a determined student, who, according to Mrs. Diamand, learned how to read German fairly well, but never mastered nor liked it.

9. Fry is, for example, probably the author of the anonymous, favorable review of Berenson's *Study and Criticism of Italian Art* in the *Ath*, 74(1901), p. 668. The review is at once a praise of Berenson and a defense of the attribution method. The author believes that because an attribution based on purely internal evidence is in fact the summing up of aesthetic judgments accumulated from the expert's total experience with works of art, ". . . attributions have their value in stimulating and setting free purely aesthetic perceptions."

10. Benedict Nicolson also sees the strong influence of Berenson on Fry in the early years, although there was a definite falling out between the two men at about the time of the first Post-Impressionist exhibition. Many people believe that this rift is due largely to Fry's new interest in modern art, for which Berenson, in spite of his 1908 article in the *Nation* (New York), enthusiastically praising Matisse, had little use.

 Nicolson also points out that Berenson hated Bloomsbury. Bertrand Russell was his only real link with the group. This also could have discouraged friendship between Fry and Berenson. Fry did, however, continue corresponding with Mariechen, long after communication between him and Berenson ceased. Interview with Nicolson in London, March, 1970.

11. Solomon Fishman finds similarities between Fry's association of the elements of design with certain fundamental physical and psychological experiences and Berenson's "ideated sensations." In both cases, the attempt to define the "emotional elements of design" is a denial of pure art for art's sake as the viable aesthetic experience. Solomon Fishman, *The Interpretation of Art* (Berkeley: Univ. of Calif. Press, 1963), p. 119.

12. This is probably a reference to Binyon's not completely favorable review of MacColl's *Ninteenth Century Art* (see p. 8).

13. Woolf, pp. 89–91.

14. Fry, *Giovanni Bellini* (London: At the Sign of the Unicorn, 1899).

15. Sutton, *Letters*, vol. I, pp. 15–16; Tancred Borenius, "Roger Fry as Art Historian," *Burl*, 65(1934), pp. 235–36.

16. "Art Before Giotto," Oct. 1900, pp. 127–51. "Giotto I," Dec. 1900, pp. 139–51. "Giotto II," Feb. 1901, pp. 96–121. "Florentine Painting of the Fourteenth Century," June 1901, pp. 112–34. The "Giotto" essay (Parts I and II) is reprinted in *V&D*, pp. 131–77.

17. It should be mentioned that the reputations of Cimabue and Duccio were extremely insecure at this time. Some of the paintings now agreed by scholars to be by Duccio were then assigned to Cimabue. Fry, in the "Giotto" essay, refers to Dr. J.P. Richter, who, in "Lectures on the National Gallery," reattributed the *Rucellai Madonna* to Duccio. But Fry, as late as 1920, still believed the painting to be a late work by Cimabue. "Giotto," *V&D*, p. 141, note.

18. Fry does, for example, give more credit and praise to Cimabue in the edited

comments appended to the 1920 version of the "Giotto" essay, reprinted in *V&D*, than he did in the original. Alastair Smart discusses the changes in Fry's attitude to early Italian art in the essay. "Roger Fry and Early Italian Art," *Apollo*, 83(1966), pp. 262–71.

19. All page references here to the "Giotto" essay refer to the version printed in *V&D*.

20. Sutton, *Letters*, vol. I, p. 17; and Interview with Mrs. Diamand in London, March, 1970.

21. "Tempera Painting," *Burl*, 7(1905), pp. 175–76. In this essay Fry discusses the renewed interest in the medium, and a current exhibition of tempera work at the Carfax Gallery.

22. Sir Joshua Reynolds, *Discourses: Delivered to the Students of the Royal Academy*, Intros. and notes by Roger Fry (London: Seeley & Co., 1905).

23. "Dutch Masters at the Burlington Fine Arts Club," *Pilot*, 1(1900), pp. 545–47.

24. Ruskin, too, criticized the aims of the seventeenth-century Dutch artists for very similar reasons. He believed that they sacrificed "motives of spiritual interest" to increased technical perfection. See Herbert, *The Art Criticism of John Ruskin*, pp. 327–29.

25. C.R. Nevinson, the English futurist and a critic of Fry, gives the following account of a meeting between Fry and a contemporary Russian sculptor (around 1910): "One day Severini and I called to see a Russian sculptor, and when we arrived he and Derain were standing before wide-open windows on a cold day and breathing deeply . . . Severini and I were mystified until he [Derain] explained that Roger Fry had been there with another milord, obviously some *New Statesman* aesthetic Cambridge critic. These two tame and highly civilized experts, with their exquisite chatter had thoroughly upset the Russian and Derain, who were infuriated that such dilettantes should appreciate their work, in which they tried to introduce a harsh and wild note . . ." C.R.W. Nevinson, *Paint and Prejudice: (reminiscences)* (London: Methuen Publ., 1937), p. 49.

 Fry, in a letter to Vanessa Bell (May 19, 1919), relates part of a conversation he himself had with Derain. He writes: ". . . He loves Giotto as much as you or I do, but thinks the English passion for the primitives absurd (tho' God knows he's got a lot from them himself) . . ." Sutton, *Letters*, vol. II, p. 451.

26. Solomon Fishman, in *The Interpretation of Art*, also notes the dependence of Fry's aesthetic theories on the concept of *disegno*, p. 107.

27. Fry, "Burlington Fine Arts Club Exhibition of Florentine Painting," *Burl*, 35(1919), rpr. in *V&D*, pp. 178–85, p. 180.

 Other articles in which Fry discusses the development of fifteenth-century Italian painting include: "The Umbrian Exhibition at the Burlington Fine Arts Club," *Burl*, 16(1910), p. 267. "Exhibition of Old Masters at the Grafton Galleries – I," *Burl*, 20 (1911), pp. 66–77.

28. Although early in his career, Fry occasionally praised artists like Jan van Eyck

(Reynolds' *Discourses*), it is clear that his preference for distilled form generally prejudiced him against northern art, with its detailed studies of nature and regard for empiricism. Paul Hendy, in a letter to the *Burlington*, objects to Fry's supposed unfair treatment of Flemish art in a recent series of articles for the *Burlington*, in which he reviewed an exhibition of Flemish art at Burlington House. Hendy maintains that Fry "proceeds to judge the Flemish pictures by the standards of the Italians and finally to cap his verdict with the dictum of a sixteenth-century Italian sculptor. . ." Paul Hendy, "Correspondence," *Burl*, 50(1927), p. 212.

29. "The Mond Pictures in the National Gallery," p. 245.

30. "Mantegna as a Mystic," *Burl*, 8(1905), pp. 87–98.

31. Fry was consistently fascinated by the subtleties of design he observed in oriental art. Over a period of years, he reviewed various writings on Chinese or Japanese art, which could have been the sources for his ideas. For example: "Four Books on Oriental Art," *Quarterly Review*, 212(1910), pp. 225–39. The books he reviews are, L. Binyon, *Painting in the Far East*, 1908; Gaston Migion, *Manuel d'Art Musulman*, 1907; Ananda K. Coomaraswamy, *Medieval Sinhalese Art*, 1908; and E.B. Havell, *Indian Sculpture and Painting*, 1908. Rev. of *La Philosophie de la Nature dans l'art d'extrême Orient*, by Raphael Petrucci, *Burl*, 19(1911), pp. 106–7.

Fry makes two interconnected claims about oriental art, which are similarly expressed by these authors. His basic notion, agreeing with Petrucci, is that oriental art, unlike that of the west, is not anthropocentric, that the Chinese system places man in a situation as only one of the products of divine creation, whereas the Graeco-Roman and Renaissance systems have increasingly elevated man, even giving him the creative power itself.

According to Fry, the oriental artist, then, does not need to channel his creative energy into the expression of ideal human form or the portrayal of human emotions. He is, therefore, the more perceptual artist because he gives greater attention to natural phenomena, independent of man's relationship to them. The oriental artist does not think in conceptual terms of using light and shade or perspective to create sculptural or plastic forms because he is not interested in recreating a three-dimensional world tailored to human scale. He is more interested in the surface of his painting as a cohesive structure.

A specific result of these musings is that Fry has discovered special devices for creating form in oriental art. A particular example is the ovoid shape. If the oval is taken as a distortion of the circle, he believes that the early Chinese artists, who had few canons of proportion to defy, used this shape where its rightness in the compositional structure was instinctively felt. He further believes that certain western artists who had the same respect for formal structure, such as Cézanne, also made use of this ovoid shape to give full gravity and amplitude to the visualization of a sphere. Eight years before he expressed this theory in *Cézanne*, he had made the exact same observation about a painting, *Madonna Enthroned*, by Veneziano: In, "Explorations at Trafalgar Square," *Ath*, 92(1919), pp. 221-22, he notes in the Veneziano the familiar oval form that he says has remained popular in Byzantine and Chinese art to satisfy structural aims.

32. Fry discusses Signorelli in the following articles: "The Symbolism of Signorelli's School of Pan," *Monthly Review*, 5(1901), pp. 110–14. This article is unusual for him because it deals primarily with iconographical problems. "Three Pictures in the Jacquemart-André Collection," *Burl*, 25(1914), rpr. in *V&D*, pp. 186–92. "A Tondo by Luca Signorelli," *Burl*, 38(1921), pp. 105–6.

33. *Ibid.*, "Jacquemart-André Collection," pp. 191–92.

34. According to Frederick Hartt, Signorelli has been erroneously listed as an Umbrian. He was actually born in Cortona, in southern Tuscany, and was trained, according to Vasari, by Piero della Francesca. Frederick Hartt, *History of Italian Renaissance Art* (New York: Harry N. Abrams, Inc., 1969), p. 428.

35. Peter Quennell gives the following account of Fry lecturing: "'And now', said the lecturer glancing keenly at his audience and motioning them with the tip of his lecturer's wand to the midmost figure of a large *Descent from the Cross*, projected on to the screen over their heads –'And now, we come to the Imposing Central Mass'. Caught up in the abstract beauty of the composition, it did not occur to him that for the great majority of his audience – old ladies who had assembled to enjoy a lecture on Flemish or Italian art – it was a novel and somewhat disconcerting experience to hear the founder of their religion referred to *tout court* as an 'imposing mass', or watch devotional symbolism disintegrate into significant form." Peter Quennell. "Roger Fry," *Architectural Review*, 76(1934), pp. 113–14.

36. Fry, "The Exhibition of French Primitives (Louvre), Part II," *Burl*, 5(1904), pp. 279–98, p. 279.

37. "Retrospect," 1920, in *V&D*, pp. 287–88. This is the essay in which Fry perceptively summarizes the course he has taken as an art critic up until 1920. He shows an ability to understand and reflect upon some of his own prejudices.

38. "Mond Pictures in the National Gallery," p. 245.

39. "Burlington Fine Arts Club Exhibition of Florentine Painting," rpr. in *V&D*, pp. 184–85.

40. "El Greco," *Ath*, 93(1920), rpr. *V&D*, pp. 205–13.

41. "The Seicento," in *Transformations*, pp. 95–124.

42. "Rembrandt, An Interpretation," *Apollo*, 76(1962, New Series), pp. 42–45. This was originally a lecture, revised posthumously for publication.

43. It is interesting that Velasquez, whom Fry might have had doubts about because of the artist's 'pre-Impressionist' experiments with light, was, however, greatly respected by Fry. He found in his paintings a satisfying formal structure, brought about through color harmonies. But the key to Fry's appreciation of Velasquez was the sense of reserve and detachment he found in the artist's work. In contrast to Caravaggio, Velasquez was the discriminating artist, who carefully manipulated his realistic visions to formal ends. That is, Velasquez was not the naturalist who passively accepted appearances. See "The Seicento," pp. 119–20; and "The Fraga Velasquez," *Burl*, 18(1911), pp. 5–13.

44. "Claude," *Burl,* 11(1907). rpr. in *V&D,* pp. 221–31.

45. Fry further believes that Claude was weak in the capacity to organize a composition, that is, to relate the various component elements. He also notices, as is maintained by others about the artist, that he could not draw details, that his leaves are clumsy, that his trees or mountains have no "inner life," and that his repoussoir devices are too blatantly placed.

46. Alastair Smart, for one, believes that Fry's experience with the Post-Impressionists, especially around 1911, helped sharpen his perception of the formal qualities of the Italian masters. For example, he cites Fry's discussion of a Masaccio [*Burl,* 20(1911), p. 71]. Fry describes the "perfect plastic synthesis of the design" in the painting and, further, makes reference to the modernity of the picture. By now, Smart maintains, plasticity and "successful modernity" have become inseparable for him. Smart, "Roger Fry and Early Italian Art."

Chapter VI

1. The following analysis is typical: "In his essay *Modernist Painting,* Clement Greenberg observed: 'Flatness, two-dimensionality, was the only condition painting shared with no other art, and so Modernist painting oriented itself to flatness as it did to nothing else.' The question that must be answered, in the light of recent developments, is how a return to illusionism – if it can be characterized as a return – can be reconciled with the notion of the preservation of the integrity of the picture plane that critics since Fry have considered the sine-qua-non of a successful painting." Barbara Rose, "Abstract Illusionism," *Artforum,* 6(1967), p. 33.

2. Letter to Sir Edward Fry, Nov. 3, 1893, Sutton, *Letters,* vol. I, pp. 155–56.

3. Fry, "Art and Socialism," revised from "The Great State," 1912, rpr. in *V&D,* pp. 55–78, p. 67.

4. Much is made of the relationship betwen Fry's brand of ethical aesthetics and the teachings of the Cambridge philosopher, G.E. Moore. See for example: Benedict Nicolson, "The Air of Bloomsbury," *Times Literary Supplement,* 53(1954), pp. 521–23. J.K. Johnstone, *The Bloomsbury Group* (New York: Noonday Press, 1954).

5. The reference here is to an article in the *Athenaeum,* which I am attributing to Fry: "Whistler" (obituary), *Ath,* 76^2(1903), pp. 133–34.

6. The theory of a fundamental human need for pleasing formal relationships is discussed by Fry, although not completely worked out, in a lecture entitled "Art and Psychoanalysis," delivered to a group of psychoanalysts in 1924.

7. *New Quarterly,* 1909, rpr. in *V&D,* pp. 16–38.

8. For example, see: C.J. Holmes, rev. of *Vision and Design,* by Roger Fry, *Burl,* 38(1921), pp. 82–83. Hough, "Ruskin and Roger Fry." Fishman, *The Interpretation of Art.* However, Berel Lang considers Fry to have had a more ambivalent attitude towards the self-sufficiency of form, doubting the possibility of its complete isolation from content and dramatic expression. See "Significance of

Form: The Dilemma of Roger Fry's Aesthetic," *Journal of Aesthetics and Art Criticism*, 21(1962, Winter), pp. 167–76.

9. It is interesting to note that Fry rests his criticism of the coldly intellectual, unfeeling nature of Egyptian art on the supposed corrupting influence and domination of artistic production by religious and political forces. See "Egyptian Art," in *Last Lectures* (Boston: Beacon Press, 1962), p. 54.

10. "Retrospect," pp. 296-302.

11. "Significant form" is the term coined by Clive Bell in *Art* in 1914. It was used to define the aesthetically satisfying condition of formal order that, according to Bell, is the one quality common to all works of visual art.

12. "Double Nature of Painting," lecture delivered by Fry in Brussels in the fall of 1933, abridged and trans. from the French by Pamela Diamand, *Apollo*, 89(1969), pp. 362–71.

13. Fry writes: "By the word 'Transformations' I wish to suggest all those various transmutations which forms undergo in becoming parts of esthetic constructions." *Transformations*, preface.

14. It is perhaps no coincidence that E.H. Gombrich, who offers some brilliant insights into the nature of perception, uses Fry and his conclusions about Constable's use of the natural motif in *Reflections on British Painting* as a whipping post in his own discussion of the relationship between artistic images and reality. See *Art and Illusion: A Study in the Psychology of Pictorial Representation*, The A.W. Mellon Lectures in the Fine Arts, Washington: National Gallery (Princeton: Princeton Univ. Press, Bollingen Series, 1956), pp. 292, 296–98.

15. *Ath*, 93(1919), rpr. in *V&D*, pp. 47–54.

16. *Ibid.*, pp. 51–52.

17. It is this pure, creative vision which Fry, somewhat naively, assumed to be the prime motivation and also the result of Impressionist painting. The outcome was the amorphous quality to which he objected.

18. In our day, Sir Kenneth Clark, who is in fact a disciple of Fry, makes a similar observation in the first installment of his *Civilization* series. In discussing the sophisticated decoration to be found in Celtic manuscripts, he notes that we tend to pass quickly over these abstract patterns and then move on to something we can read. Normal vision, for practical reasons, seeks out intelligible symbols. But if we could not read, or had nothing else to do, we could stare at these decorations for hours and become hypnotized.

19. Lecture delivered to the Fabian Society in 1917, rpr. from notes in *V&D*, pp. 1–15.

20. *Cézanne*, p. 40. E.H. Gombrich makes similar observations in *Art and Illusion*. He notes that standards for what is 'real' can be altered by new artistic conventions invented to cope with perceptual data.

21. Gombrich, again in *Art and Illusion*, indicates the need for an educational process to explain artistic language and to adjust our conceptions of how we perceive things.

22. *Burl*, 16(1910), rpr. in *V&D*, pp. 85–98.

23. *Burl*, 30(1917), pp. 225–31.

24. *Burl*, 44(1924), pp. 35–41.

25. However, when Fry discusses Greek art in an essay in *Last Lectures*, he expresses his dislike for its supposedly total intellectual justification, devoid of feeling.

26. Fry, "Negro Sculpture," *Ath*, 94(1920), rpr. in *V&D*, pp. 99–103.

27. "Art and Life," *V&D*, p. 11.

28. Pamela Diamand, in a footnote appended to Fry's published lecture, "The Double Nature of Painting," has suggested that her father did not have the opportunity to see the best Impressionist paintings, neither in Paris, nor London, and she repeated this to me in an interview.

29. Clement Greenberg has observed that for a long time Monet had nothing to say to the next generation of artists, who saw form in terms of volumetric structure. Then in the 1940s, critics again became interested in the surface, and Monet was resurrected. Clement Greenberg, "The Later Monet," in *Art and Culture: Critical Essays* (Boston: Beacon Press, 1969) pp. 37–45.

30. "French Art of the Nineteenth Century: Paris Exhibition," *Burl*, 40(1922), pp. 271–78.

31. *Ath*, 75^1(1902), pp. 440–41. I am attributing this essay to Fry. I am less certain of his authorship here than in some other cases. However, the ideas, if not the vocabulary and writing style, are definitely consistent with his thinking. The several critics for the *Athenaeum* at this time seem to have supported a general and coherent critical thesis. Most of the ideas they expressed were compatible with Fry's beliefs.

32. "An Essay on Aesthetics," *V&D*, p. 35.

33. However, he does at one point question the automatic equation, proposed by William James, between physiological states and emotions. Letter to Henry Rutgers Marshall, July 24, 1909, Sutton, *Letters*, vol. I, p. 323.

34. *L'Amour de l'Art*, 5(1924), pp. 141–60.

35. The Cézanne monograph was published in 1927. Therefore, it cannot be considered, chronologically, as a formulative essay in Fry's thinking about form. However, it does represent an accumulation of ideas under consideration for about 20 years. This could be carefully proven by isolating earlier references to contour, color and Cézanne himself, which are restated in this essay. One limitation of the essay is that Fry's ideas about Cézanne had to be applied to an arbitrary selection of paintings, exclusively those Cézannes in the Pellerin collection.

36. Fry was quite familiar with Wölfflin's work. He favorably reviewed *Kunstgeschichte Grundbegriffe* (4th German edition) for the *Burlington.* And in a review for the *Athenaeum,* which I am attributing to him, of the English translation of *Klassische Kunst,* he again praises Wölfflin. However, this time he takes exception to the German writer's notion of progress. He agrees that, using "Disegno" as a criterion, we would consider sixteenth-century art to be an advance over fifteenth-century art. But he warns that the concern for expression which preoccupied the quattrocento artists was sacrificed along the way. *Burl,* 39(1921), pp. 145–48. *Ath,* 76(1903), pp. 862–63.

37. "On Some Modern Drawings," *Transformations,* pp. 197–212.

38. "Drawings at the Burlington Fine Arts Club," *Burl,* 32(1918), rpr. in *V&D,* pp. 244–55, p. 245.

39. Fry was most at home with Cézanne's still-life paintings. They maintain the representational elements with which he could associate the inspiration for the formal design. They thus provide the material for emotional response, while eliminating the problem of the narrative elements, which he suspected are separate from, and incompatible with, aesthetic contemplation. *Cézanne,* p. 42.

40. Nevinson, *Paint and Prejudice,* p. 47. Mark Gertler, *Selected Letters,* ed. Noel Carrington, intro. Quentin Bell (London: Rupert Hart-Davis, 1965), p. 180.

41. For example, Fry talks about Picasso's drawing in which he exhibits an innate rhythmic feeling, the ability to envisage decorative beauty without any expression of a definite reaction. He does not start from natural appearances. ". . . He is more a priori and abstract . . ." He also talks about Picasso and Cubist drawing and is not very complimentary to the latter. ". . . the Cubists, on the other hand, basing themselves in part upon certain *obiter dicta* of Cézanne, sought to reduce form to certain almost geometrical elements, to resolve the infinity of nature into a combination of a few recognisable and regular curves. In contrast to the free 'prose' rhythms of Matisse they reverted to a monotonously regular and fixed 'prosody'." He exempts Picasso from these criticisms, because of his innate genius. *Transformations,* pp. 206, 208.

42. *Cézanne,* p. 33.

43. "Plastic Colour," *Transformations.*

44. *Ibid.,* p. 218.

45. I do not mean to imply that Fry exalted this artist above all others of his contemporaries. I do not know the circumstances under which he wrote this essay. It is in fact possible that a current exhibition of Lévy's work was the motivation and that he then worked backwards to the more ambitious description of the history of the use of color.

46. "Renoir," 1919, rpr. in *V&D,* pp. 266–71.

47. Fry was fascinated with the concept of the bas-relief as an attitude towards formal unity. In "Negro Sculpture," again probably borrowing from the German theorist,

Emanuel Löwy, he considers the structural origins for western sculpture. He claims that European sculpture "approaches plasticity from the point of view of the bas-relief," that is, the combination of front, back and side reliefs. Negro sculpture, in contrast, initially attains to a greater plastic freedom, the notion of a freely rounded volumetric form, independent of the ground plane. Löwy's theory is that man's first experience with three-dimensional form is the necessary perceptual discovery of the distinction betwen figure and ground, out of which he develops relief images that gradually free themselves from the ground plane.

48. "Seurat's *La Parade*," *Burl*, 55(1929), pp. 289–93.

49. *Ibid.*, and "Seurat," in *Transformations*, pp. 188–96.

50. *Transformations*, p. 193.

51. "Seurat's *La Parade*."

52. There is also possibly a more practical reason. He might have been exposed to more of Seurat's paintings and also to the favorable comments on his work by other artists and critics.

53. This 'chronology' cannot be completely consistent. Fry was looking at Italian primitive, Mohammedan and Byzantine art before 1915 (he went to Constantinople with Clive and Vanessa Bell in 1914). He must have observed in these works the use of strongly contrasted areas of local color. But he rarely talks about color. For example, in his essay on Mohammedan art, *Burl*, 17(1910), p. 283, his main concerns are linear design and the persistent and successful use of certain patterns and rhythms.

54. "The Salons and Van Dongen," *Nation*, 9(1911), pp. 463–64.

55. "Jean Marchand," *Ath*, 92(1919), rpr. in *V&D*, pp. 279–83.

56. Fry might have taken exception to this last phrase, since he probably considered himself to be primarily an artist, but the constant awareness of how other people work and where they fall short could only have inhibited freedom and experimentation in his own work.

57. Letter to Helen Anrep, May 8, 1925, Sutton, *Letters*, vol. II, p. 571.

58. "On Some Modern Drawings," *Transformations*.

59. "The Allied Artists," *Nation*, 13(1913), pp. 676–77.

60. "Reflections on British Painting," in *French, Flemish and British Art* (London: Chatto & Windus, 1951).

61. *Ibid.*, p. 127.

62. "International Society's Exhibition (Whistler)," *Ath*, 74(1901), pp. 601–2. This is another anonymous article which I am attributing to Fry because the ideas expressed are consistent with his thinking throughout his career.

63. These ideas are also very close to Ruskin's expressed feelings about Whistler and about the desired function for art in general.

64. "The New English Art Club," *Pilot*, 2(1900). pp. 684–85.

65. "Aubrey Beardsley's Drawings," *Ath*, 77(1904), rpr. in *V&D*, pp. 232–36, p. 236.

66. *Ibid.*

67. *Characteristics of French Art* (London: Chatto & Windus, 1932). The text here is actually reconstituted from a series of lectures Fry delivered before the members of the National Art Collections Fund in connection with an exhibition of French art being held at Burlington House. To be fair, one should distinguish between Fry's essays initially intended to be written and published, and those which were originally lectures, because of the special demands of the two media. The lectures were probably conceived with the character of the audience in mind and with an awareness of the demands upon the lecturer to be clear, organized and not boring The lecture, which proceeds without footnotes and scholarly interpretations, is therefore less rigorous than the printed article. However, because some of Fry's lectures have been published and exist only in that form, I am evaluating them in terms similar to those applied to essays intended for publication.

68. "Drawings at the Burlington Fine Arts Club," *V&D*, p. 249.

69. This early reference to Daumier appears in one of several essays devoted to a large scale exhibition in Paris in 1900. "Paris Exhibition III," *Pilot*, 2(1900), pp. 299–330. For all Fry's protestations about the unique and completely non-utilitarian character of the aesthetic act, there is this strand of ethical criteria, which runs through his criticism and cannot be dismissed. He is more subtle than Ruskin or the avowed Socialists or Fourierists of the mid nineteenth century in France, such as Thoré, but he shares their belief in the possibilities and necessity for a totally dignified and comfortable existence. He would probably have insisted that aesthetic, versus political or economic, refinement is the best way to achieve this ideal state.

70. *Characteristics of French Art*, pp. 89–90.

71. *Ibid.*, p. 90.

72. "Plastic Colour," *Transformations*, p. 217.

73. Letter to Vanessa Bell, May 18, 1921, Sutton, *Letters*, vol. II, p. 509.

74. This belief in continuity must, however, be distinguished from a more optimistic belief in progress. Fry did not ascribe to an evolutionary theory which maintains that the study of art in chronological sequences automatically implies a development based on accumulated knowledge, from less to better. He makes this point in a favorable review of *Führer durch die alte Pinakothek* by Karl Voll. He praises Dr. Voll's employment of an art historical method to help the reader establish his own "aesthetic truths." However, he warns that the extreme consciousness of influence and tradition can overemphasize a positive experience of

progress from old to new. "Notes on the Pinakothek at Munich," *Burl.* 14(1908), pp. 94–96.

75. One has only to look to a group of Fry's artist and literary contemporaries in England – Ezra Pound, T.E. Hulme, Wyndham Lewis, David Bomberg – to see the differences between the avant-garde and art historical approaches to contemporary art. Bomberg, for example, maintains in the foreword to the catalogue for his 1914 one-man show: "I look upon NATURE, while I live in a steel city . . . My object is the *construction of Pure form.* I reject everything in painting that is not Pure form. I hate the colors of the East, the Modern Medievalist and the fat Man of the Renaissance."

Bomberg's comments could be compared with those of Fry in a letter to the *Burlington* (12(1908), pp. 374–75), in which he criticizes the periodical for not giving modern art just representation in comparison with the old masters. He emphasizes the traditional aspects of Cézanne's and Gauguin's art, and in claiming the historical veracity of the new Post-Impressionist art, likens the movement from Impressionism to Post-Impressionism to the shift in style from Roman to Byzantine art.

76. "Retrospect," *V&D*, pp. 287–88.

Selected Bibliography

I. Roger Fry's Published Writings

A. Books — Fry as Author

Giovanni Bellini. London: At the Sign of the Unicorn, 1899.

Catalogue of an Exhibition of *Manet and the Post-Impressionists*. London: Grafton Galleries, 1910.

Catalogue of an Exhibition of *Old Masters* in aid of the National Art-Collections Fund. London: Grafton Galleries, 1911.

Catalogue of an Exhibition of *Venetian Painting of the Eighteenth Century*. London: Burlington Fine Arts Club, 1911.

Catalogue of an Exhibition of *The Second Post-Impressionist Exhibition*. London: Grafton Galleries, 1912.

The New Movement in Art. Exhibition of representative works selected and arranged by Roger Fry. Birmingham: Royal Birmingham Society of Artists, 1917.

Catalogue of an Exhibition of *Florentine Painting before 1500*. London: Burlington Fine Arts Club, 1919.

Vision and Design. London: Chatto & Windus, 1920; 2nd ed., 1928; ed. Hammondsworth: Penguin Books, 1937; ed. London: Chatto & Windus, 1957; rpt. Cleveland and New York: World Publishing Co. (Meridian Books), 1956; 7th printing, 1966.

Architectural Heresies of a Painter (lecture). London: Chatto & Windus, 1921.

A Sampler of Castile. Richmond: L.&V. Woolf, 1924.

The Artist and Psycho-Analysis. London: L.&V. Woolf, 1924.

Art and Commerce. London: L.&V. Woolf, 1926.

Transformations: Critical and Speculative Essays on Art. London: Chatto & Windus, 1926.

Cézanne: A Study of His Development. London: L.&V. Woolf, 1927; 2nd ed., 1952; ed. New York: The Noonday Press, 1958; 2nd Noonday ed., 1960. Review of 2nd Woolf ed.: *Apollo*, 56(1952), p. 212.

Flemish Art: A Critical Survey. London: Chatto & Windus, 1927.

Henri-Matisse. London: A. Zwemmer; Paris: Editions des Chroniques du Jour, 1930; 2nd ed. London: A. Zwemmer, 1935.

Characteristics of French Art. London: Chatto & Windus, 1932.
Reviewed:
American Magazine of Art, 26(1933), pp. 353–54.
Connoisseur, 91(1933), p. 257.

Art-History as an Academic Study (Inaugural lecture). Cambridge: Cambridge University Press, 1933.

Reviewed:
 American Magazine of Art, 28(1935), p. 188.
Reflections on British Painting. London: Faber & Faber, 1934.
Reviewed:
 American Magazine of Art, 28(1935), p. 188.
 Apollo, 19(1934), p. 327.
 Art Bulletin, 19(1937), p. 601.
 Burlington Magazine, 65(July,1934), p. 45.
Last Lectures; with an introduction by Sir Kenneth Clark. Cambridge: Cambridge
 University Press, 1939; ed. Boston: Beacon Press, 1962.
Reviewed:
 Apollo, 30(1939), pp. 187–88.
 Architectural Review, 88(Oct.,1940), pp. 99–100.
 Art Bulletin, 23(1941), pp. 90–92.
 Art Digest, 15(Mar., 1941), p. 27.
 Burlington Magazine, 75(1939), p. 215.
 Connoisseur, 107(1941), pp. 84–85.
 Journal of Aesthetics and Art Criticism, 1(1941), pp. 127–28.
 Magazine of Art, 32(1939), p. 718.
 Parnassus, 12(Nov., 1940), p. 25.
*French, Flemish and British Art. (Characteristics of French Art. Flemish Art. Reflections
 on British Painting.)* London: Chatto & Windus, 1951.
Georges Seurat; forward and notes by Sir Anthony Blunt. London: Phaidon, 1965.
Reviewed:
 Apollo (new series), 83(1966), p. 76.

B. Books—Fry as a Contributor

Trevelyan, Robert Calverley. *Polyphemus and Other Poems;* with designs by R.E. Fry.
 London: R. Brimley Johnson, 1901.
Reynolds, Sir Joshua. *Discourses Delivered to the Students of the Royal Academy;* with
 introductions and notes by R. Fry. London: Seeley & Co., 1905.
Dalton, Ormon de Maddock. *Byzantine Enamels in Mr. Pierpont Morgan's Collection;*
 with note by Roger Fry (rpr. from the *Burlington Magazine*). London: Chatto &
 Windus, 1912.
Dürer, Albrecht. *Records of Journeys to Venice and the Low Countries;* (ed. by Roger
 Fry. Boston: Merrymount Press, 1913.)
Ardenne de Tizac, Jean Henri d'. *Animals in Chinese Art;* preface by Roger Fry.
 London: Benn Bros., 1923.
Grant, Duncan. (Collection of Plates); introduction by Roger Fry. London: L.&V.
 Woolf, 1923; 2nd ed., 1930.
B. R. *English Handwriting* (signed R. B., that is, Robert Bridges); with facsimile plates
 and artistic and paleographic criticisms by Roger Fry and E. A. Lowe. Oxford:
 Clarendon Press, 1926.
Cameron, Julia. *Victorian Photographs of Famous Men and Fair Women;* introductions
 by Virginia Woolf and Roger Fry. London: L.&V. Woolf, 1926.
Mauron, Charles. *The Nature of Beauty in Art and Literature;* trans. and preface by
 Roger Fry. London: L.&V. Woolf, 1927.
Tatlock, Robert R. *English Painting of the XVIIIth–XXth Centuries;* introduction by
 Roger Fry. London: Record of the Collections in the Lady Lever Art Gallery, vol.
 I, 1928.

Fry, R. (and others). *Georgian Art (1760–1820)*. London: B. T. Batsford, 1929.
Fry, R. (and others). *Chinese Art; Burlington Magazine* monograph. London: B. T. Batsford, 1935; revised ed., 1946.
Reviewed:
 Burlington Magazine, 68(1936), p. 104.
 Connoisseur, 97(1936), p. 112.
 Die Kunst, 77(May, 1938), pp. 10–11.
 Ostasiatische Zeitschrift (new series), 13(1937), p. 182.
Mauron, Charles. *Aesthetics and Psychology*; trans. by R. Fry and Katherine John. London: L.&V. Woolf, 1935.
Mallarmé, Stéphane. *Poems;* trans. by Roger Fry, with commentaries by Charles Mauron (trans. by Julian and Quentin Bell). London: Chatto & Windus, 1936; 2nd ed., 1952.

C. Articles (listed chronologically according to periodical)

Apollo (new series)

"Rembrandt, An Interpretation." 76(1962), pp. 42–45. This was originally a lecture, revised posthumously for publication.
"Double Nature of Painting." Lecture delivered by Fry in Brussels in the fall of 1933, abridged and trans. from the French by Pamela Diamand. 89(1969), pp. 362–71.

Athenaeum

Fry was one of the regular art critics for the *Athenaeum* between 1901 and 1905, approximately. The articles were published anonymously, and it is not possible at this time to determine the authorship of each essay. The several critics presented a seemingly unified critical attitude. Pamela Diamand has compiled one list of those articles she believes to have been written by her father.

Athenaeum (1919-1920). The following articles were signed by Fry at the time of publication:

"Jean Marchand." 92(1919), p. 178; rpr. in *Vision and Design.*
"Explorations at Trafalgar Square." 92(1919), pp. 211–12.
"Art and Science." 92(1919), p. 434; rpr. in *Vision and Design.*
"The Scenery of La Boutique Fantastique." 92(1919), p. 466.
"The Ottoman and the Whatnot." 92(1919), p. 529; rpr. in *Vision and Design.*
"The Artist's Vision." 93(1919), pp. 594–95; rpr. in *Vision and Design.*
"The Allied Artists at the Grafton Galleries." 93(1919), pp. 626–27.
"Modern French Art at the Mansard Gallery." 93(1919), pp. 723–24.
"Modern French Art at the Mansard Gallery, II." 93(1919), pp. 754–55.
"Explorations at Trafalgar Square, II." 93(1919), p. 849.
"Teaching Art." 93(1919), pp. 887–88.
"The Burlington Fine Arts Club (Winter Exhibition)." 94(1920), p. 215.
"Renoir (Exhibition at the Chelsea Book Club)." 94(1920), p. 247; rpr. in *Vision and Design.*
"Negro Sculpture at the Chelsea Book Club." 94(1920), p. 516; rpr. in *Vision and Design.*
"The Last Works of Renoir." 94(1920), pp. 771–72.
"Indigenous American Art (Exhibition at the Burlington Fine Arts Club)." 95(1920), p. 55.
"Bolshevik Art." 95(1920), pp. 216–17.

Burlington Magazine

"Two Pictures in the Possession of Messrs. Dowdeswell." 2(1903), p. 89.
"Pictures in the Collection of Sir Hubert Parry at Highnam Court Near Gloucester (Italian pictures of the fourteenth century)." 2(1903), pp. 117–31.
"*Christ Mocked* by Jerome Bosch." 3(1903), pp. 86+.
"Three Pictures in Tempera by William Blake." 4(1904), pp. 204–6; rpr. in *Vision and Design*.
"Exhibition of French Primitives – Louvre, Part II (Part I not by Fry)." 5(1904), pp. 279–98.
"French Primitives, Conclusion." 5(1904), pp. 356–80.
"Constantine Ionides Bequest to the National Gallery." 5(1904), pp. 455+.
"Titian's *Ariosto*." 6(1904), pp. 136–38.
"On a Florentine Picture of the Nativity." 7(1905), pp. 70+.
"On a Painting by Antonio da Solario." 7(1905), pp. 75–76.
"Tempera Painting." 7(1905), pp. 175–76.
"*Pietro Aretino* by Titian." 7(1905), pp. 344–47.
"Two Miniatures by de Limbourg." 7(1905), pp. 435–45.
"Mantegna as a Mystic." 8(1905), pp. 87–98.
"Some Recent Acquisitions of the Metropolitan, New York." 9(1906), pp. 136+.
"Fry's Campaign of Restoration at the Metropolitan." 9(1906), p. 292.
"The Maître de Moulins – Identification of a Style," 9(1906), p. 363.
"On a Fourteenth Century Sketchbook." 10(1906), pp. 31–38.
"The Stolen Portraits." 10(1907), pp. 375–76.
"A Note on Water Colour Technique." 11(1907), pp. 161–62.
"Claude." 11(1907), pp. 267–275; rpr. in *Vision and Design*.
"English Portraits Recently Added to the Uffizi Galleries." 12(1907), p. 47.
"Review of *Cimabue Frage* by Andreas Aubert." 12(1907), p. 171.
"Review of *The Painters of North Italy* (last volume of *North Italian Painters of the Renaissance*) by Bernard Berenson." 12(1908), pp. 347–49.
"Correspondence on 'The Last Phase of Impressionism'." 12(1908), pp. 374–75.
"The Art of Albert P. Ryder." 13(1908), pp. 63–64.
"Mr. Horne's Book on Botticelli." 13(1908), pp. 83–87.
"An Altarpiece of the Catalan School (Musée des Arts Decoratifs, Paris)." 13(1908), pp. 123–24.
The Exhibition of Illuminated Manuscripts at the Burlington Fine Arts Club." 13(1908), pp. 128–29.
"The Exhibition of Illuminated Manuscripts at the Burlington Fine Arts Club, cont'd." 13(1908), pp. 261–73.
"Notes on the Pinakothek at Munich (review of *Führer durch die Alte Pinakothek, München* by Karl Voll)." 14(1908), pp. 94-96.
"The Exhibition of Fair Women (paintings by Courbet, Manet, Goya, Monticelli and others)." 15(1909), pp. 14–18.
"Early English Portraiture at the Burlington Fine Arts Club." 15(1909), pp. 73–75.
"On a Picture Attributed to Giorgione." 16(1909), p. 6.
"The Painters of Vicenza." 16(1909), pp. 152+.
"The Umbrian Exhibition at the Burlington Fine Arts Club." 16(1910), pp. 267+.
"Bushmen Paintings." 16(1910), pp. 334+; rpr. in *Vision and Design*.
"The Sculpture of Maillol." 17(1910), pp. 26+.
"Some Specimens from the Japanese National Monuments (seen at the Japanese-British exhibition at Shepherd's Bush)." 17(1910), pp. 119+.
"A Modern Jeweller." 17(1910), pp. 169+.

"The Munich Exhibition of Mohammedan Art, I." 17(1910), pp. 283+; rpr. in *Vision and Design.*

"A Portrait of Leonello d'Este by Roger van der Weyden." 18(1911), pp. 200–2.

"On a Profile Portrait by Baldovinetti, #758 in the National Gallery." 18(1911), pp. 311+.

"The Fraga Velasquez." 18(1911), pp. 5–13.

"Review of *La Philosophie de la Nature dans l'Art d'Extrême Orient,* by Raphael Petrucci." 19(1911), pp. 106–7.

"Richard Bennett Collection of Chinese Porcelain." 19(1911), pp. 133–37.

"*Diana and Her Nymphs* (attribution)." 19(1911), pp. 206–11.

"Exhibition of Old Masters at the Grafton Galleries, I." 20(1911), pp. 66–77.

"Old Masters at the Grafton Galleries, II." 20(1911), pp. 161–67.

"Exhibition of Pictures of the Early Venetian School at the Burlington Fine Arts Club." 20(1912), pp. 346–59.

"*The Redeemer* by Giovanni Bellini." 21(1912), pp. 10–15.

"Early Venetian School, II." 21(1912), pp. 47+.

"Early Venetian School, III." 21(1912), pp. 95+.

"An Appreciation of the Swenigordskoi Enamels." 21(1912), pp. 290+.

"*The Journey of the Three Kings* by Sassetta (attribution)." 22(1912), p. 131.

"Notes on the Anghiari and Pisa Cassoni Panels." 22(1913), p. 239.

"*Madonna and Child* by Carlo Crivelli." 22(1913), p. 309.

"Some Pictures by El Greco." 24(1913), pp. 3–4.

"The Art of Pottery in England (exhibition at the Burlington Fine Arts Club)." 24(1914), pp. 330–35.

"Note on a Portrait of Guiliano de Medici by Sandro Botticelli." 25(1914), p. 3.

"Three Pictures in the Jacquemart-André Collection." 25(1914), pp. 79–85; rpr. in *Vision and Design.*

"A Picture Attributed to Bartolomeo di Giovanni." 29(1916), p. 3.

"Art and Socialism (lecture)." 29(1916), pp. 36–39; rpr. in *Vision and Design.*

"Rossetti's Water Colours of 1857." 29(1916), pp. 100–9.

"Gaudier-Brzeska (review of book by Ezra Pound)." 29(1916), pp. 209–10.

"The National Gallery Bill." 30(1917), pp. 21–23.

"Children's Drawings." 30(1917), pp. 225–31.

"Review of *Paul Cézanne,* by Ambroise Vollard." 31(1917), pp. 52–60; rpr. in *Vision and Design.*

"The New Movement in Art in its Relation to Life (lecture)." 31(1917), pp. 162–67; rpr. in *Vision and Design.*

"Drawings at the Burlington Fine Arts Club." 32(1918), pp. 51–63; rpr. in *Vision and Design.*

"On a Composition by Gauguin." 32(1918), p. 85.

"A Sale of Degas' Collection." 32(1918), p. 118.

"A Cassone-Panel by Cosimo Roselli (?)." 32(1918), p. 201.

"Review [signed R. F.] of *Pot-Boilers*—collection of essays and reviews, by Clive Bell." 33(1918), pp. 27–28.

"American Archaeology (reviews of *South American Archaeology, Mexican Archaeology, Central American Archaeology,* by Thomas A. Joyce)." 33(1918), pp. 155–57; rpr. in *Vision and Design.*

"Line as a Means of Expression in Modern Art." 33(1918), pp. 201–8.

"Recent Acquisitions for Public Collections, VII (French paintings: the National Gallery)." 34(1919), pp. 15–23.

"Line as a Means of Expression in Modern Art, cont'd." 34(1919), pp. 62–69.

"M. Larionow and the Russian Ballet." 34(1919), pp. 112–18.

"Notes on the Exhibition of Florentine Painting at the Burlington Fine Arts Club, I." 35(1919), pp. 3–12.

"Mr. MacColl and Drawing." 35(1919), pp. 84–85.

"Exhibition of Renoirs at the Chelsea Book Club [signed R.F.]." 36(1920), p. 146.

"A Portrait by Lorenzo Lotto." 37(1920), p. 39.

"Review of *The Tomb of Nakht at Thebes*, by Norman de Garis Davies." 37(1920), pp. 254–55.

"Modern Paintings in a Collection of Ancient Art." 37(1920), pp. 303–9.

"A Tondo by Luca Signorelli." 38(1921), pp. 105–6.

"Pictures at the Burlington Fine Arts Club." 38(1921), pp. 131–38.

"Two Rembrandt Portraits." 38(1921), p. 210.

"A *Self-Portrait* by Rembrandt." 38(1921), pp. 262–63.

"The Baroque (review of *Kunstgeschichte Grundbegriffe*, 4th German ed., by Heinrich Wölfflin)." 39(1921), pp. 145–48.

"A Reconstructed Annunciation." 40(1922), p. 54.

"French Art of the 19th Century – Paris exhibition." 40(1922), pp. 271–78.

"A Portrait by Rubens." 40(1922), pp. 284–87.

"A Crucifixion of the Avignon School." 41(1922), pp. 53–54.

"A Toad in White Jade, I [Part II by Una Pope-Hennessy]." 41(1922), p. 103.

"Settecentismo." 41(1922), pp. 158–69.

"Old Masters Exhibition at Messrs. Agnew." 42(1923), pp. 53–54.

"A Florentine Pietà." 42(1923), pp. 161–62.

"An Antonello da Messina at Nancy." 42(1923), pp. 181–82.

"Scythian Art (review of *Iranians and Greeks in South Russia*, by M. Rostovtzeff." 42(1923), pp. 216–22.

"*Pyramus and Thisbe* by Nicholas Poussin." 43(1923), p. 53.

"A Still-life by Chardin." 43(1923), p. 124.

"Some Chinese Antiquities." 43(1923), pp. 276–81.

"Van Gogh Exhibition at the Leicester Galleries." 43(1923), pp. 306–8.

"Children's Drawings." 44(1924), pp. 35–41.

"*The Creation of Eve* by Fra Bartolommeo." 44(1924), p. 114.

"*Horseman in the Wood* by Corot." 44(1924), pp. 157–58.

"Rembrandt Problems." 44(1924), pp. 189–92.

"The Mond Pictures in the National Gallery." 44(1924), pp. 234–46.

"An Unpublished Andrea del Sarto (*Madonna and Child with Saint John*)." 44(1924), p. 265.

"Titian as Draughtsman." 45(1924), pp. 160, 165.

"Cézanne at the Goupil Gallery." 45(1924), pp. 311–12.

"Mr. Frank Dobson's Sculpture." 46(1925), pp. 171–77.

"A Claude Landscape." 46(1925), p. 240.

"Exhibition of French Landscapes in Paris, Part II – Claude and Poussin." 47(1925), pp. 10–12.

"Giovanni Bellini's *Madonna and Child*." 47(1925), p. 64.

"A Tondo from Perugino's Atelier." 48(1926), pp. 77–78.

"Sandro Botticelli." 48(1926), pp. 196–200.

"The Author and the Artist." 49(1926), pp. 4–8.

"Siamese Art." 49(1926), pp. 68–73.

"Flemish Art at Burlington House, I – the Primitives." 50(1927), pp. 59–73.

"Flemish Art, II – The Later Schools." 50(1927), pp. 132–53.

"The Authenticity of the Renders Collection." 50(1927), pp. 261–67.

"Review of *Italian Primitives at Yale*, by Richard Offner." 51(1927), pp. 196–99.

"Bonnington and French Art." 51(1927), pp. 268–74.

"A Correggio Problem." 52(1928), p. 3–9.

"Review of *Three Essays in Method*, by Bernard Berenson." 52(1928), pp. 47–48.

"Review of *Cézanne*, by Julius Meier-Graefe, trans. by J. Holroyd-Reece." 52(1928), pp. 98–99.
"Review of *Jan Steen*, by F. Schmidt Degener and H.E. Van Gelder." 52(1928), pp. 247–48.
"Another Unpublished Correggio." 52(1928), pp. 109–10.
"At the Dutch Exhibition (Royal Academy)." 54(1929), pp. 54–67.
"A Chartres Sculpture for South Kensington." 55(1929), p. 3.
"Seurat's *La Parade.*" 55(1929), p. 289–93.
"Notes on the Italian Exhibition at Burlington House, I." 56(1930), pp. 72–89.
"Italian Exhibition at Burlington House, II." 56(1930), pp. 129–36.
"Mr. Berenson on Medieval Painting (review of *Studies in Medieval Painting*)." 58(1931), pp. 345–46.
"Observations on a Keeper (review of *Confessions of a Keeper and Other Essays*, by D.S. MacColl)." 60(1932), pp. 97–100.
"The Flemalle, Van der Weyden Question." 61(1932), pp. 114–18.
"The Bridgewater Titians." 62(1933), pp. 3–10.
"*Madonna and Child* by Andrea Mantegna.*" 62(1933), pp. 53–54.
"A Still-life Painting by Zurburan." 62(1933), p. 253.
"Negro Sculpture at the Lefèvre Gallery." 62(1933), pp. 289–90.
"Modern French Art at the Lefèvre Gallery." 63(1933), pp. 24, 29.
"Review of *A Critical and Historical Corpus of Florentine Painting*, by Richard Offner." 63(1933), pp. 42–43.
"*Cleopatra's Feast* by G. B. Tiepolo." 63(1933), pp. 131–35.
"The Artist as Critic." 64(1934), pp. 78–80.
"Review of a volume from the Offner Corpus – *The Fourteenth Century.*" 64(1934), p. 147.
"Review of *Art Now: An Introduction to the Theory of Modern Painting and Sculpture*, by Herbert Read." 64(1934), pp. 242, 245.
"Exhibition of French Painting (Lefèvre Gallery)." 65(1934), pp. 30, 35.
"A New Corot in the National Gallery." 65(1934), p. 53.

The Listener

"The Genius of Italy." 3(1930).
"Persian Art." 5(1931).
"What I like in Art – XIII; *The Toilet*, by Rembrandt." 12(1934), pp. 366–68.

Metropolitian Museum Bulletin

"Ideals of a Picture Gallery." 1(1906), p. 58.
"Accessions: #164 – *Madonna* by Pisanello." 1(1906), p. 164.
"Altarpiece Dedicated to St. Andrew, Attributed to Luis Borrassá [signed R.E.F.]." 2(1907), pp. 77–80.
"*The Charpentier Family.*" 2(1907), p. 102.
"An Important Loan (*Deposition* by Antonello da Messina)." 2(1907), p. 199.
"Drawings (Gainsborough and Cousins)." 2(1907), p. 200.
"Semi-Circular Panel of the Madonna and Child with Donors, by Giovanni da Milano." 3(1908), p. 11.
"Sculpture from the Château de Biron." 3(1908), p. 135.
"*Lady Lilith*, by Dante Gabriel Rossetti." 3(1908), p. 144.
"*Madonna and Child* by Giovanni Bellini." 3(1908), p. 180.
"Drawings." 4(1909), p. 24.
"*Richmond Castle* by P. Wilson Steer." 4(1909), p. 46.

"Italian Triptych of the Fifteenth Century." 4(1909), p. 88.
"*Madonna and Child* – Bartolommeo Montagna." 4(1909), p. 156.
"Tondo by Lorenzo di Credi." 4(1909), p. 186.
"Accessions: *Portrait of the Artist* by William Rothenstein; *Portrait of his Wife* by Ford Madox Brown." 4(1909), pp. 225, 226.

Monthly Review

"Art Before Giotto." 1(Oct., 1900), pp. 127–51.
"Giotto, I." 2(Dec., 1900), pp. 139–57; rpr. in *Vision and Design.*
"Giotto, II." 3(Feb., 1901), pp. 96–121; rpr. in *Vision and Design.*
"Florentine Painting of the Fourteenth Century." 3(June, 1901), pp. 112–34.
"A Note on an Early Venetian Picture." 4(July, 1901), pp. 86–97.
"The Symbolism of Signorelli's *School of Pan.*" 5(Dec., 1901), pp. 110–14.

The Nation

"The Grafton Gallery – I." 8(1910), pp. 331–32.
"The Post-Impressionists – II." 8(1910), pp. 402–3.
"A Postscript on Post-Impressionism." 8(1910), pp. 536–37.
"Artlessness." 9(1911), pp. 287–88.
"Plastic Design." 9(1911), p. 396.
"The Salons and van Dongen." 9(1911), pp. 463–64.
"Mr Walter Sickert's Pictures at the Stafford Gallery." 9(1911), p. 536.
"The Carlisle Mabuse." 9(1911), p. 838.
"Mr. Gordon Craig's Stage Designs." 9(1911), p. 871.
"The Autumn Salon." 10(1911), pp. 236–37.
"Alfred Stevens (exhibition at the Tate Gallery)." 10(1911), pp. 414–15.
"The Old Masters at Burlington House." 10(1912), pp. 656–58.
"Various Exhibitions (Venetian art at the Burlington Fine Arts Club, Modern French Art at the Goupil Galleries)." 10(1912), pp. 777–78.
"The Allied Artists at the Albert Hall." 11(1912), pp. 583–84.
"The Exhibition of Modern Art at Cologne." 11(1912), pp. 798–99.
"The Grafton Gallery: An Apologia." 12(1912), pp. 249–51.
"The Allied Artists." 13(1913), pp. 676–77.
"Blake and British Art." 14(1914), pp. 791–92.

Nation and Athenaeum

"Sisley at the Independent Gallery." 42(1927), p. 352.
"The Contemporary Art Society's Loan Exhibition." 42(1928), p. 747.
"Pierre Bonnard." 42(1928), p. 778.
"Mr. Gertler at the Leicester Galleries." 42(1928), p. 935.
"Dutch Art at Burlington House." 44(1929), p. 522.
"Russian Icons." 46(1929), p. 315.

The Pilot

"The New Gallery." 1(1900), pp. 291–92.
"The Royal Academy." 1(1900), pp. 321–22.
"New Gallery, II." 1(1900), pp. 353–54.

"The Grafton Gallery Romney Exhibition [signed R.E.F.]." 1(1900), pp. 419–20.
"Turner at the Fine Art Society." 1(1900), pp. 482–83.
"The Turners at the Fine Art Gallery." 1(1900), p. 516.
"Dutch Masters at the Burlington Fine Arts Club." 1(1900), pp. 545–47.
"Hertford House." 2(1900), pp. 43–44.
"Various Exhibitions (Italians at the Burlington Fine Arts Club, Strang Exhibition at the Carfax Gallery, and others)." 2(1900), pp. 75–76.
"At the Paris Exhibition (architecture of the buildings)." 2(1900), pp. 109–10.
"Paris Exhibition, II." 2(1900), pp. 139–40.
"Paris Exhibition, III." 2(1900), pp. 299–300.
"Paris Exhibition, IV." 2(1900), pp. 333–34.
"Mr. Rothenstein's Drawings." 2(1900), pp. 653–54.
"The New English Art Club." 2(1900), pp. 684–85.
"Portraits at the New Gallery and at Lawrie's." 2(1900), pp. 715–17.
"Recent Acquisitions at the National Gallery." 3(1901), pp. 10–11.
"Burlington House – British Art Retrospective." 3(1901), pp. 44–46.
"The Ruskin Drawings." 3(1901), pp. 207–8.

Quarterly Review

"Review of Four Books on Oriental Art (*Painting in the Far East* by Laurence Binyon, *Medieval Sinhalese Art* by Ananda K. Coomaraswamy, *Indian Sculpture and Painting* by E.B. Havell, *Manuel d'Art Musulman* by Gaston Migeon)." 212(1910), pp. 225–39.

II. Related Works

A. Principal Writings on Modern Art and Art Theory Contemporary with Fry

Bell, Arthur Clive Howard. *Art.* London: Chatto & Windus, 1914.
Binyon, Laurence. "Post-Impressionists." *Saturday Review*, 110(1910), pp. 609–10.
Brownell, William C. *French Art: Classic and Contemporary Painting and Sculpture.* London: David Nutt, 1892.
Clutton-Brock, A. "Post-Impressionists." *Burlington Magazine*, 18(1911), pp. 216 +.
Croce, Benedetto. *Estetica comme scienze dell' espressione e linguistica generale.* Milan, 1902; 2nd ed. in *Filosofia comme Scienza dello Spirito.* Bari, 1908–1917. Trans. by Douglas Ainslie in *Aesthetic as Science of Expression and General Linguistic,* London: Macmillan & Co., 1909-1921; 2nd ed., 1922; reissue London: Peter Owen, 1953.
Denis, Maurice. "Cézanne (I & II)." Trans. by Roger Fry. *Burlington Magazine*, 16(1910), pp. 207–19, 275–80.
Dewhurst, Wynford. *Impressionist Painting: Its Genesis and Development.* London: George Newnes, 1904.
Duret, Théodore. *Les Peintres Impressionistes.* Paris: Librarie Parisienne, 1878; 2nd ed., 1906; 3rd ed., 1922. Trans. by J. E. Crawford Flitch, London: Grant Richards, Phila.: J. B. Lippincott Co., 1910.
Eaton, Daniel Cady. *A Handbook of Modern French Painting.* London, Cambridge: Gay & Hancock, 1909.
Fiedler, Conrad. *Ueber die Beurteilung von Werken der bildenden Kunst.* 1876. Trans. by Henry Schaefer-Simmern and Fulmer Mood, intro. by Henry Schaefer-Simmern, Berkeley: Univ. of California Press, 1949.
Finberg, A.J. *Turner Sketches and Drawings.* London: Methuen & Co., 1910.

Hammerton, P.G. "The Present State of the Fine Arts in France." *Quarterly Review*, 185(1897), pp. 160–68.

Hildebrand, Adolf von. *Das Problem der Form in der bildenden Kunst*. Strassburg: J. H. E. Heitz, 1903; other ed., 1961. Trans. and rev. by Max Meyer and Robert Morris Ogden, New York: G.E. Stechert & Co., 1907.

Hind, C. Lewis. *The Post-Impressionists*. London: Methuen & Co., 1911.

Holmes, Charles J. *Notes on the Post-Impressionists, Grafton Galleries, 1910*. London: Philip Lee Warner, 1911.

Löwy, Emanuel. *Die Naturwiedergabe in der älteren grieschischen Kunst*. Rome: Loescher, 1900. Trans. by John Fothergill, London: Duckworth & Co., 1911.

Mauclair, Camille. *L'Impressionisme: son histoire, son esthétique, ses maîtres*. Paris: Librairie de l'Art ancien et moderne, 1904. Trans. by P.G. Konody, London: Duckworth & Co. (The Popular Library of Art), 1903.

MacColl, Dugald Sutherland. *Nineteenth Century Art*. With a chapter by Sir T.D. Gibson Carmichael. Glasgow: J. Maclehose & Sons, 1902.

————————. "A Year of Post-Impressionism." *Nineteenth Century*, 71(1912), pp. 285–302.

Meier-Graefe, Julius. *Paul Cézanne*. Munich: R. Piper, 1910; 2nd ed., 1923.

————————. *Cézanne und sein Kreis*. Munich: R. Piper, 1918; 2nd ed., 1922.

————————. *Cézanne*. Trans. by J. Holroyd-Reece. London: E. Benn and New York: C. Scribner's Sons, 1927. This work incorporates various writings by Meier-Graefe on Cézanne.

————————. *Entwicklungsgeschichte der modernen Kunst*. 3 vols. First version, Stuttgart, 1904; final version, vols. I and II, Munich: R. Piper, 1914; vol. III, 1924; rpt. 2 vols., Piper, 1966. Trans. by Florence Simmonds and George W. Chrystal, London: Heinemann and New York: G. P. Putnam's Sons, 1908.

————————. *Impressionisten*. Munich and Leipzig: R. Piper, 1907.

Moore, George. *Modern Painting*. London: Walter Scott, 1893; 2nd ed., Walter Scott and New York: C. Scribner's Sons, 1898; 3rd ed., Walter Scott, 1906.

Rutter, Francis Vane Phipson (Frank). *Revolution in Art*. London: Art News Press, 1910.

Sickert, Walter. "Post-Impressionists." *Fortnightly Review*, 95(1911), pp. 79–89.

Stevenson, Robert Alan Mowbray. *Velasquez*. In the series, *The Great Masters in Painting and Sculpture*, edited by G. C. Williamson. London: G. Bell & Sons, 1899; 2nd ed., edited by Denys Sutton, 1962.

The following periodicals were also good sources of information during the period being considered: *Art Journal, Athenaeum, Daily Mail, Daily Telegraph, Fortnightly Review, Illustrated London News, Morning Post, New Age, Observer, Pall Mall Gazette, Rhythm, Saturday Review, Speaker, Spectator, Studio, London Times*.

B. Later Works about Fry

Obituaries:

American Institute for Persian Art and Archaeology, 7(1934), pp. 53 + .

Apollo, 20(1934), p. 226.

Architect's Journal, 76(Sept., 1934).

Art Digest, 9(Oct., 1934), p. 14.

Art News, 32(Sept., 1934), p. 10.

Belfast News-letter, Sept. 11, 1934.

Beaux-Arts, Sept. 14, 1934, p. 2.

Burlington Magazine, 65(1934), p. 145.

Evening News, Sept. 10, 1934.

Liverpool Post, Sept. 11, 1934.

London Studio, 8(1934), p. 267.

London Times, Sept. 10, 1934.

Morning Post, Sept. 11, 1934.

New Statesman, Sept. 12, 1934, p. 357.

Revue de l'Art Ancien et Moderne, 66(1934), p. 353.

Scotsman (Edinburgh), Sept. 11, 1934.

The Star, Sept. 10, 1934.

Anon. "Measuring Roger Fry." *Art Digest*, 8(Nov., 1933), p. 12.

Bell, Quentin. "John Sargent and Roger Fry." *Burlington Magazine*, 99(1957), pp. 380–82.

_____. "Roger Fry." Inaugural Lecture. Leeds: Leeds Univ. Press, 1964.

_____. *Bloomsbury: Pageant of History*. London: Weidenfeld and Nicolson, 1968.

Borenius, Tancred. "Roger Fry as Art Historian." *Burlington Magazine*, 65(1934), pp. 235–36.

Buermeyer, Laurence. "The Esthetics of Roger Fry." In *Art and Education*, by J. Dewey et al. Merion, Pa.: Barnes Foundation Press, 1947.

Egbert, Donald D. "English Art Critics and Modern Social Radicalism." *Journal of Aesthetics and Art Criticism*, 26(Fall, 1967), pp. 29–46.

Fishman, Solomon. *The Interpretation of Art*. Berkeley: Univ. of California Press, 1963.

Godfrey, F.M. "Rebirth of an Aesthetic Ideal; An Essay on Three Masters of Art Appreciation: Pater, Wilde and Fry." *Studio*, 135(1948), pp. 150–51, 182–85.

Hannay, Howard. *Roger Fry and Other Essays*. London: Unwin Bros., 1937.

Harrison, C. "Roger Fry in Retrospect." *Studio*, 171(1966), pp. 220–21.

Holmes, Sir Charles J. "Vision and Design." Review of *Vision and Design*. *Burlington Magazine*. 38(1921), pp. 82–83.

_____. "Roger Fry and the *Burlington Magazine*." *Burlington Magazine*, 65(1934), pp. 145–46.

Holroyd, Michael. "Rediscovery: The Bloomsbury Painters." *Art in America*, 58(1970), pp. 116–23.

Hough, Graham. "Ruskin and Roger Fry: Two Aesthetic Theories." *Cambridge Journal*, 1(1947–1948), pp. 14–27.

Johnstone, J. K. *The Bloomsbury Group*. New York: Noonday Press, 1954.

Lang, Berel. "Significance or Form: The Dilemma of Roger Fry's Aesthetic." *Journal of Aesthetics and Art Criticism*, 21(Winter, 1962), pp. 167–76.

MacColl, Dugald Sutherland. "Mr. Fry and Drawing." *Burlington Magazine*, 24(1919), pp. 203–6, 254–56; 25(1919), pp. 42–46.

_____. "Cézanne as Deity." (1928) Rpt. in *Confessions of a Keeper and Other Papers*. New York: Macmillan Co., 1931.

_____. "Note on Roger Fry." *Burlington Magazine*, 65(1934), pp. 23–25.

Nicolson, Benedict. "Air of Bloomsbury." *Times Literary Supplement*, 53(1954), pp. 521–23.

Pevsner, Nikolaus. "Omega Workshops." *Architectural Review*, 90(Aug., 1941), pp. 45–48.

Price-Jones, Gwilym. "Le Condizioni attuali della Critica d'Arte in Inghilterra." *l'Arte*, 5(new series) (1934), pp. 365–82.

Quennell, Peter. "Roger Fry." *Architectural Review*, 76(Oct., 1934), pp. 113–14.

Read, Herbert. "Tribute." *Art News*, 33(Oct., 1934), p. 10.

Sewter, A.C. "Roger Fry and El Greco." *Apollo*, 52 (Aug., 1950), pp. 32–35.

Smart, Alastair. "Roger Fry and Early Italian Art." *Apollo* (new series), 83(1966), pp. 262–71.

Summerson, Sir John. Inaugural lecture: "What is a Professor of Fine Art?" Hull: University of Hull, 1961.

Sutton, Denys, editor. *Letters of Roger Fry*, 2 vols. London: Chatto & Windus, 1972.

Woolf, Virginia. *Roger Fry: A Biography*. London: Hogarth Press, 1940.

C. Later Works about the
Period in England, c. 1885–1920

Anon. "Neglected Phase of British Art." Editorial. *Apollo* (new series), 91(1970), pp. 174–85.

Bell, Arthur Clive Howard. "How England met Modern Art: The Post-Impressionist Exhibitions of 1910 and 1912." *Art News,* 49(Oct., 1950), pp. 24–27 + .

Bell, Quentin. "Bloomsbury and the Arts in the Early Twentieth Century." *Leeds Art Calendar,* # 55, 1964.

Bloomfield, Paul. *Uncommon People: A Study of England's Elite.* London: Hamish Hamilton, 1955.

Campos, Christophe. *The View of France from Arnold to Bloomsbury.* Oxford: Oxford Univ. Press, 1965.

Cooper, Douglas. Introduction to the *Courtauld Collection.* London: Univ. of London, Athlone Press, 1954.

Garnett, David. *The Flowers of the Forest.* London: Chatto & Windus, 1955.

Gaunt, William. *The Aesthetic Adventure.* Hammondsworth, Middlesex: Penguin Books, 1957.

Gertler, Mark. *Selected Letters.* Edited by Noel Carrington; introduction by Quentin Bell. London: Rupert Hart-Davis, 1965.

Holmes, Sir Charles J. *Self and Partners (Mostly Self): Being the Reminiscences of C. J. Holmes.* London: Constable & Co., 1936.

Holroyd, Michael. *Lytton Strachey: A Critical Biography.* Vol. 1: "The Unknown Years, 1880-1910"; Vol. 2: "The Years of Achievement, 1910-1932." London: Heinemann, 1967-1968.

Lipke, William C. "Omega Workshops and Vorticism." *Apollo* (new series), 91(1970), pp. 224–31.

_____. "Futurism and the Development of Vorticism." *Studio,* 173(1967), p. 176.

Martin, Wallace. *The 'New Age' Under Orage.* Manchester: Manchester Univ. Press, 1967.

Michel, W. "Tyros and Portraits: The Early '20s and Wyndham Lewis." *Apollo* (new series), 82(1965), pp. 128–33.

Morrell, Lady Ottoline. *The Early Memoirs of Lady Ottoline Morrell, 1873–1915.* Edited by Robert Gathorne Hardy. London: Faber, 1963.

Nevinson, C. R. W. *Paint and Prejudice (Reminiscences).* London: Methuen Publ., 1937.

Nicolson, Benedict. "Post-Impressionism and Roger Fry." *Burlington Magazine,* 93(1951), pp. 11–15.

Nowell-Smith, Simon, editor. *Edwardian England, 1901–1914.* London: Oxford Univ. Press, 1964.

Rothenstein, William. *Men and Memories: Recollections of William Rothenstein.* 2 vols. New York: Coward-McMann, Inc., 1931-1932.

Russell, Bertrand. *The Autobiography of Bertrand Russell. 1872–1914.* London: Allen & Unwin, 1967.

Rutter, Francis Vane Phipson (Frank). *Art in My Time.* London: Rich & Cowan, 1933.

Sadler, Michael Thomas Harvey. *Michael Ernest Sadler: 1861–1943. A Memoir by His Son.* London: Constable & Co., 1949.

Spender, Stephen. *World Within World.* London: Hamish Hamilton, 1951.

Thornton, Alfred. *Diary of an Art Student of the Nineties.* London: Sir I. Pitman & Sons., 1938.

Index